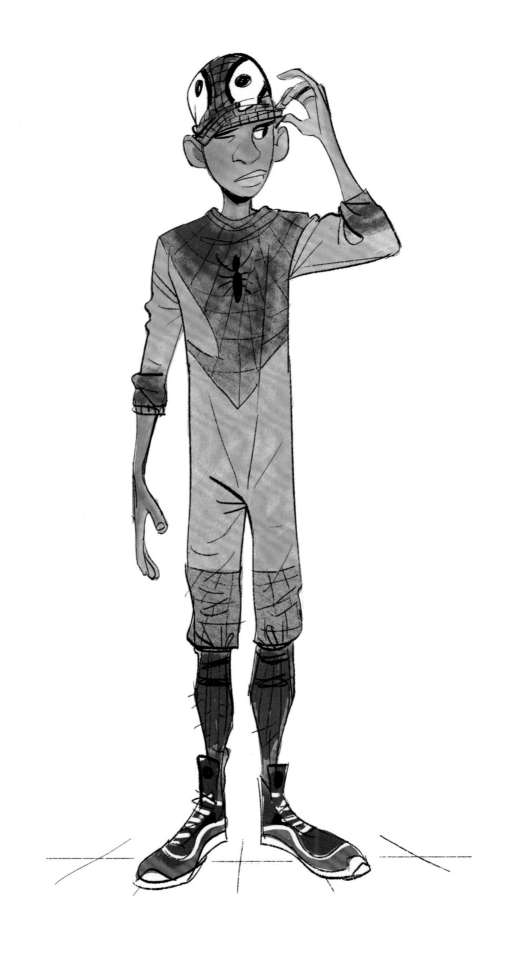

SPIDER-MAN: INTO THE SPIDER-VERSE: THE ART OF THE MOVIE

Spider-Man created by Stan Lee and Steve Ditko

MARVEL PUBLISHING
Jeff Youngquist, VP Production & Special Projects
Caitlin O'Connell, Assistant Editor, Special Projects
Jeff Reingold, Manager, Licensed Publishing
Sven Larsen, Director, Licensed Publishing
David Gabriel, SVP Print, Sales & Marketing
C.B. Cebulski, Editor in Chief
Joe Quesada, Chief Creative Officer
Dan Buckley, President, Marvel Entertainment

ISBN: 9781785659461
Limited Edition ISBN: 9781789090437

Published by Titan Books
A division of Titan Publishing Group Ltd.
144 Southwark St.
London
SE1 0UP

First edition: December 2018

13

Ramin Zahed is a Los Angles-based author and journalist who specializes in animation, VFX, pop culture, and indie films. He is the Editor in Chief of *Animation Magazine* and his writings have appeared in *Variety*, *The Hollywood Reporter*, the *Los Angeles Times*, *Emmy Magazine*, *Sight and Sound,* and *PBS*. Among his recent books are *The Art of The Little Prince*, *The Art of Captain Underpants*, *The Art of Boss Baby,* and *J.K. Rowling's Wizarding World: Movie Magic Vol. 2*.

To receive advance information, news, competitions, and exclusive offers online, please sign up for the Titan newsletter on our website: www.titanbooks.com

Did you enjoy this book? We love to hear from our readers. Please e-mail us at: readerfeedback@titanemail.com or write to Reader Feedback at the above address.

A CIP catalogue record for this title is available from the British Library.

Printed and bound in China.

Artist credits:
Endpapers: Front and back by Neil Ross.
Previous page: Concept sketch by Shiyoon Kim
Next spread: Concept art by Alberto Mielgo

SPIDER-MAN

INTO THE SPIDER-VERSE

THE ART OF
THE MOVIE

RAMIN ZAHED

MARVEL

TITAN BOOKS

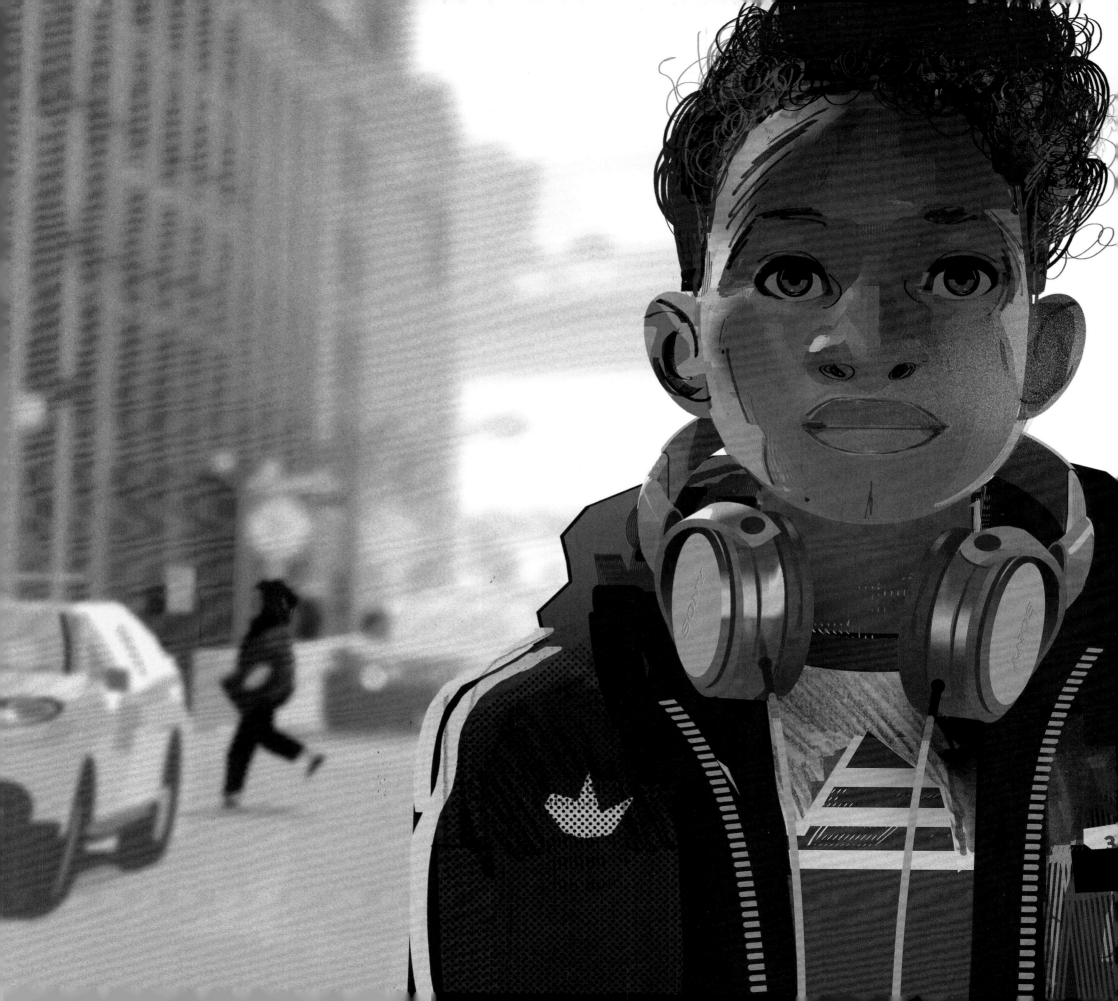

CONTENTS

FOREWORD

Hi! Hey! I'm the co-creator of Miles Morales. For the first five years of his life, I wrote every word he ever said and I am here to tell you: I didn't see any of this coming. I did not see Miles Morales becoming as big as he is today! And even if I did, maybe, sometimes, dream about it in my quietest of moments, I certainly didn't imagine it would become such a gorgeous piece of animation that it would deserve its own art book.

Okay. A little context into Miles' history and then I'll tell you the secret reason why art books like this are the absolute best. What Spider-Man had subtly done over the years is grow beyond itself. Quite a few things were happening in the comics. First off we launched a comic called *Ultimate Spider-Man* which chronicled the teen exploits of Peter Parker as if they happened today instead of 1960-something something. Now there were different Spider-Man titles doing very well. Then over in *Amazing Spider-Man*, quite a few supporting or 'legacy' characters became very popular. Popular enough to get their own comics and toys. Before you knew it Spider-Man was more than a character... he had become his own universe. A Spider-Verse, if you will...

FLASHBACK! At Marvel, We have frequent get-togethers called 'retreats' where we just sit around and talk about everything you'd think nerds of our caliber would talk about. One of the subjects was *Ultimate Spider-Man*. We talked about what we would do differently today. We talked about his universal appeal. His unique global appeal. We talked about how Spider-Man, if you look at the basic building blocks of its origin—where he's from, what motivated him—there's

really nothing that said this character should be Caucasian. In fact, you could argue there's very little that says he should be. Is that part of his unique appeal?

Could Spider-Man BE someone else? Who? Why? Well, those ideas scared the hell out of me. So I did what you do when something scares the hell out of you creatively. You do it. You do it in spite of.

We created a brand-new Spider-Man named Miles Morales. But none of it was easy. Should he be created from scratch or should he be something out of the *Ultimate Spider-Man* story? Should Miles be motivated by Peter Parker or should he be motivated by his own situation? Should they EVER meet? Is the world ready for a new kind of Spider-Man? Does the world want this?

All good questions. All scary questions. No easy answers. I sat on this for a while. I needed that extra special magic connection in my brain. Between Miles and Peter? Between myself and the character? A couple months later, on a long bike ride, the simple, elegant idea finally found its way to the surface: if Peter Parker dies heroically enough, he could be the 'Uncle Ben' character to this new Spider-Man. Then he continues the legacy of Peter, which is the legacy of Uncle Ben, which is the legacy of 'with great power comes great responsibility.' This new character can feel the words from his new perspective. Now we have a Spider-Man that means something to the legacy of Spider-Man but takes it in a completely different place.

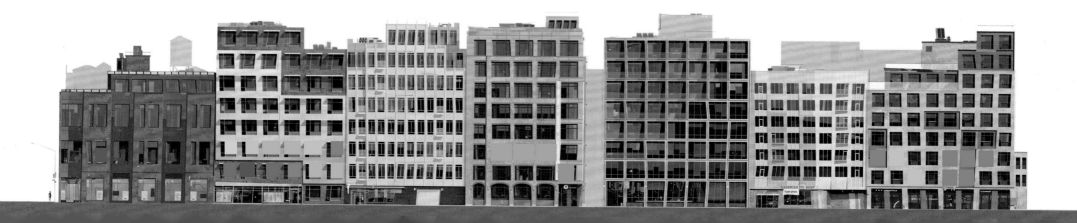

Co-created by Sarah Pichelli, the artist of *Ultimate Spider-Man*, with a great deal of input and inspiration from Marvel chief creative officer Joe Quesada, Miles Morales was born.

Miles really took off. I KNOW I sound like I'm bragging but you just bought the book of the art of the movie of the character so I think you know by this point Miles took off.

And here we are, you and I, in one of my favorite places. In the hands of such talented artists and filmmakers. I love art books. I love them. I have learned, explored, challenged myself so much diving into books JUST like this.

That's why 'art of' books are the best! If this is your first I am so excited for you! If you loved something, seeing the concepts at their most raw and most expressive can show you deeper truths and deeper appreciation. Sometimes it's ideas at their most unmanageable that inspire true greatness. Sometimes it's ideas creeping out from the back of the artists' heads. I love rough character sketches so much. It's an artist's id, ego, and momentary subconscious showing itself to you all at once. But, to me, so many of these abandoned ideas and sketches are still so worthy and so inspiring. One sketch can inspire a universe of ideas. One sketch can ruin an entire franchise. A book like this is artists of incredible temperament showing you one thing... THIS IS REALLY HARD!

BEWARE! These books are addictive. Often, as a storyteller challenge, I would think how *Star Wars* would have played out with some of those original designs. I studied *The Art of the Matrix* like it was the Torah. And I'm not alone. Every artist in this book probably owns more books like this than anything else in their house. Now they get to be in one or get to be in one again. It's SO cool.

Sit back and let these amazing visuals wash over you. Let them inspire you. Let them take over your imagination. Let them inspire you to put pen to paper or tablet.

If you can't tell, I am very moved by the very existence of this book. This is the work of really amazing artists, designers, and craftsmen, some of which I have met and some of which I might never but we share a great affection. You can tell with every line and brush mark, with every pixel and color choice that every person in this book shares a deep personal passion for all things Spider-Man.

I worked on Spider-Man for eighteen years, and I know I can speak for everyone involved in this book, and movie, when I tell you this was our dream job. Now enjoy this chronicle of the sweet torture of them trying to figure out how to do it.

Brian Michael Bendis

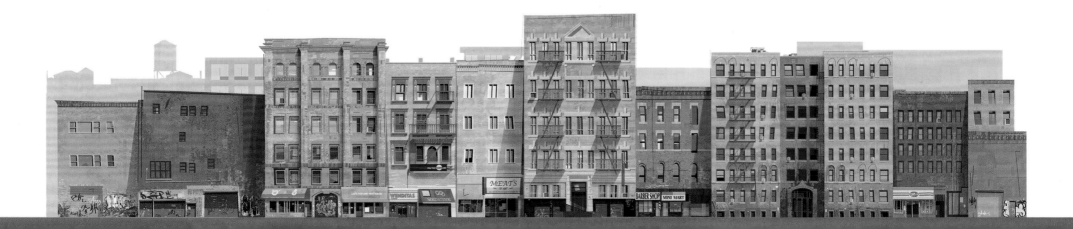

INTRODUCTION
CREATING A THOROUGHLY MODERN HERO

In 2011, when comic book writer Brian Michael Bendis and artist Sara Pichelli introduced Miles Morales as the hero of the *Ultimate Spider-Man* comics, fans eagerly embraced the new incarnation of the character created by Stan Lee and Steve Ditko over five decades ago. The smart, nerdy son of an African-American father and a Puerto Rican mother, Miles struck a fresh chord of diversity in the Marvel Universe.

The popularity of Miles Morales and the freshness of his world didn't escape producer Amy Pascal (Sony Pictures Entertainment chief at the time) and Marvel Studios founder Avi Arad, who were looking for a new project featuring the classic web-slinger. "Avi and I both agreed that there had never been a super hero movie done in animation for the big screen," recalls Pascal. "We wanted to produce a four-quadrant animated movie that was made for everyone, not just for kids. Animation offers us a whole new way to explore the characters and allows us to explore the characters in ways that we couldn't do in live-action movies before."

Arad, who has had a long, successful career producing both animated and live-action TV series and movies (including the six previous *Spider-Man* features) was also excited to try something new. "Everyone was going from animation to live-action, and I told Amy, 'I think we should do it the other way,'" he says. "We should showcase the style and art of the amazing comic books and make a movie for all ages. The idea of diversity was also very important to us, because the big theme of Spider-Man is that anybody can be under that mask. What the mask

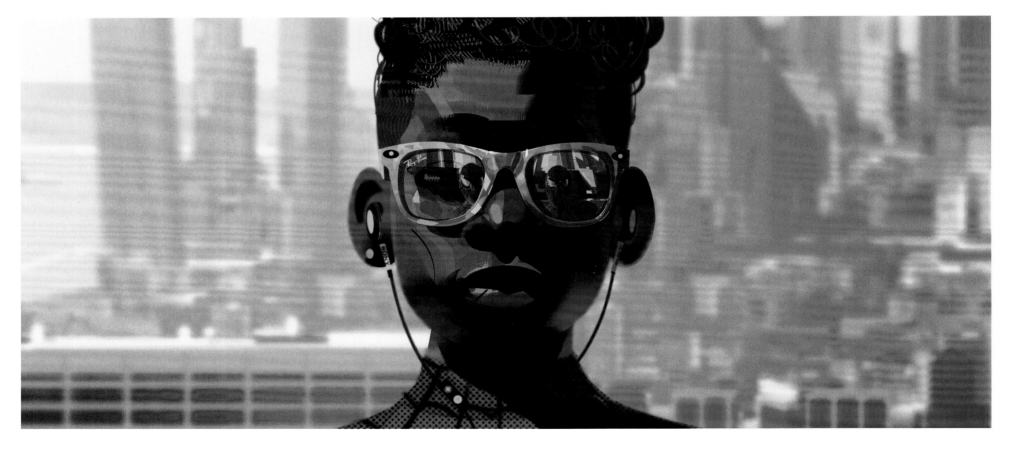

says is that when you put it on, you have the heart and soul of a hero."

Sony Pictures Animation's *Spider-Man: Into the Spider-Verse* began to really take flight when the acclaimed directing/producing team of Phil Lord and Chris Miller came on board as executive producers. The dynamic duo, who had worked on Sony's well-received *Cloudy with a Chance of Meatballs* (2009) and its sequel (2013) as well as *The LEGO Movie*, and *The LEGO Batman Movie* were happy to return to the studio to help shape the animated adventure.

"We decided we were in if the movie didn't center on Peter Parker," admits Lord. "At that time, Miles was easily the most exciting character in the Marvel Universe. Oddly enough, around the same time, I went to the Jeff Koons retrospective in New York City—and love it or hate it—all his art is about other people's work. It made me like, 'We could perhaps create a post-modern Spider-Man.' So, we leaned into this idea of a post-modern Spider-Man in this environment that has multiple spider-people from all of the comics."

Lord and producing partner Miller believe that we live in a peak super hero world, and one way to deliver something new is to tell a story about how it feels to be a wide-eyed, first-time super hero in an environment where everyone has been doing it for a long time. As Miller explains, "I think both the visuals and the story are especially cool, and we haven't seen anything like them before. From a story standpoint, we are telling this story about Miles and Peter Parker, who have a very interesting dynamic between them. Miles is younger, doesn't really want to be Spider-Man, and being a super hero is more problematic for him."

Lord and Miller are equally excited about the cutting-edge visuals of the movie. Thanks to the work of production designer Justin K. Thompson, art director Dean Gordon, and the brilliant technical team at Sony Imageworks, this new version of Spider-Man looks very different from any of the other CG-animated or 2D features we have seen in the past decade.

"We have moments when the frame gets broken into panels, just like you see in comic books," notes Miller. "There are flash frames that allow for unusual compositions, and there are weird sound effects and stylized visuals that are spread throughout the movie. There are scenes where you feel you are watching the movie through the eyes of one of the characters, about 100 yards away from the sidelines of the action. It's very exciting to watch, and it's choreographed to provide a whole new perspective into the sequence."

PREVIOUS SPREAD: Buildings by Zac Retz and Wendell Dalit.
LEFT: Concept art of Miles by Alberto Mielgo.
ABOVE: Sketch of Miles by Jesús Alonso Iglesias.

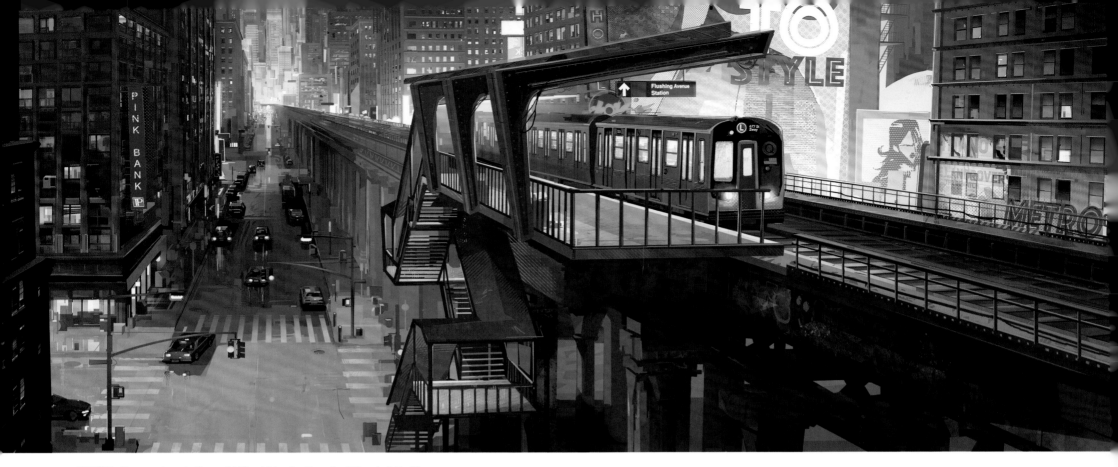

ABOVE: Concept painting of Miles' Manhattan by Wendell Dalit.

The film's acclaimed co-director Peter Ramsey (DreamWorks' *Rise of the Guardians*) says the project's loyalty to the comic book aesthetic is something that hasn't really been experienced on the big screen to this level. "Of course, dozens of Marvel movies lean on that look while telling a cinematic story, but I can't think of any other animated film that makes this much of a visual statement. That's why people had such a great reaction to the film's first trailer."

Ramsey, who is one of the top animation directors working in the business today, says it has been especially rewarding to work on Miles' story. "Until recently, the scarcity of heroes and lead characters that are not white has always been a bit of a subtle mental stumbling block for people of color," he shares. "You feel left out of the fantasy narratives, unless you have a hero whose mind and heart you're getting into. I believe that the introduction of Miles Morales as Spider-Man sparked a renaissance and a trend to reimagine and feature characters that are not white and not male. As Phil and Chris mentioned, the idea has always been that anyone can be under that Spider-Man mask. That's the story we set out to tell."

Sony Pictures Animation president Kristine Belson also brings up that she finds the movie's central storyline quite powerful. "Miles is trying to figure out who he is as a young man in relation to his father and uncle, and he has to deal with all these new expectations and responsibilities. As Chris [Miller] and Phil [Lord] often pointed out, the great message for the kids in the audience is that you are all powerful and we are counting on you."

She adds, "We are trying to bring something fresh to the table by exploring the graphic language of comics in the animation. Early in the process we were lucky enough to work with Alberto Mielgo, a truly extraordinary artist whose vision put us on the path, and continued to guide and inform the groundbreaking final look of the movie. His influence was pretty remarkable. We are hoping to subvert expectations, take some chances and surprise people with something that they haven't seen before."

A WEB OF VISUAL DELIGHTS

To realize their vision for the new Spidey and his world, the producers reached out to production designer Justin K. Thompson, who previously collaborated with Lord and Miller on the two *Cloudy with a Chance of Meatballs* movies.

"I looked at the early development and thought it was beautiful. I used that as a jumping off point, but wanted to give the film an even stronger visual identity by leaning into the comic book language that was hinted at there," says Thompson. "I learned how to draw by emulating the artists who created the comic books I grew up with. I loved the line-work, the color, the texture, the screen-printing, everything. And Spider-Man was a character that I loved from an early age so I was really excited when Chris and Phil asked me, 'What if you were given carte blanche and could make an animated movie based on a comic book?

What would you do differently?'"

Thompson said he wanted to avoid anything slick or glossy that would eliminate the hand of the artist or downplay the stakes of the universe Miles lives in. "Comic books are actually quite gritty in the way they're made," he points out. "One of the things that has always appealed to me about comics was that I felt as if they gave me a window into a mysterious, darker world where the super heroes were dealing with the same problems that I was dealing with, but where the stakes were much higher. Miles' actions lead to the death of his uncle and I thought it would be a really interesting challenge not to downplay that. The filmmakers didn't want to short change that either, and it informed nearly every design choice I made when we were designing Miles' world."

BELOW: Concept art by Patrick O'Keefe.

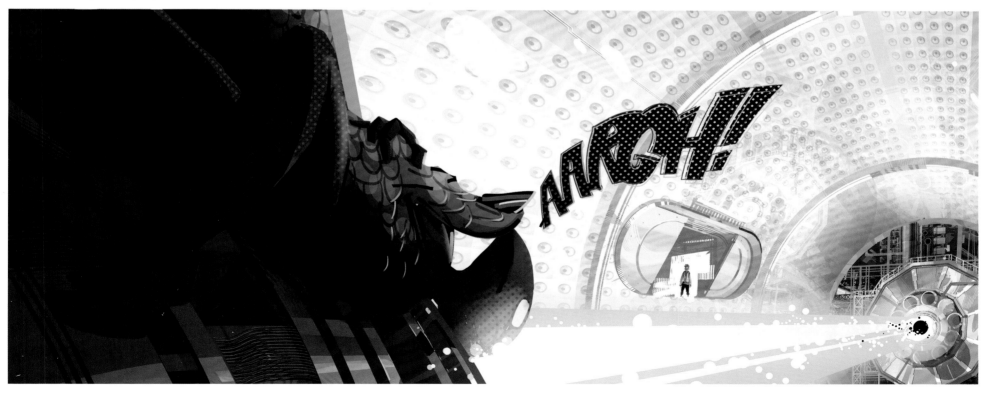

ABOVE: Artwork by Yuhki Demers.
RIGHT: Early sketch of Miles by Jesús Alonso Iglesias.

The technical team at Sony Imageworks set out to recreate the tactile, granular feeling of graphic novels, even going as far as recreating the dot-printing process used in older comic books. "You really felt the artistry as you turned the page," recalls Thompson. "But I knew that the computer excelled at the opposite. It was best at simulating realism. What I challenged the team to do was bend those rules and expectations and create a whole new reality. Our character's reality."

As art director Dean Gordon, who also worked on the two *Cloudy with a Chance of Meatballs* movies with Lord and Miller, explains, "The nature of computer rendering tends to fight a graphic look. We worked on painting textures that are less naturalistic, definitely more abstract, to take a step away from true realism. We worked to get away from soft transitions between colors and values, which is what computers naturally do. In our artwork we broke down colors and values into defined shapes with short or no transitions to give them a more illustrative feel.

We brought the same ideas to the characters' skin tones. Having the skin tones fit into the same environment using the same screen tones and hatchings, and value banding we see in comics elevated that illustrative element."

Another way to get the comic book feel was to play with the lighting of scenes throughout the movie. "There's a tendency in animated movies to go for bright, colorful lighting," says Gordon. "We wanted to extend our range, and looked at some of the techniques of live action films. We were allowed to go as dark in a sequence as we needed creatively. We used dark shapes, with just glimpses of light at times. We always think about what part of the shot we're exposing for. We're bringing in light bleeds at the edge of frames. And we always want to include something observed in our lighting. It really extended the range of what we can put up on the screen."

Animation supervisor Josh Beveridge, an alum of many movies at Sony—including *Open Season*, *Surf's Up*, *Cloudy with a Chance of Meatballs* and its sequel, *Arthur Christmas*, *Hotel Transylvania* and its sequel, echoes Gordon's comments. "Our big challenge was creating that balance between being cartoony and realistic," he notes. "To deliver the best representation of comic books to animated life, we had to break and overhaul our way of looking at things. It led us to frame modulation to get this crunchy, crispy version of pop art. When you do Spider-Man in live action, it never feels completely believable because we had to deal with real physics to put him in these fantastic poses. Animation allows us to break physics, but you don't want to be too choppy and not too smooth. You want crisp pop with aggressive clarity. At Sony Pictures Animation, we have an amazing robust animation and VFX pipeline, and I think we have forever altered our pipeline thanks to this project."

Imageworks veteran Danny Dimian, who is *Into the Spider-Verse*'s visual effects supervisor, compares the film's creative journey to one of the studio's earlier technical milestones. "This return to Spider-Man reminds me of our work on *The Hollow Man* (2000)," says Dimian. "Back then, what we were trying to do wasn't readily available off the shelves, so we had to rethink everything. This time, though, we are not writing the software from scratch. We are trying to find a new technique to tell the story."

Dimian—whose many credits include the 2002 *Spider-Man*, *Stuart Little 2*, *The Polar Express*, *Surf's Up* and *Cloudy with a Chance of Meatballs*—says the technical team tried to stay away from the rigid formality associated with CG animation. "Computers do everything correctly and you have the right perspective and geometry all the time," he points out. "What's interesting about art is all the imperfections that go hand in hand with a human creating things. We had to find a way to break things."

Among the many stylistic ways the tech team paid homage to old comic books was emulating the way color offsets were not aligned properly in some prints of the run. "We took that as an opportunity to explore how to play with focuses in a scene," says Dimian. "It was hard to focus on an image when all the color passes were not properly aligned. We thought, 'What if the camera didn't de-focus like a lens?' So, we splintered and offset the image in a way that is similar to a misprint. It has a really cool feel to it that creates this illusion that something is printed on the screen."

Thompson says that all along, the goal has been to keep the comic book aesthetic alive and well with the aid of the latest in 3D technologies. "Ideally, we want to be able to stop every frame of the film and have it look like an illustration," he concludes. "We don't want it to look great only in the wide shots. The dots, the screen tones, the panels, the way everything works in a 3D space—the goal was to make you feel like you're living inside a comic book."

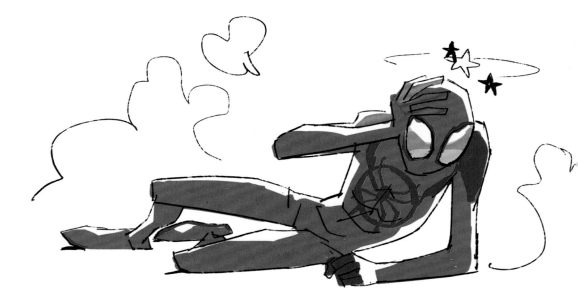

SETTING THE SCENE

As in many of Spider-Man's previous big-screen movies, New York City is more than just the backdrop for our hero's adventures. The web-slinger's adventures are frequently set against the busy streets of Manhattan, and we often see him jumping on subway cars and swinging perilously from tall skyscrapers. As a departure from the other films, however, Miles Morales and his family live in Brooklyn, and their comfortable home is in sharp contrast with the stark, hustle-and-bustle of the Big Apple.

"Our Manhattan is a caricature of the real one," says visual development artist Yuhki Demers. "We wanted to make sure that the sense of wonder you get when you stare up from the bottom of a skyscraper carries through with this entire part of the city. From a color standpoint, Manhattan lives on the cooler side of the color wheel, giving Miles cold and uninviting vibes. This stands in direct contrast with the warmth of Brooklyn and Miles' family apartment."

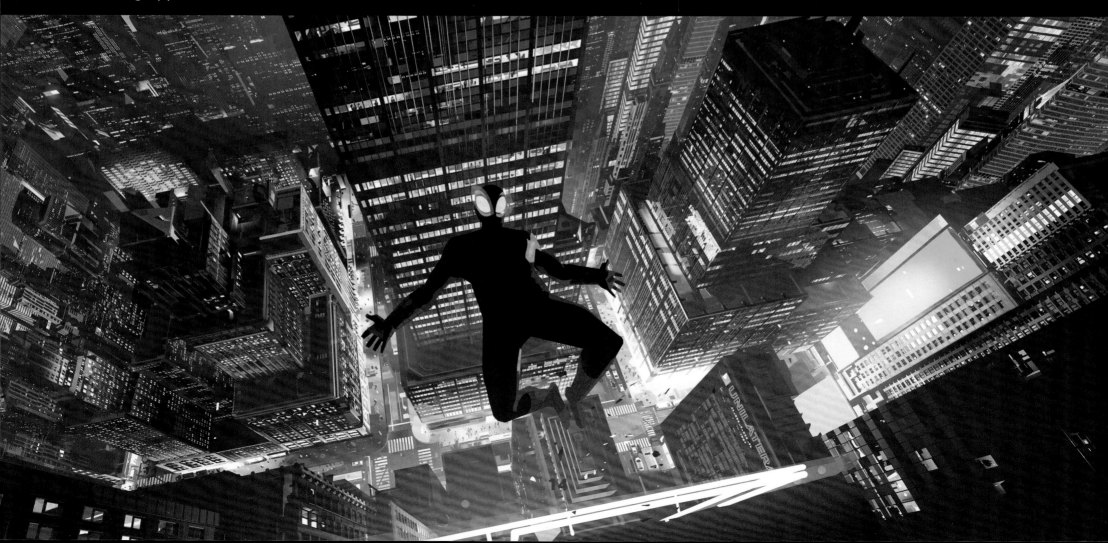

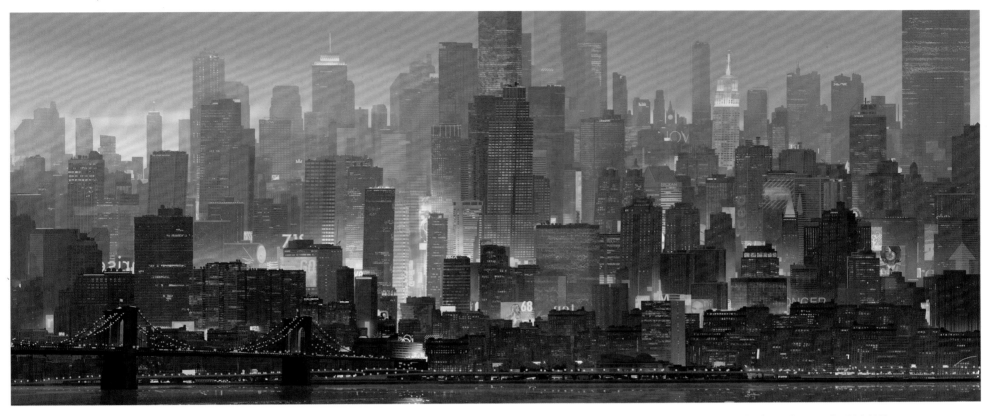

LEFT: Spider-Man in his natural habitat by Alberto Mielgo. **ABOVE:** Skyline painting by Patrick O'Keefe. **BELOW:** Street-level view of Miles' Manhattan by Yuhki Demers.

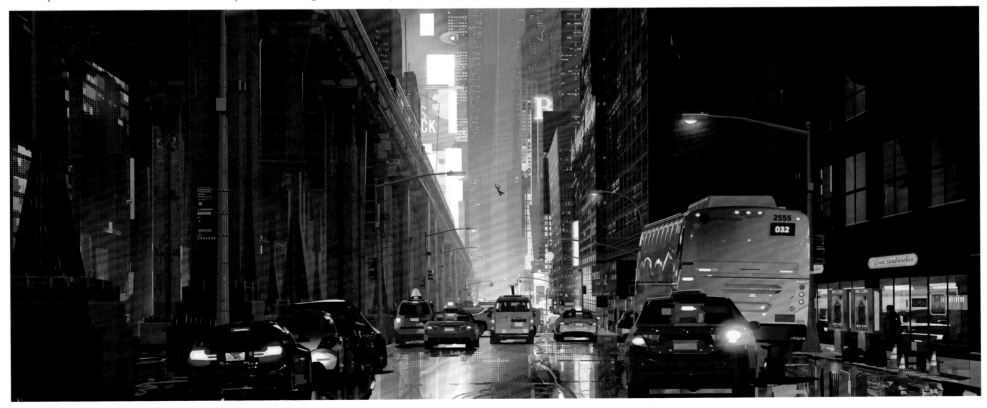

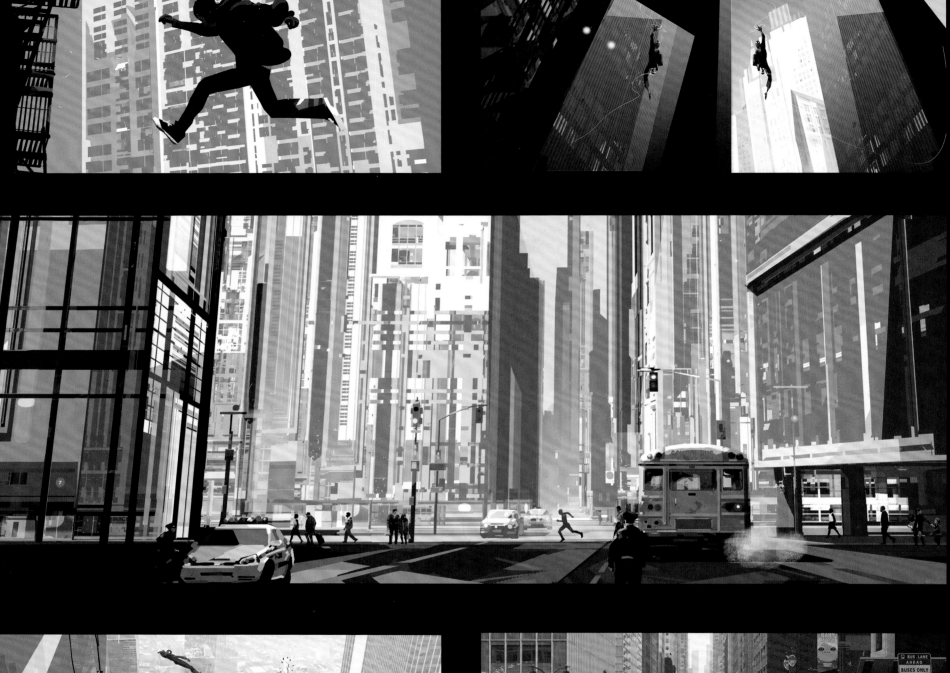
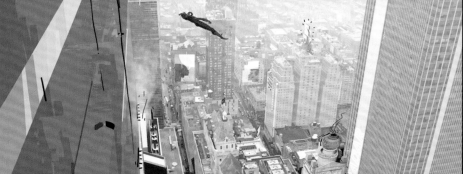
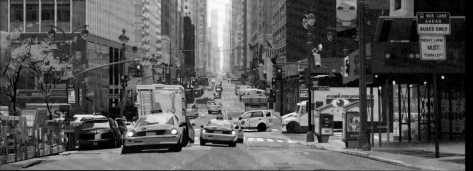

"I'm really proud of how illustrative and unique our film looks compared to other big studio animated features. One of our big goals was to make the movie look as gritty as the classic comic books, which offer a window through these mysterious worlds."

Justin K. Thompson, *Production Designer*

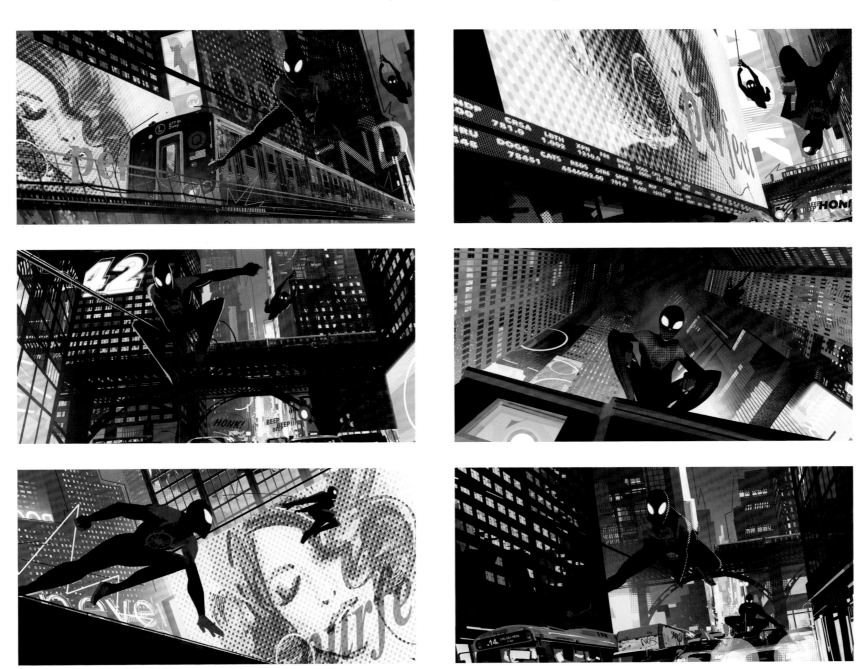

LEFT: Concept art by Neil Ross, Craig Mullins, and Peter Chan. **ABOVE:** Artwork by Patrick O'Keefe.
NEXT SPREAD: Artwork by Zac Retz.

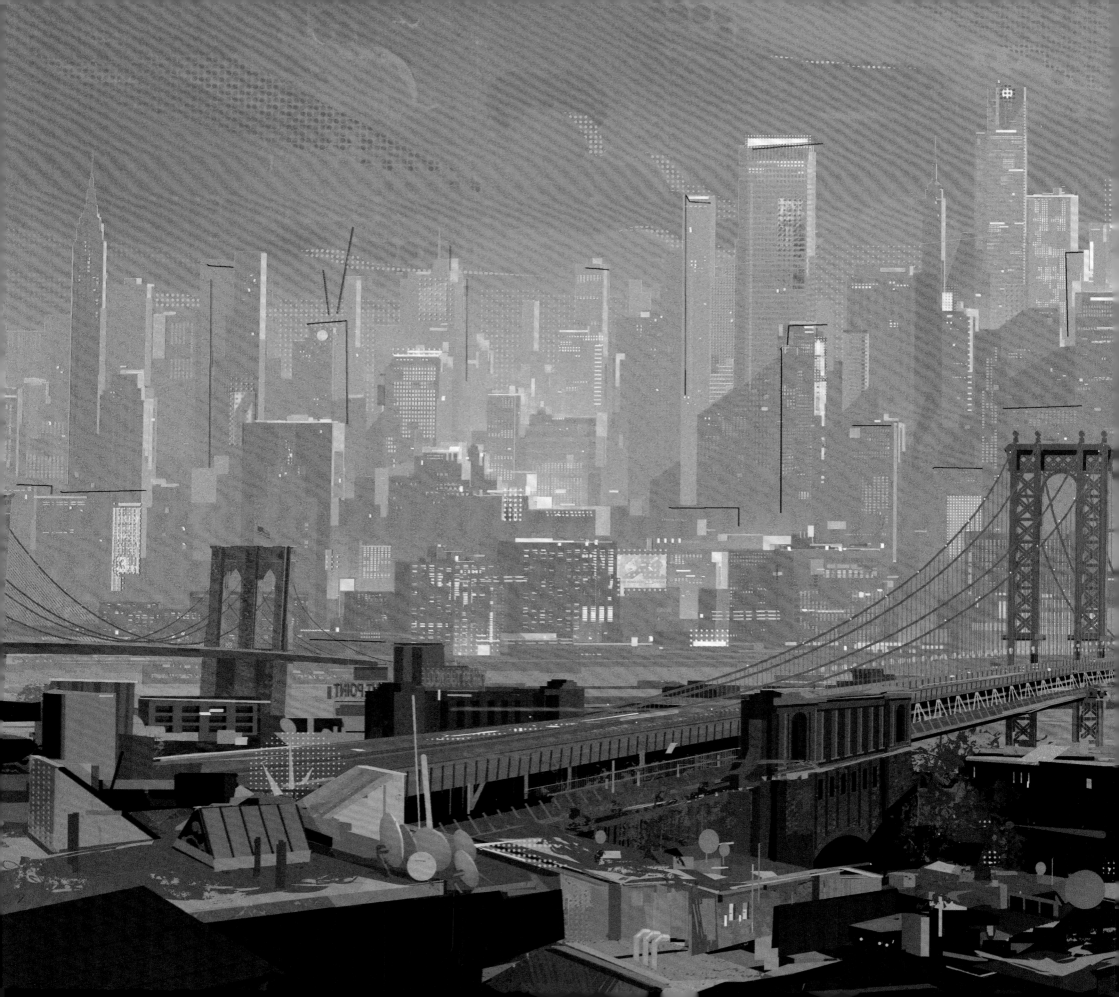

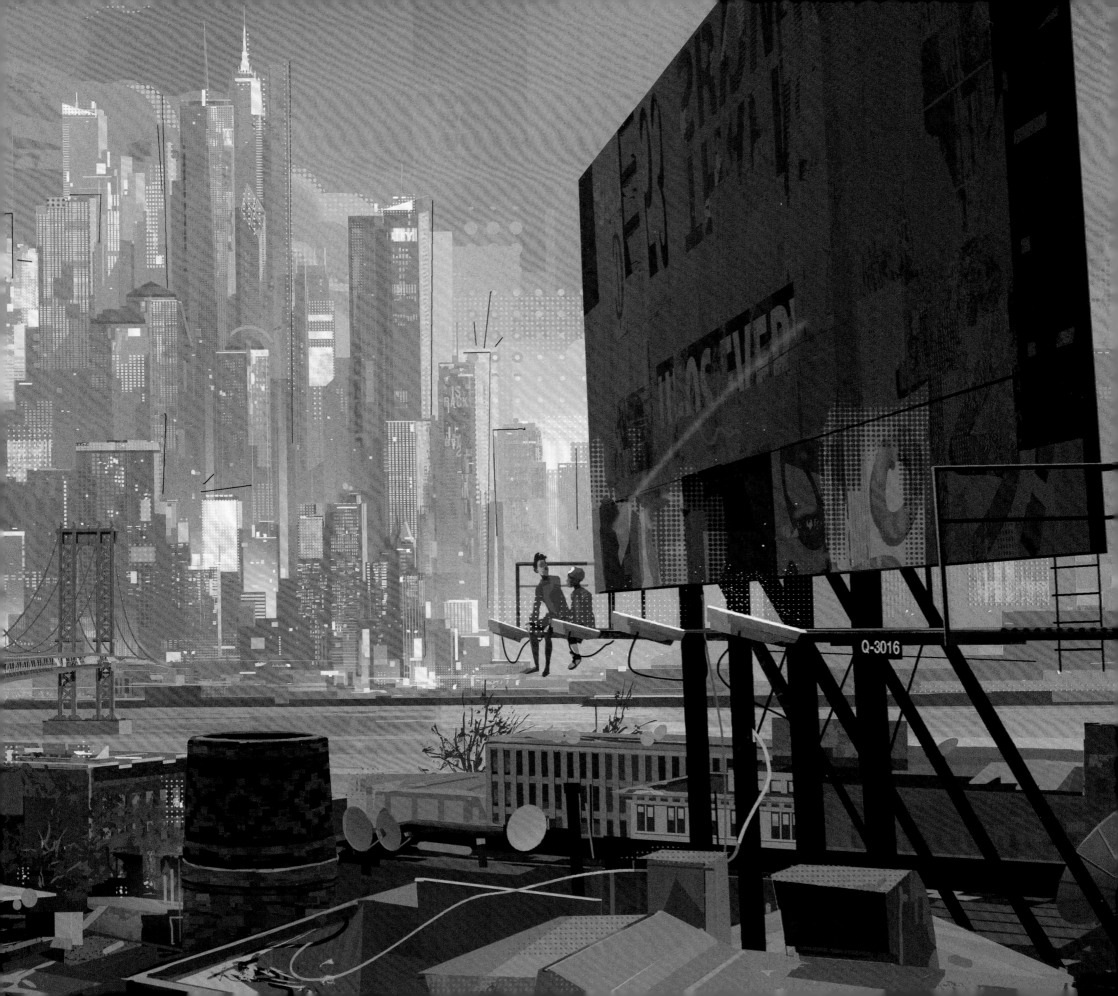

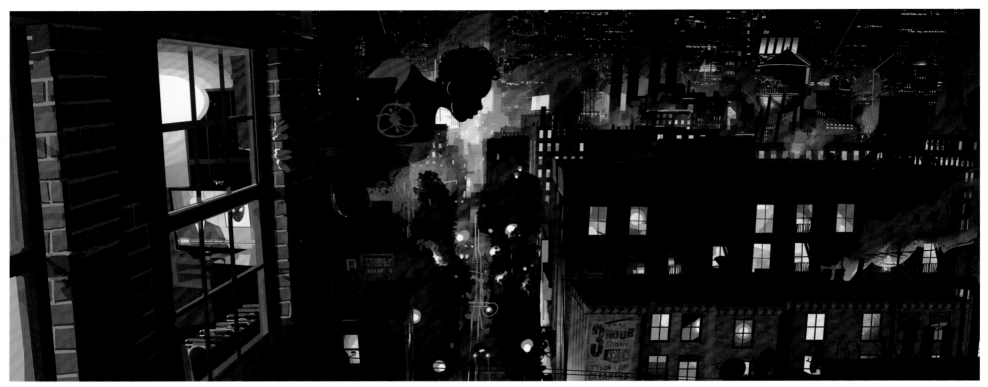

ABOVE: Concept art by Patrick O'Keefe. **BELOW LEFT:** Artwork by Yuhki Demers. **BELOW RIGHT:** Art by Patrick O'Keefe.
BOTTOM: Building designs by Wendell Dalit. **NEXT PAGE AND SPREAD:** Concept art by Alberto Mielgo.

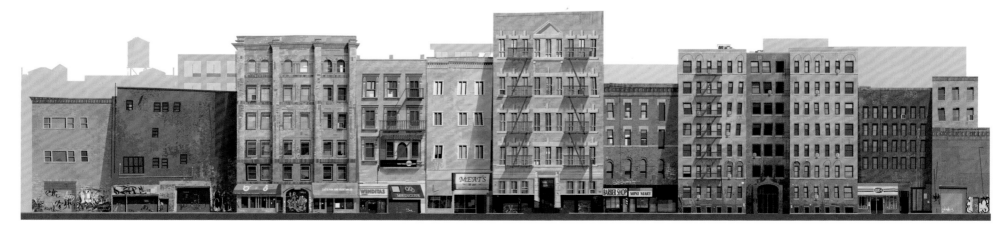

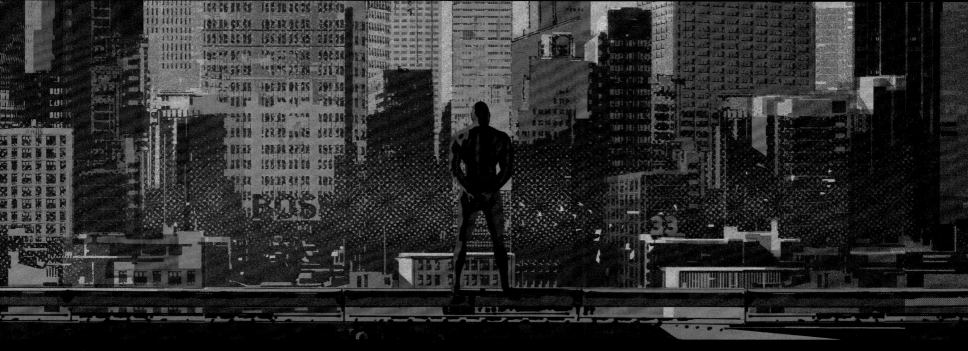

"The idea was to make the movie look like a comic book come to life. We also spoke quite a bit about wanting the final version of the film to look just like the early concept paintings. They were so dynamic, fresh and visually arresting that we wanted to make sure they were translated to the screen."

Christina Steinberg, *Producer*

Affectionately known as 'RIPeter,' by the film's artists (because he dies early on in the first act), the original Spidey is the idealized version of the super hero. With perfect blond hair (modeled after Brad Pitt in *A River Runs Through It*) and the ideal physique, he stands as a powerful contrast to the older version of Spidey which arrives from another Spider-Verse. He has developed his own suits and web-shooters. He even has the Spidey workshop built under Aunt May's house.

"If you were bitten by a spider and needed a Spider-Man mentor, he would be the perfect guy for the job," says director Bob Persichetti. "He is voiced by Chris Pine (uncredited), he is in his prime, in his mid-twenties, and has been Spider-Man for about ten years. He's married to M.J., Aunt May is still alive. Miles just stumbles into him when he witnesses a fight between this Peter and the Green Goblin. It's during this fight that they have an interaction. Peter Parker saves Miles and his spider-sense resonates and realizes that Miles is also Spider-Man. He tells Miles, 'Let me go save the world quickly, and I'll come back and teach you how to do this.' So, we deliver the perfect mentor to Miles only to take him away. His role is to make the next Peter that arrives feel very inadequate!"

LEFT: 2D design by Shiyoon Kim, 3D design by Omar Smith, paint by Wendell Dalit. **ABOVE:** Concept art by Alberto Mielgo. **BELOW:** Early development sketches by Jesús Alonso Iglesias.

"One of the key messages of the movie is that anyone can wear the mask. We all have the power and the responsibility. It's up to the future generation of this country to stand up and do the right thing."

Kristine Belson,
Sony Pictures Animation President

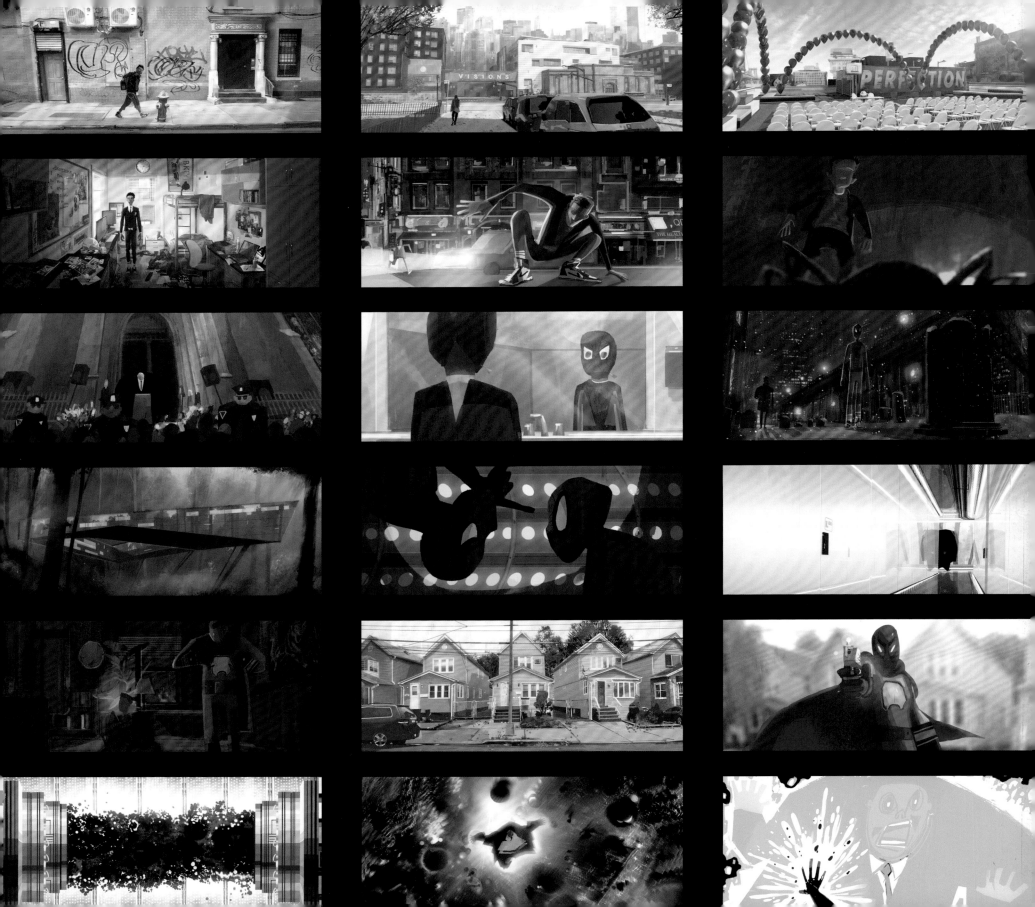

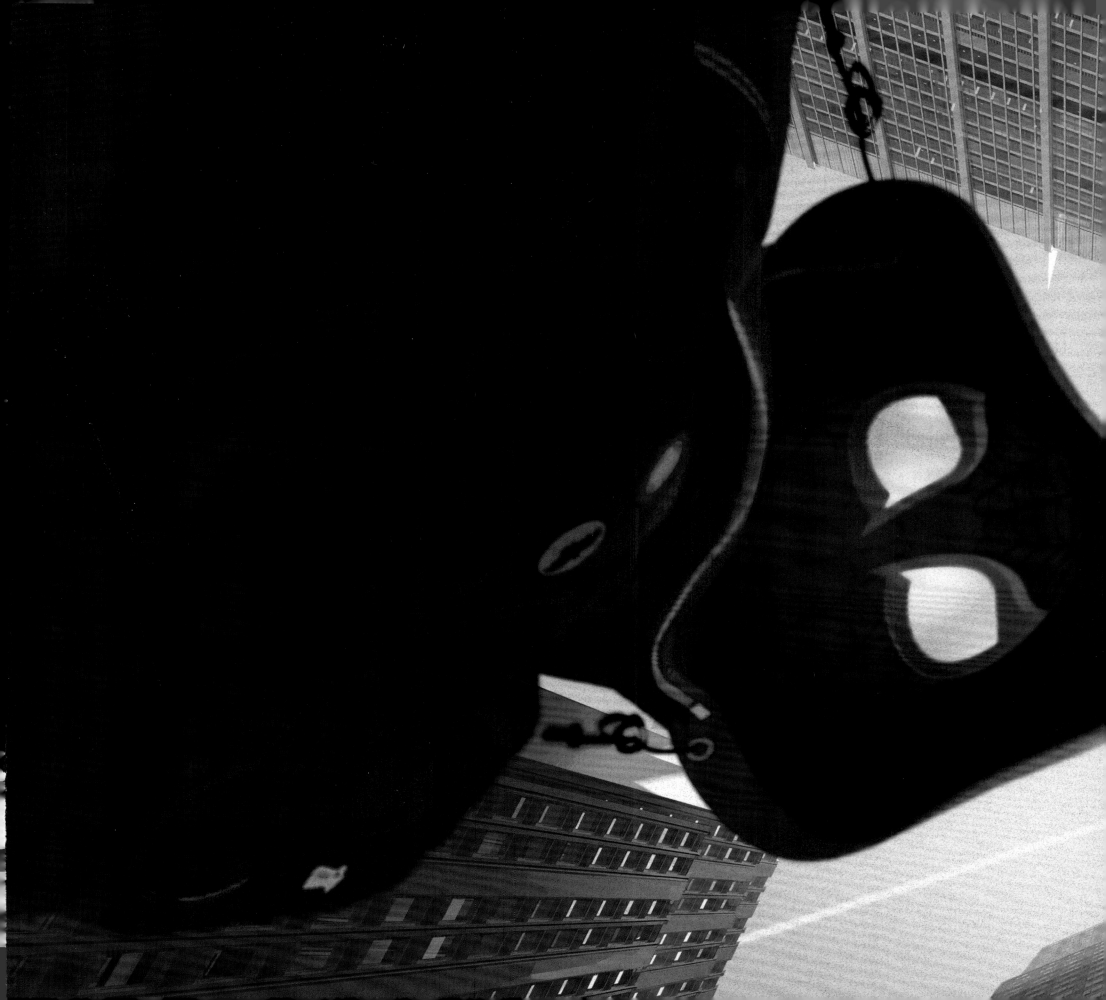

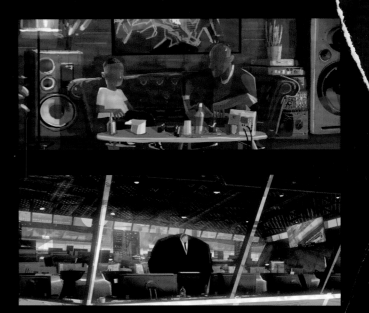
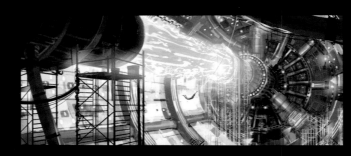
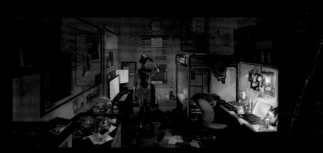
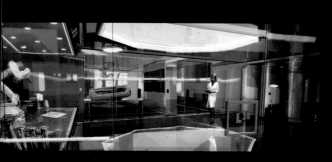
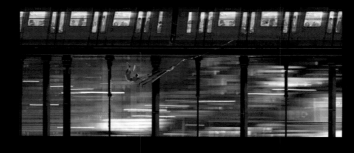
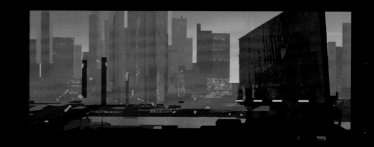
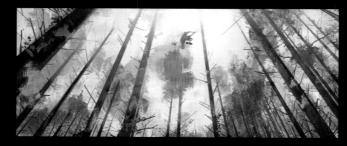
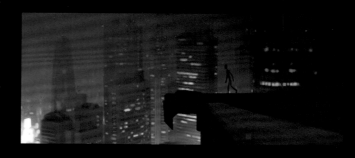
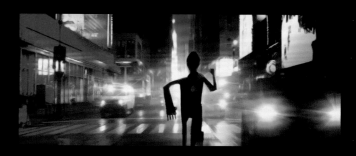
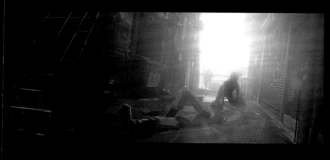

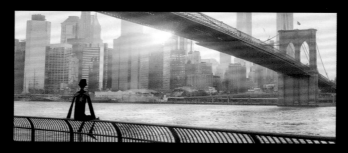

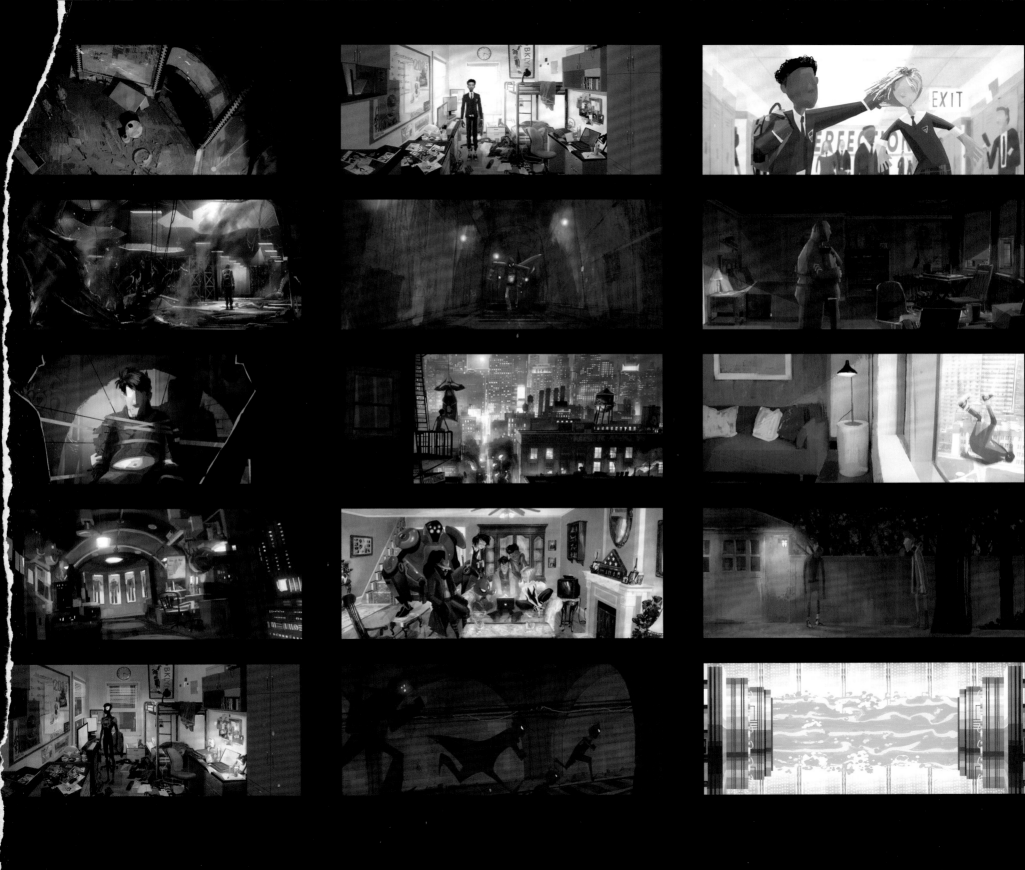

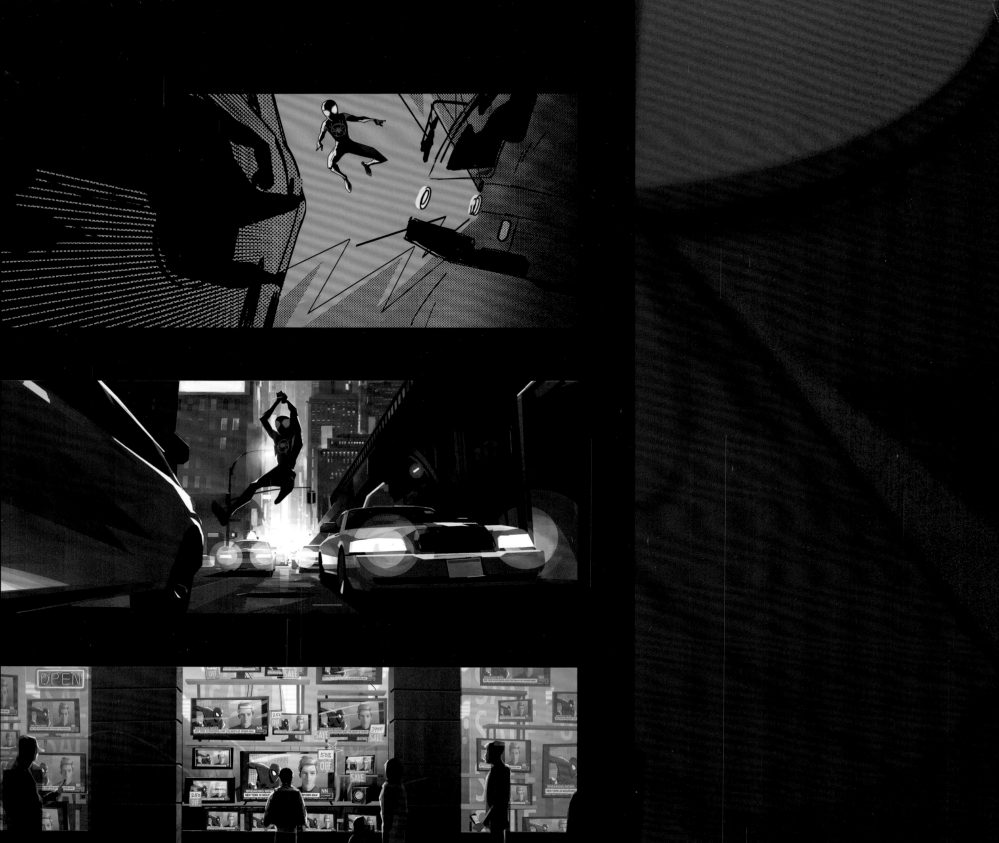

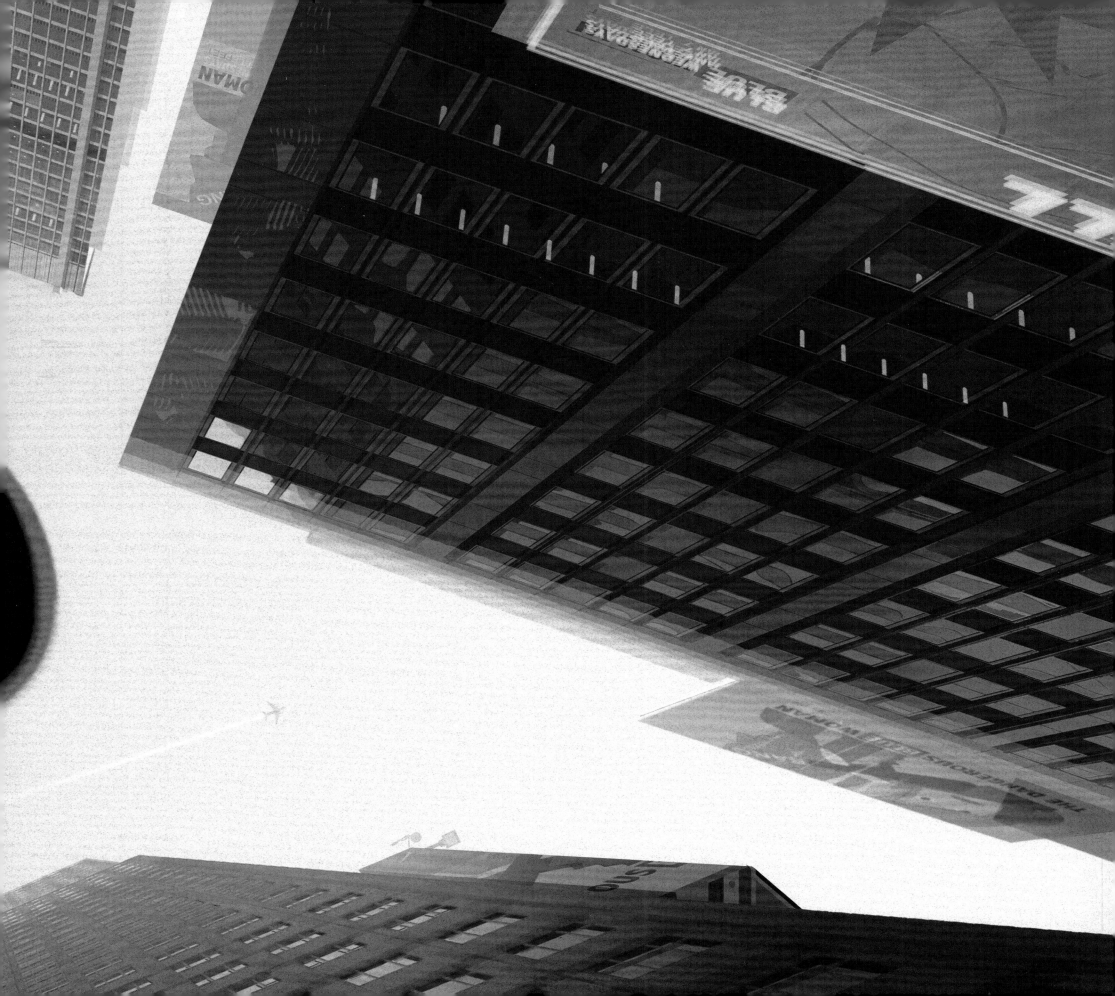

WHO IS MILES MORALES?

Miles Morales, the hero of the movie and the comic book created by Brian Michael Bendis and Sara Pichelli, is a dynamic half-black, half-Puerto Rican thirteen-year-old boy, who was reportedly inspired by then-U.S. President Barack Obama and actor Donald Glover. The filmmakers behind *Into the Spider-Verse* were thrilled to center the animated feature on an exciting new character who is uncertain about his role as a super hero.

FOLD-OUT: Color script by Dave Bleich.
FOLD-OUT: Artwork by Justin K. Thompson, Wendell Dalit, Alberto Mielgo, and Yuhki Demers.
BELOW: Early concept artwork of Miles in his suit and cape.
RIGHT: Concept art. All by Alberto Mielgo.

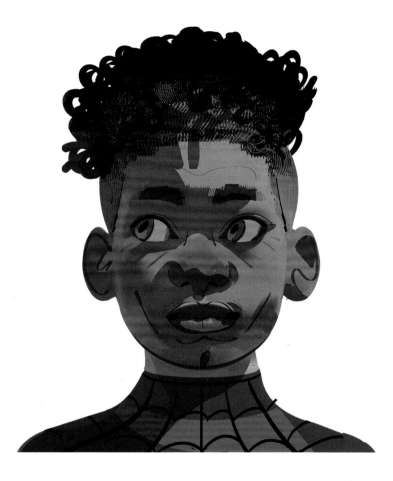

"Only until recently, there was this scarcity of non-white heroes and lead characters, which always created this mental stumbling block for people of color. You feel left out from these fantasy narratives unless you have a hero whose mind and heart you're getting into."

Peter Ramsey, *Director*

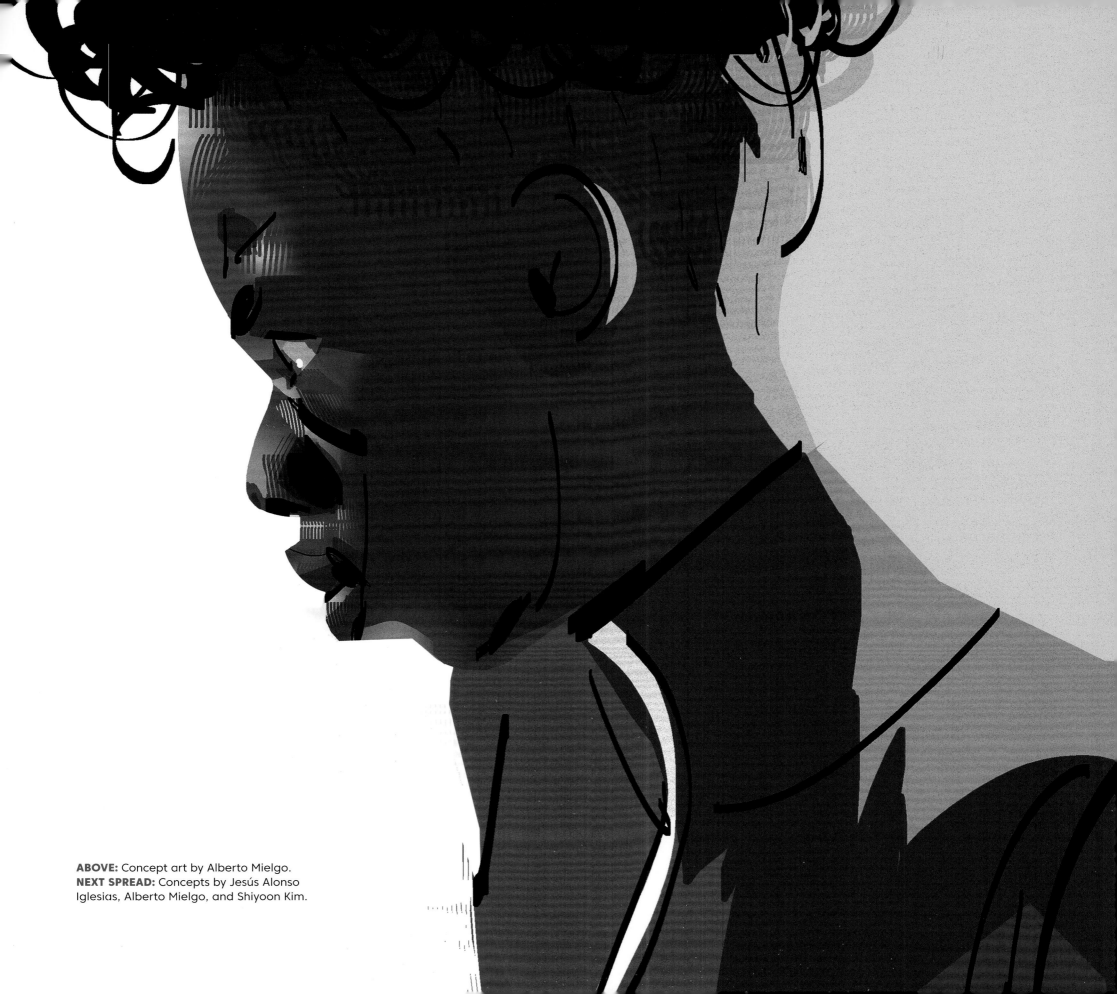

ABOVE: Concept art by Alberto Mielgo.
NEXT SPREAD: Concepts by Jesús Alonso Iglesias, Alberto Mielgo, and Shiyoon Kim.

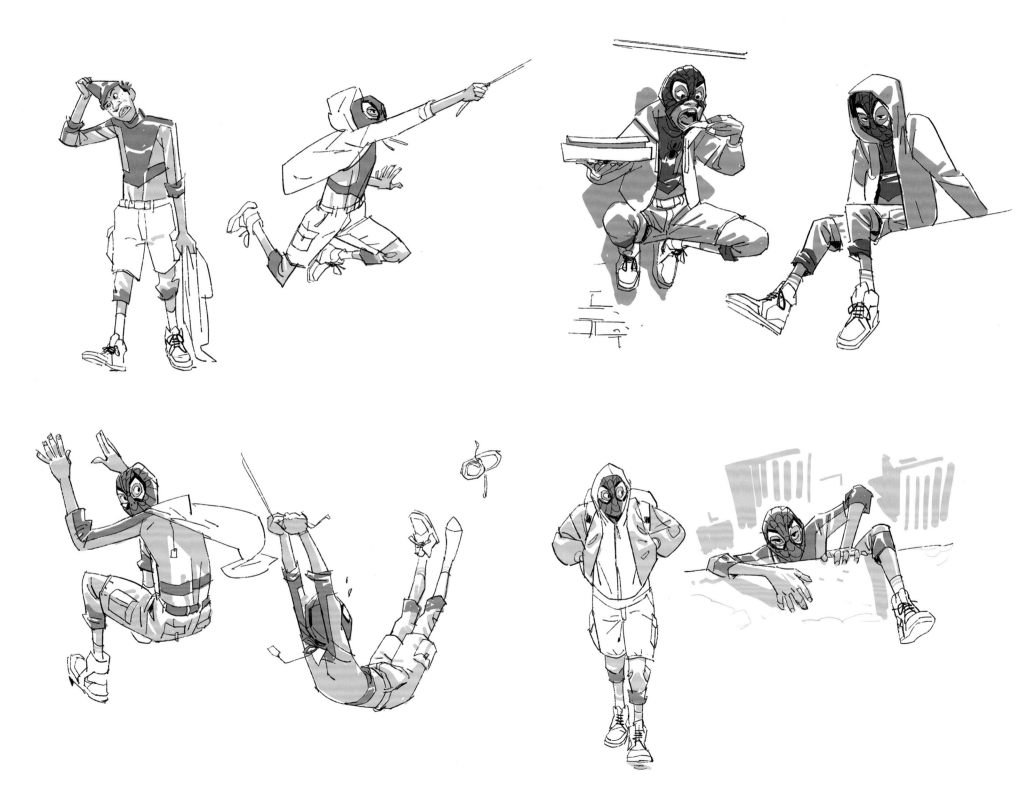

"It's Miles that makes me love this movie," says Kristine Belson, president of Sony Pictures Animation. "He is just a great character and is very different from Peter Parker. Miles is the child of two present and loving parents. He is confident, and has a very different set of problems to deal with."

Miles is also a great foil for the Peter Parker we meet in the movie. "Both Miles and Peter become super heroes in similar ways," says animation supervisor Josh Beveridge. "But Peter was a boy genius, while Miles is a kid that wants to be a kid. He has a more challenging and interesting journey."

As production designer Justin K. Thompson describes him, "We wanted Miles to feel like he's still developing at the beginning. He sort of resembles a baby deer—he's got skinny legs with wobbly knees and he's got these big hands and feet," he notes. "He really stands out when he's in fight scenes with some of the other characters."

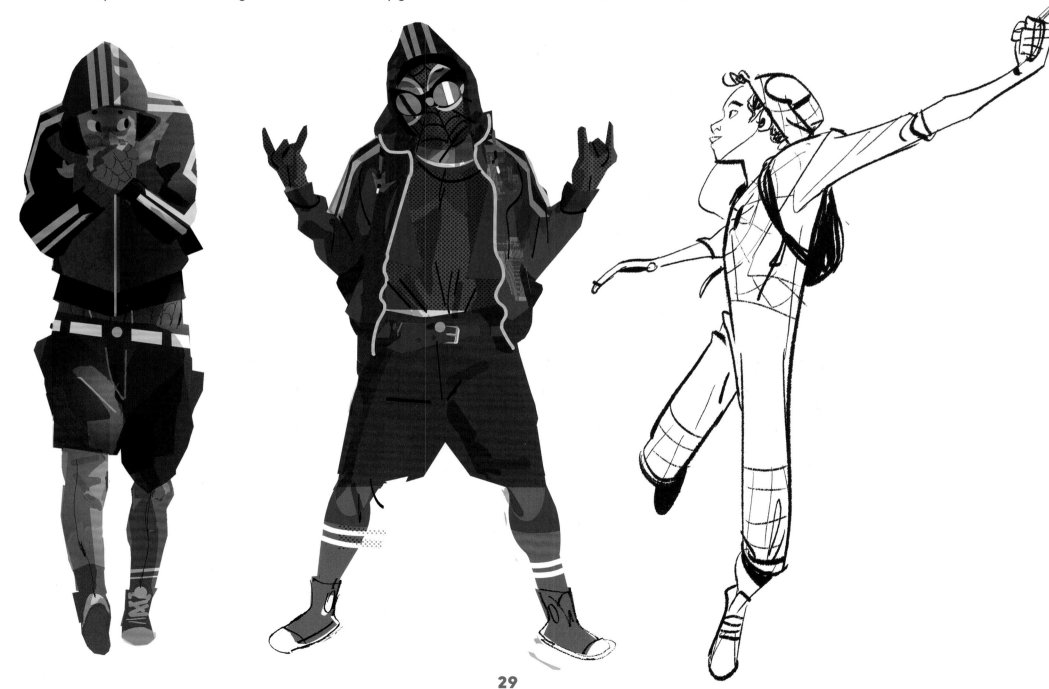

Storyboard artist Miguel Jiron adds, "With all the fun ideas and elements we got to play with in this film, it was helpful to remind myself to always bring it back to Miles and ground all the craziness with his unique perspective—a thirteen-year-old boy who can't quite believe his destiny and finds himself greater than he could ever imagine."

Producer Avi Arad hopes audiences will fall in love with Miles as much as he and his team did as they developed and created the movie. "The takeaway is that you don't have to be muscular and tall to be strong. Everyone is beautiful in their own way, and it always looks better in animation!"

ABOVE: Sketches of Miles in his suit. Artwork by Jesús Alonso Iglesias.

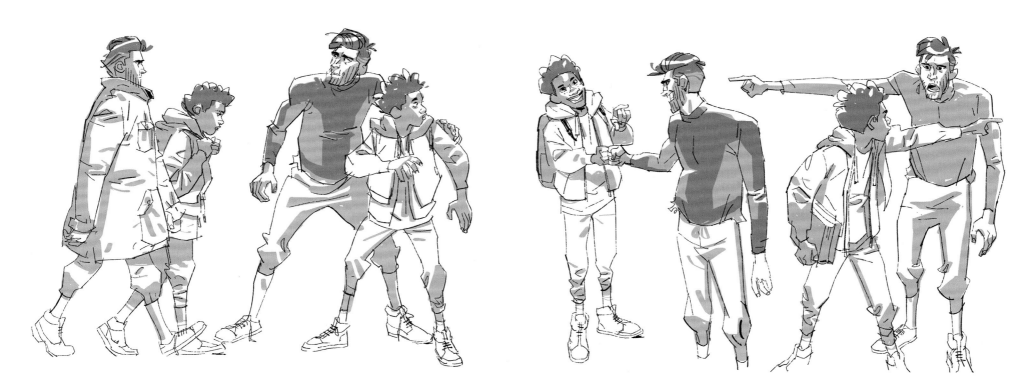

ABOVE: Sketches of Peter and Miles by Jesús Alonso Iglesias. **BELOW:** Story art by Miguel Jiron.

"We are using these contemporary 3D, CG animation tools, but we want every artist to remember that every frame is an illustration of something. We are trying to bring the human hand back into visibility on top of all the amazing technological achievements."

Phil Lord, *Writer / Executive Producer*

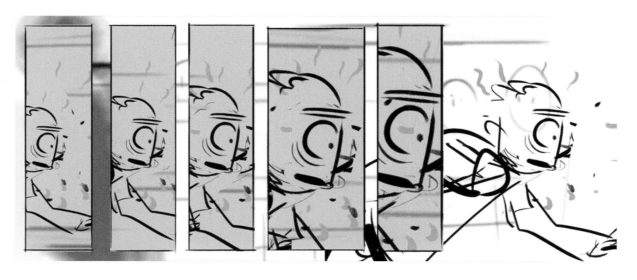

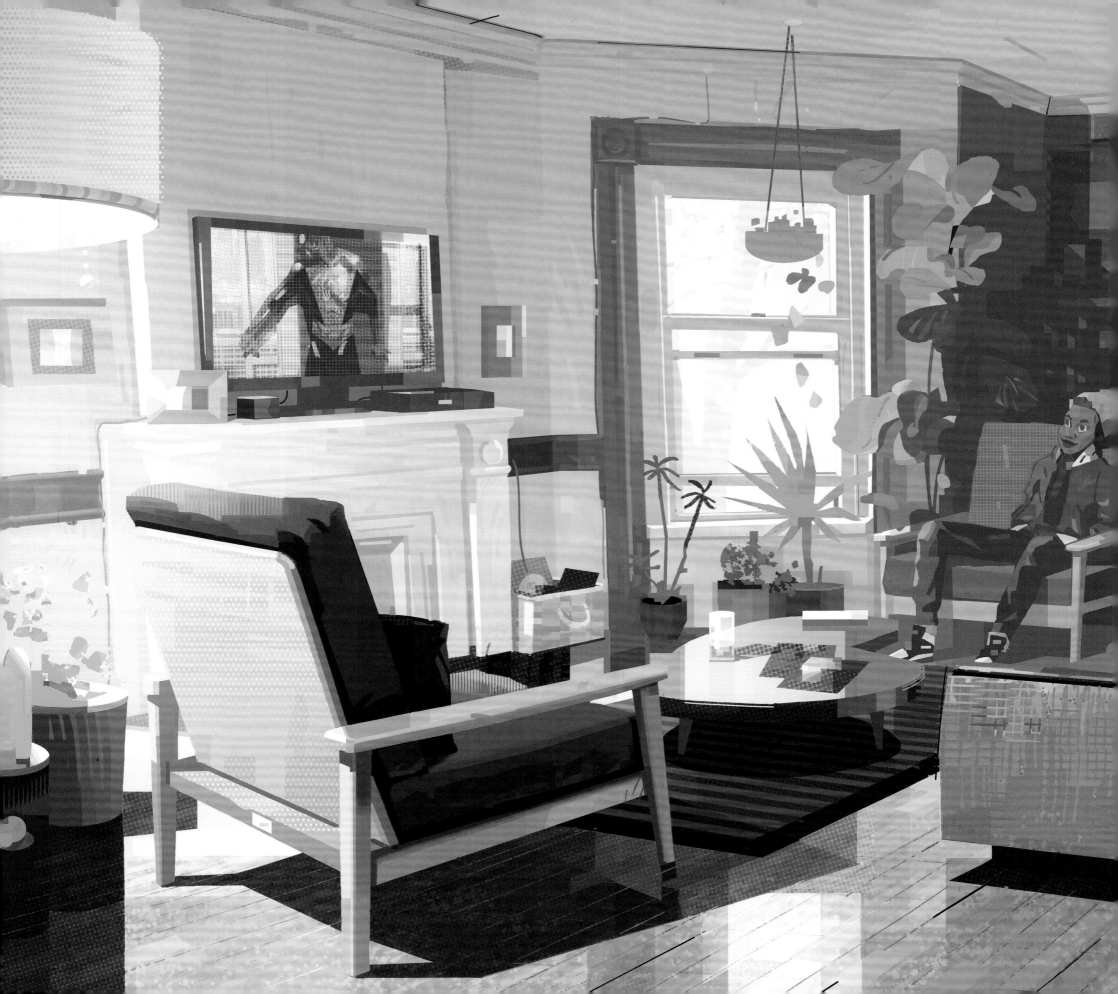

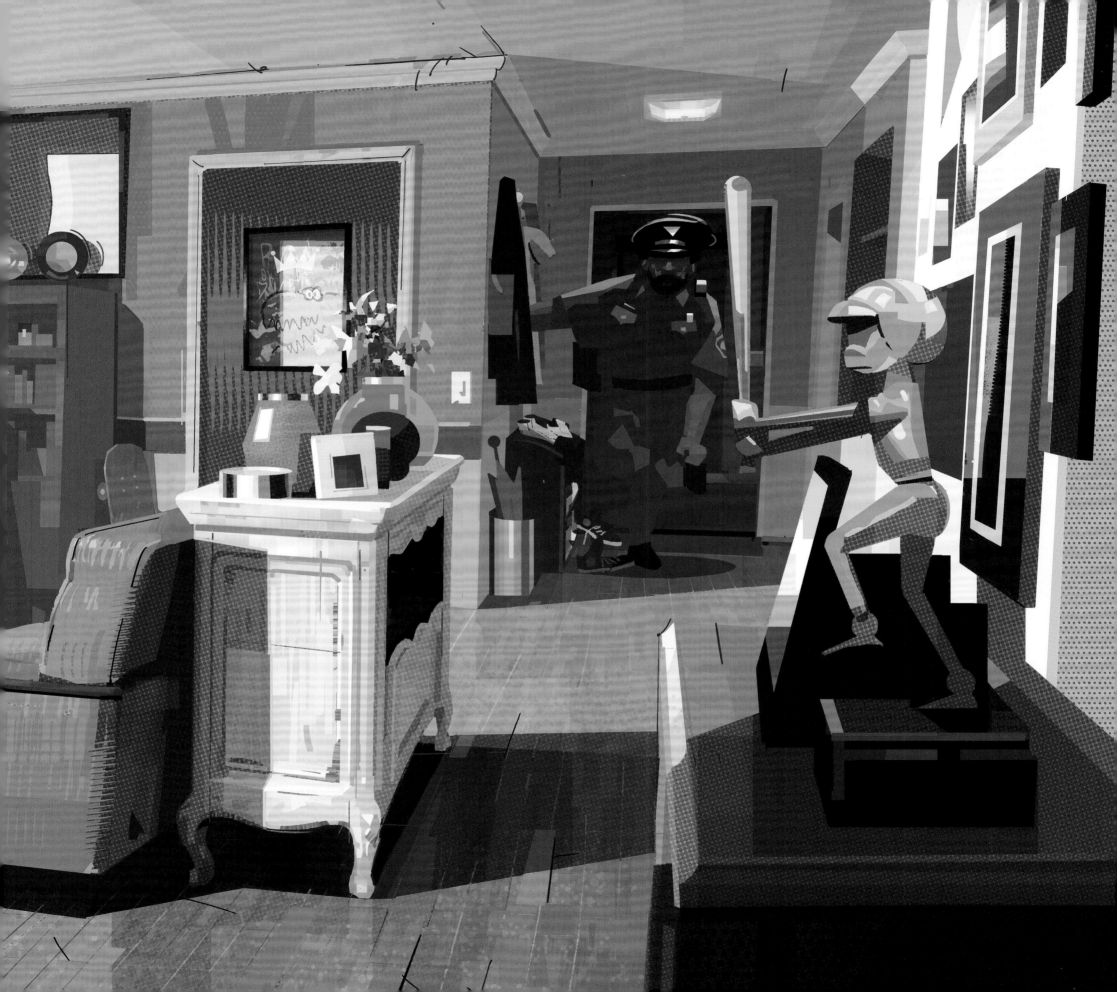

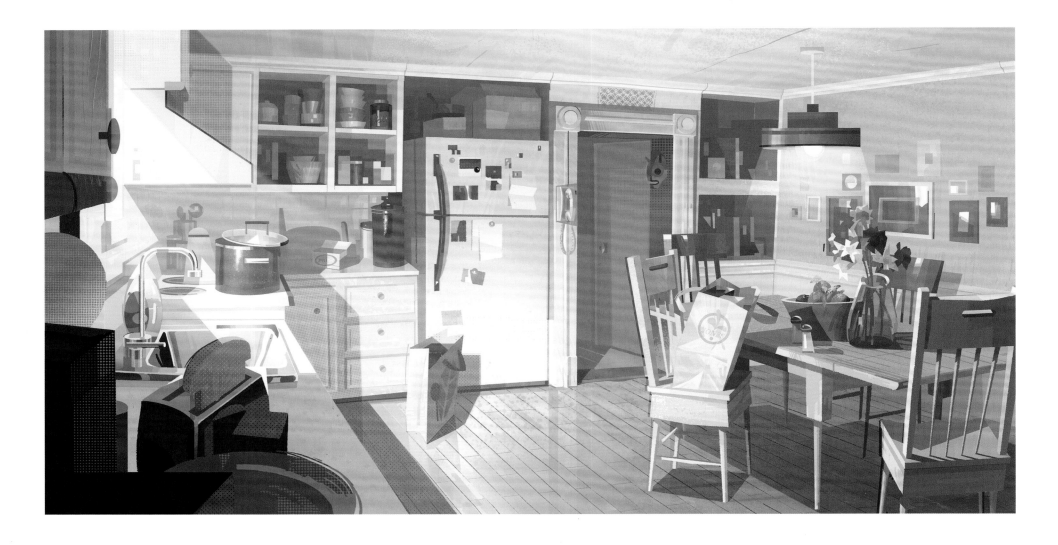

Everything about the Morales' apartment in Brooklyn reflects the warm, multicultural upbringing that our young hero has been exposed to all his life. The designers strove to include elements of both parents' heritage in the details of the family's warm and inviting residence. "They live in this old, classic building in Brooklyn," says production designer Justin K. Thompson. "You can see Rio Morales' strong Puerto Rican heritage reflected in the décor as well as Jefferson's back story laid out in the designs. Miles' own bedroom is a combination of both parents as well as a reflection of his artistic style. It's really the culmination of being raised in this warm community. There's a great scene on his first day of school and we see him driving away from his old neighborhood, waving at his old friends. When he arrives at the Brooklyn Visions Academy, Miles experiences a bit of a culture shock when he sees how regimented everything is."

PREVIOUS SPREAD, ABOVE, AND RIGHT: Peter Chan's illustrations of the Morales' apartment.

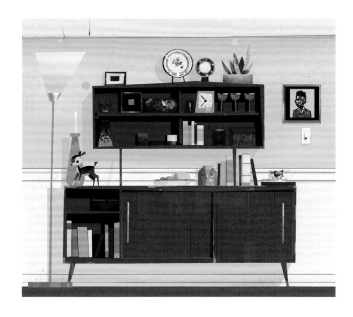

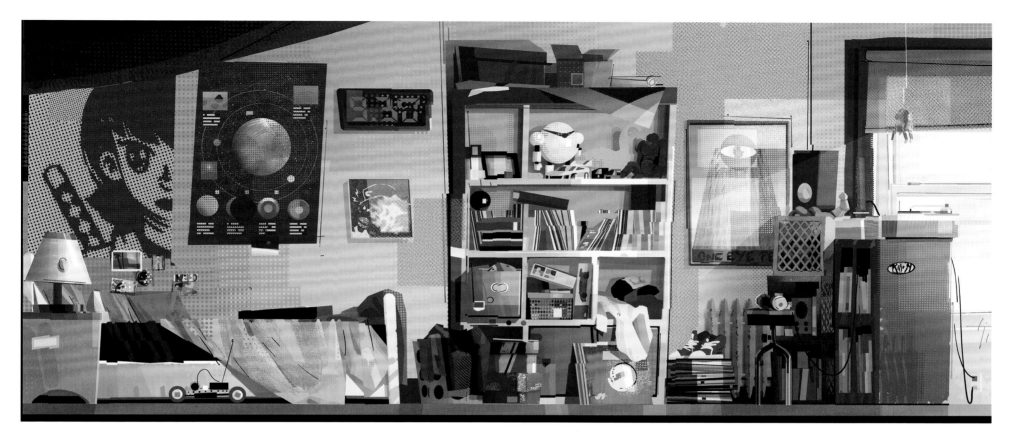

ABOVE AND BELOW: Artwork by Peter Chan.

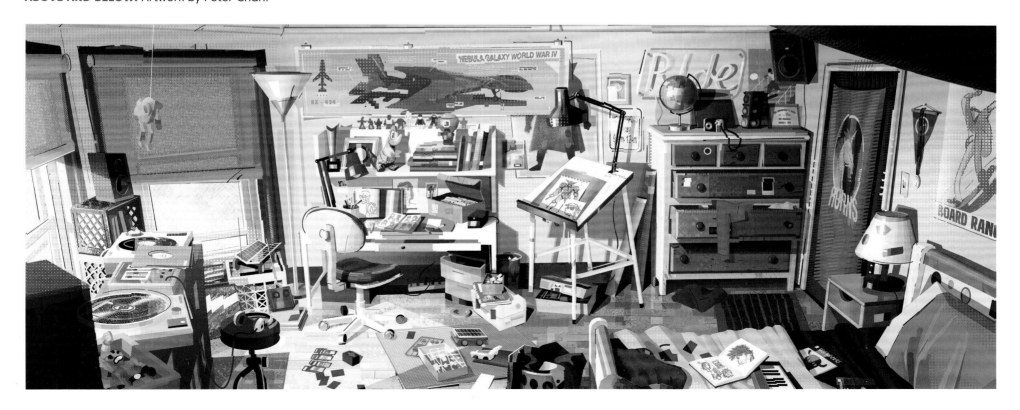

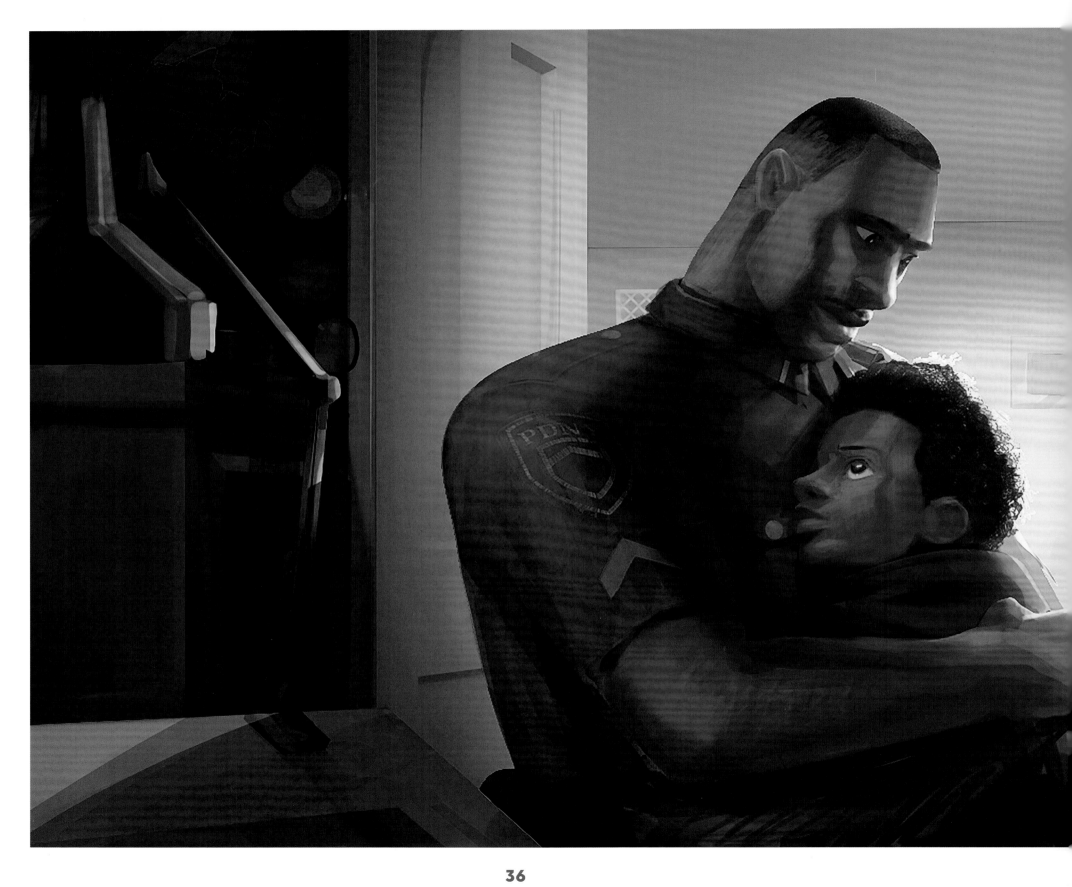

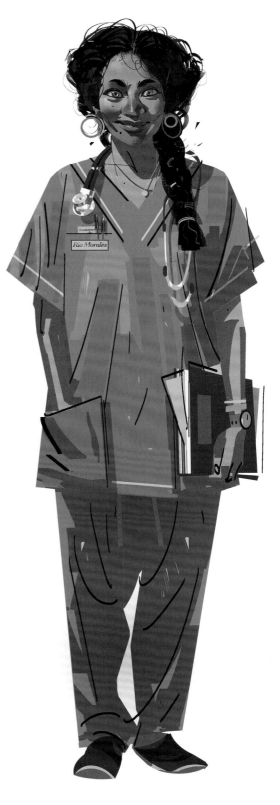

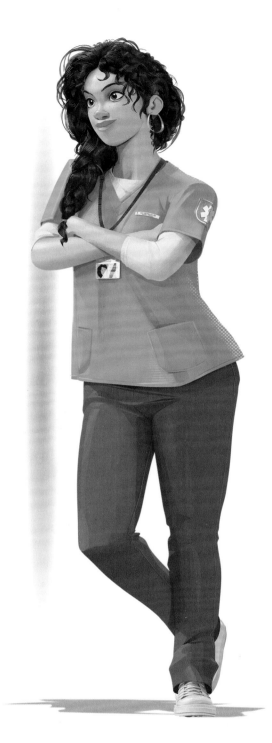

A loving, modern Brooklyn mom, Rio is a hard-working Puerto Rican nurse who wants the best for her son. She clearly understands her son's reluctance to attend Brooklyn's Visions Academy, but also believes in exposing Miles to the best educational opportunities possible. In designing her, the film's artists wanted to create an authentic everywoman that shared a distinct physical resemblance to her son.

Who is Miles Morales?

To create the character, the artists opted for being inspired by real people they would run into in New York. "We tried to create a more observed character with Rio," says Justin K. Thompson. "She has a really sensitive and expressive appeal that we can see echoed in Miles' features. It helps the audience feel her strong bond with Miles and their relationship."

PREVIOUS SPREAD: Artwork by Dean Gordon and character concept by Alberto Mielgo.
LEFT: 2D design by Shiyoon Kim and paint by Wendell Dalit. **BELOW:** Facial expression development by Shiyoon Kim.

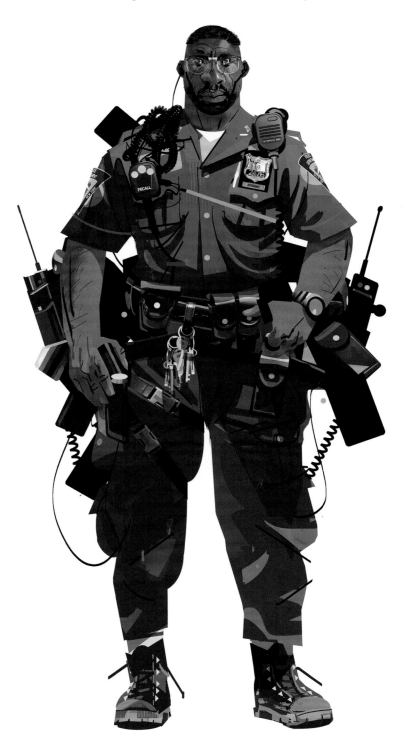

Miles' dad is a tough veteran police officer who is struggling to get his son to understand the expectations he has for him. He has his own back story as well. When they were younger, he and his brother Aaron used to hang out together and get into trouble, but when he met Rio and had a child with her, he decided to go straight and joined the police force.

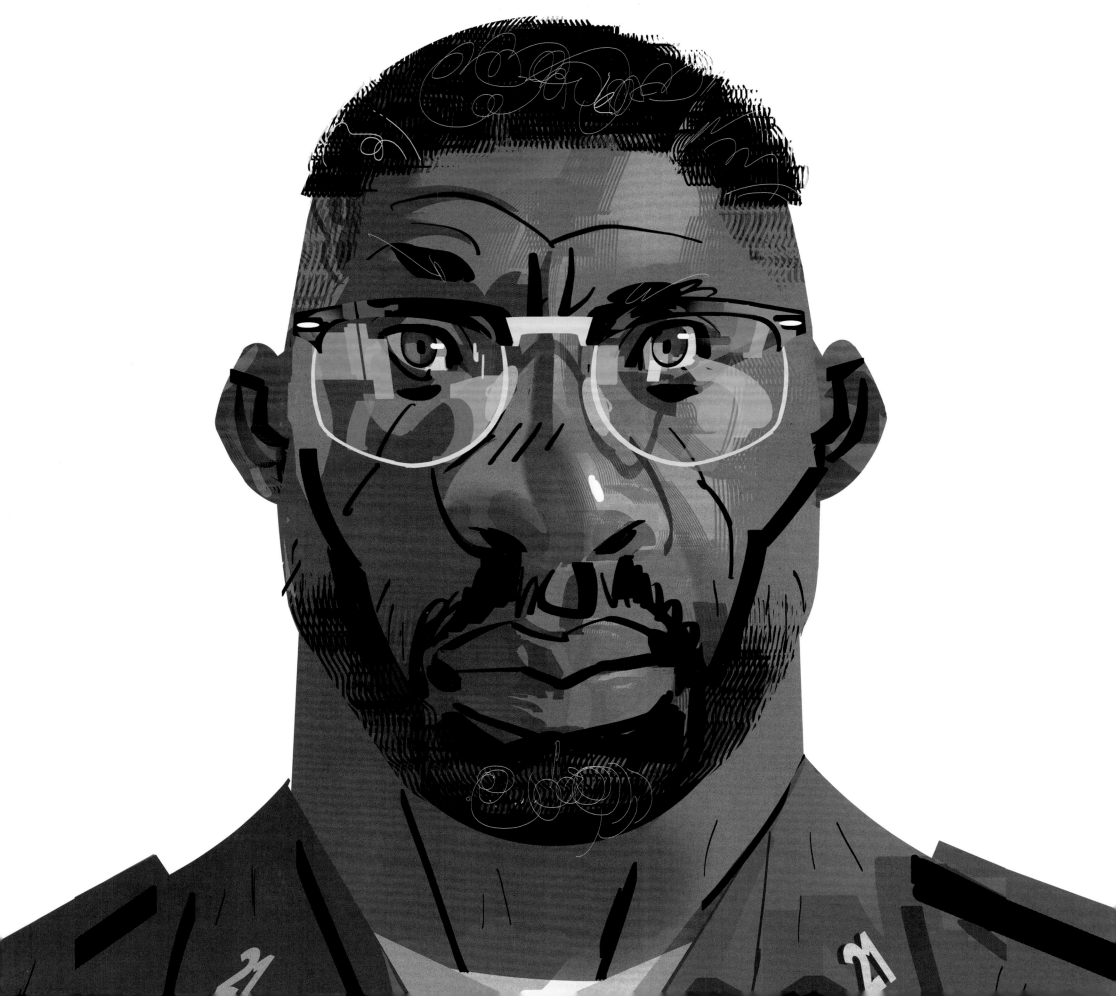

To design the character, the artists had to make sure he represented strength and physicality to match his tough-guy persona. "But we also had to make sure he had this great warmth to him," says production designer Justin K. Thompson. "Physically, Jefferson is very imposing, but he is still someone we are supposed to empathize with. His design is a great reflection of these two sides of his personality. Sometimes he can be strict simply because he wants Miles to avoid some of the troubles he got into when he was young, but most of the time he has a very warm, rich smile which can melt just about any heart." Thompson also notes that Jefferson has an uncanny resemblance to someone in director Peter Ramsey's life. "He actually looks a lot like Peter's dad!"

PREVIOUS SPREAD: Character concept art by Alberto Mielgo.
LEFT: Jefferson and Aaron in their youth by Wendell Dalit.

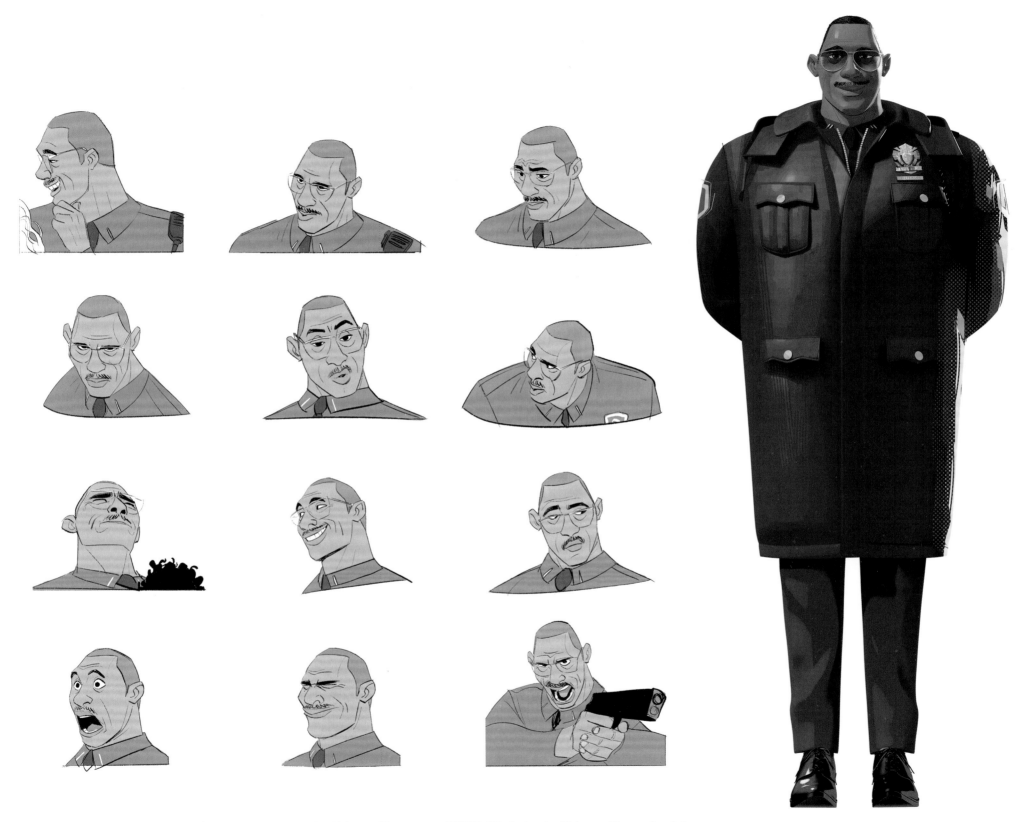

ABOVE: Development of Jefferson's facial expressions by Shiyoon Kim.

RIGHT: 2D design by Shiyoon Kim and paint by Yashar Kassai.

Since Aaron is the cool uncle Miles has always looked up to, his apartment also needed to reflect this sense of fun and teenage appeal. Vis dev artist Yuhki Demers explains, "Aaron's apartment is meant to be a refuge of sorts for Miles from a world that doesn't understand him. It's filled with things any teenage boy would love to have, but any sane parent would say no to—things like throwing knives, katanas, strange electronic gadgets, and an absurdly loud sound system. Ultimately, it's where Miles goes to escape responsibility, and in the end, the only place he can learn it!"

ABOVE AND BELOW: Final artwork of Aaron's apartment by Yuhki Demers.

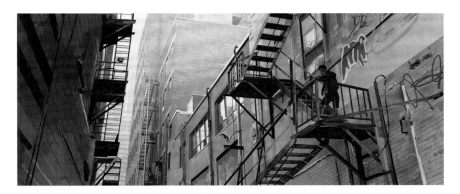

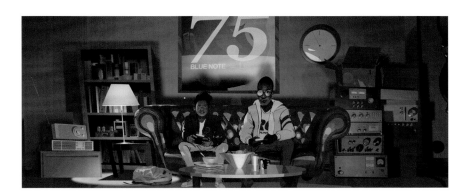

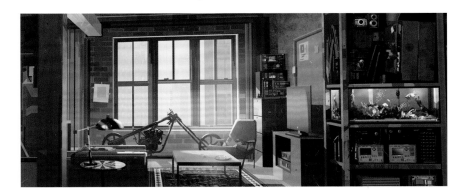

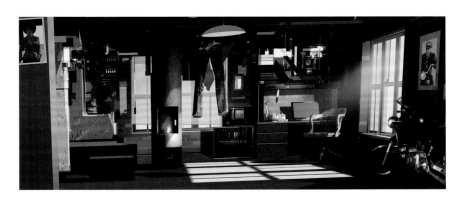

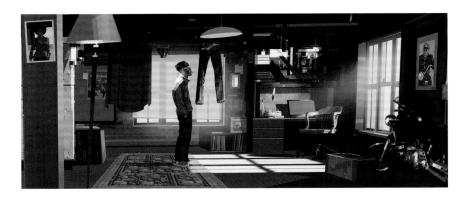

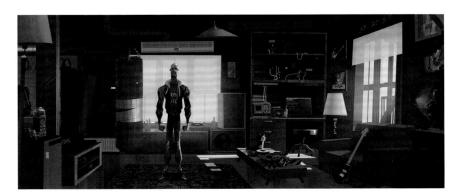

ABOVE: A collection of concept art for Aaron's apartment by Yuhki Demers, Yun Ling, Vaughan Ling, and Neil Ross.

Miles' uncle is one of the most complex and charismatic characters featured in both the original Miles Morales comic book and in the movie. He is the cool uncle who serves as a fun influence on our young hero's life, until we learn his dark secret. "He is the guy who teaches Miles that he doesn't have to take everything so seriously all the time," says writer and producer Chris Miller. "Of course, we find out that he is one of the bad guys, the Prowler. He has a very interesting and nuanced relationship with Miles as he oscillates between being a positive role model and a darker, more disturbing presence. Aaron and Jefferson represent the two possible paths that Miles has to choose from. Both of them are amazing actors." Aaron is voiced by Mahershala Ali (*Moonlight, Alita: Battle Angel*), and Jefferson is voiced by Brian Tyree Henry (*Atlanta*).

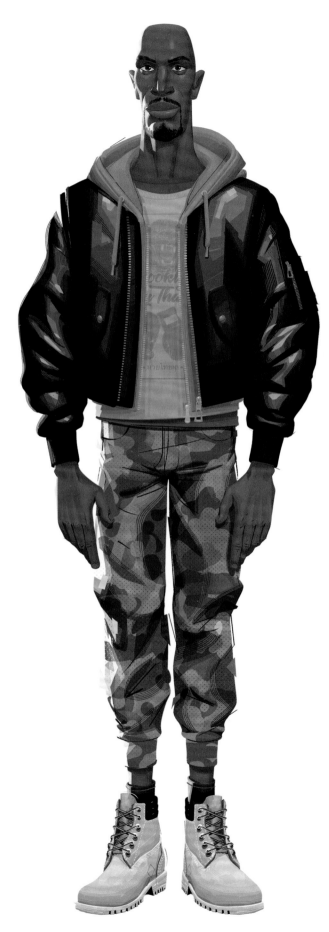

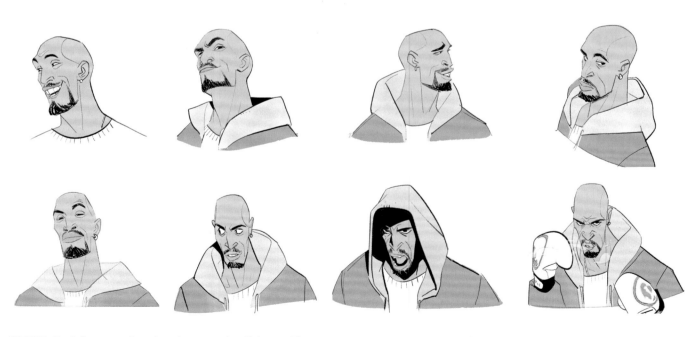

ABOVE: Facial expression development by Shiyoon Kim.
RIGHT: 2D design by Shiyoon Kim, 3D design by Omar Smith, and paint by Yashar Kassai.

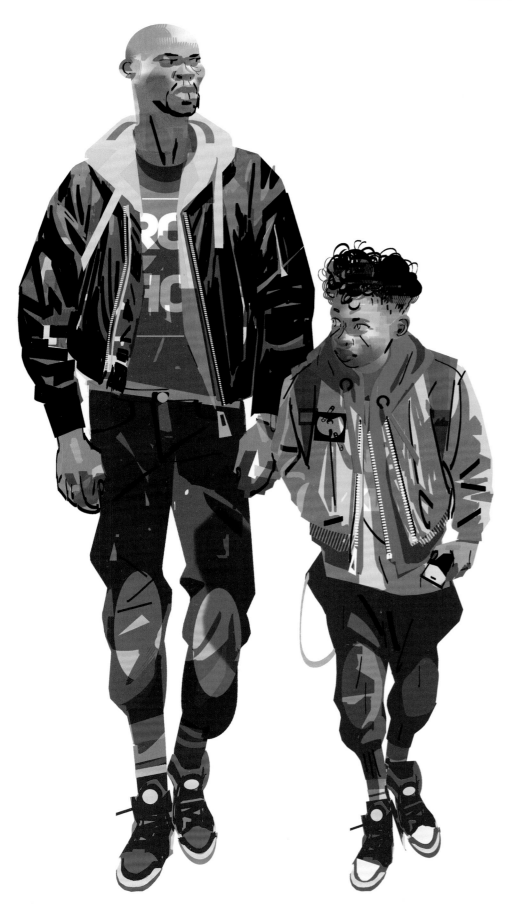

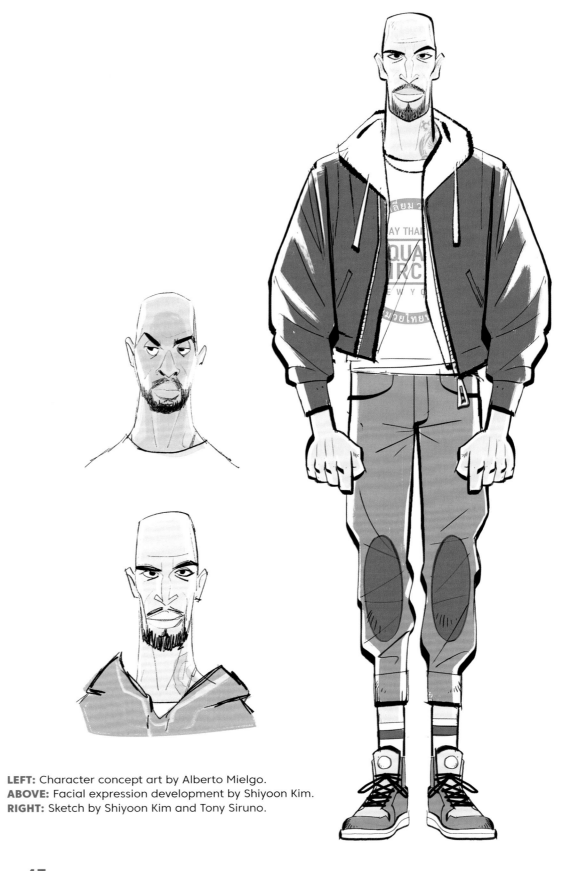

LEFT: Character concept art by Alberto Mielgo.
ABOVE: Facial expression development by Shiyoon Kim.
RIGHT: Sketch by Shiyoon Kim and Tony Siruno.

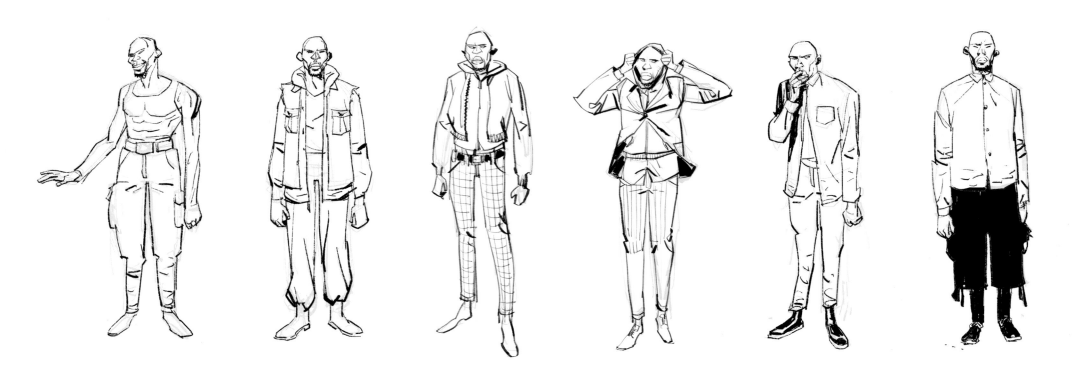

ABOVE AND BELOW: Early character sketches developing the look and style of Aaron Davis. All by Jesús Alonso Iglesias.

Who is Miles Morales?

Unlike many of the other characters that were inspired by regular people on the streets, the character designers were heavily influenced by Ali's physical characteristics. "Aaron is one of the few characters that resembles the actor that voices him," says production designer Justin K. Thompson. "He has such an interesting face, and he was one of the first actors cast in the movie, so our designer Shiyoon Kim (*Tangled*, *Frozen*, *Wreck-It Ralph*) was inspired by Ali's long, thin physique and his tall, thin head. Jefferson has more of a wide offensive lineman football player body, while Aaron has more of lean basketball player shape. Shiyoon created a beautiful and original design."

ABOVE: Concept development by Jesús Alonso Iglesias.

PREVIOUS PAGE: Concept art of Miles and Aaron by Zac Retz. Story art by John Puglisi. THIS PAGE: Concept art by Patrick O'Keefe.
NEXT SPREAD: Artwork by Neil Ross.

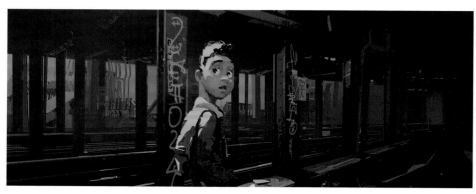

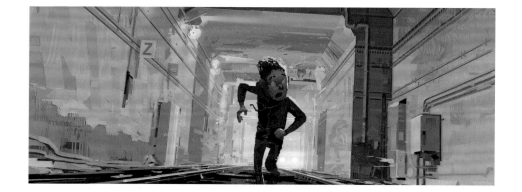

THIS PAGE: Miles explores the subway in concepts by Zac Retz and Yun Ling.
RIGHT: Lighting keys by Zac Retz.

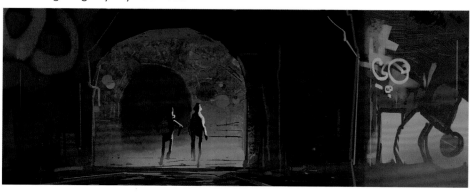

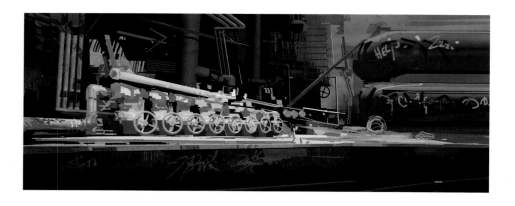

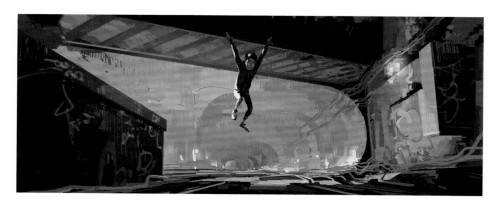

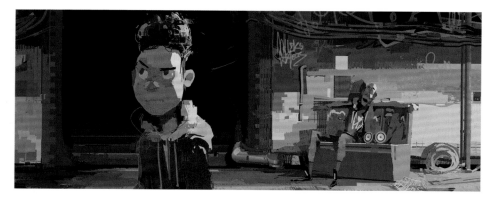

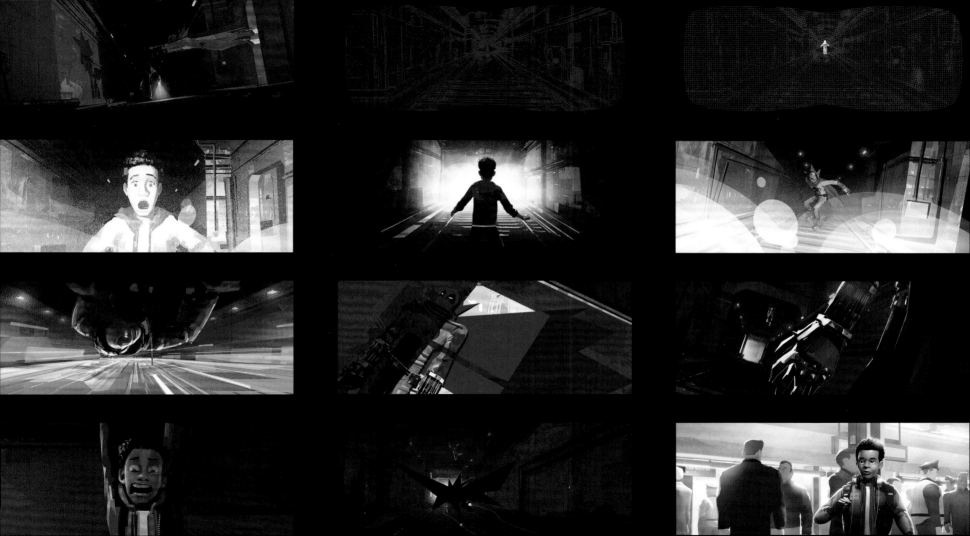

BLURRED VISION

The Academy was split into three parts: the school exterior, the interior, and the dorm room exterior. The goal was to create the opposite feeling of the warm, raw, and lived-in world that Miles belonged to in Brooklyn. As development artist Peter Chan explains, "This idea translated to how different contemporary design aesthetics and construction materials cover up the historic stonework from the past, with only a tiny bit showing through the entrance of the school. There are lots of clean, perfect geometric plans and shapes. The overall scheme is also very cold and sterile."

ABOVE: The entrance to the school by Peter Chan.
RIGHT: Artwork by Neil Ross.

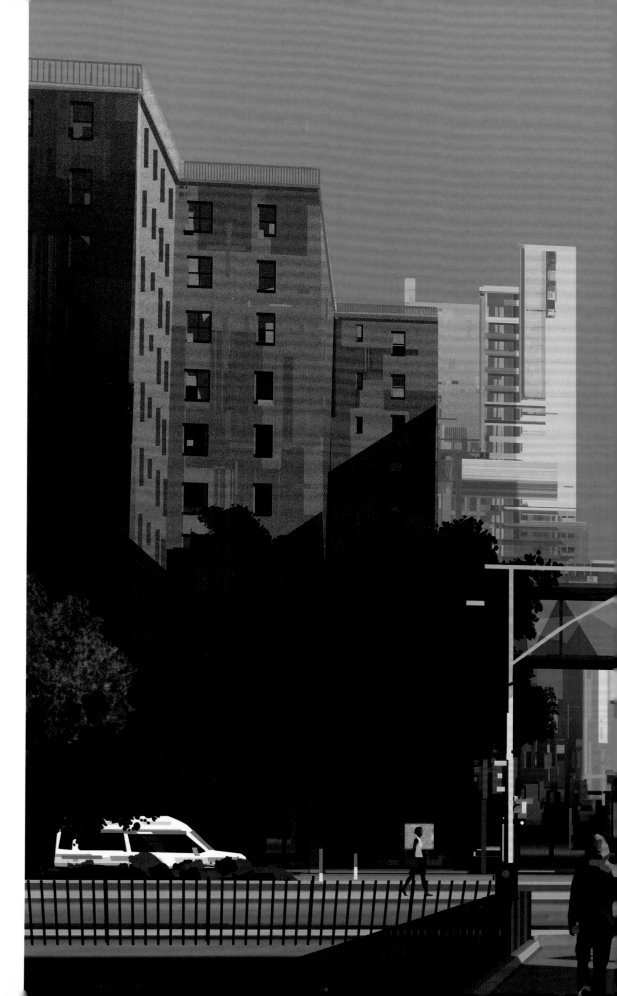

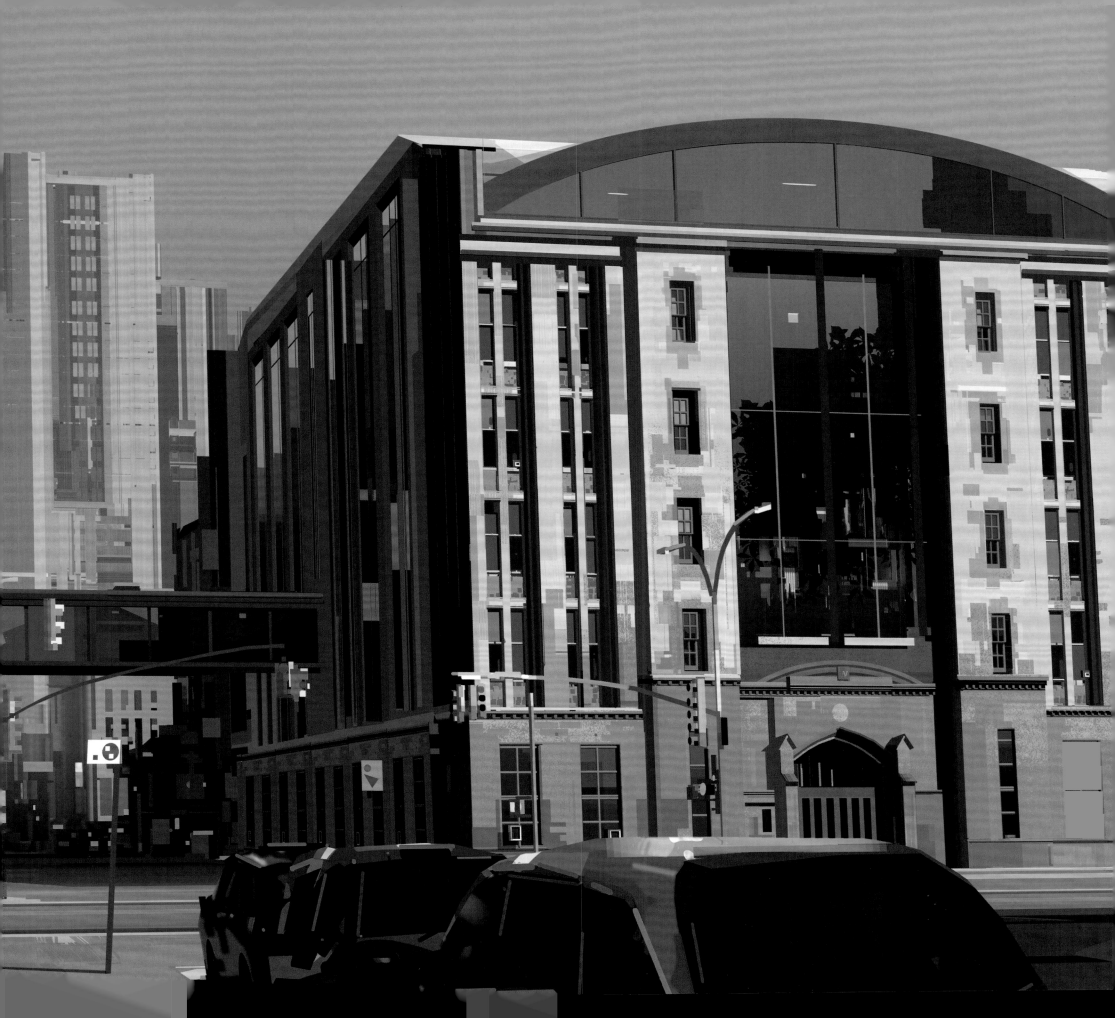

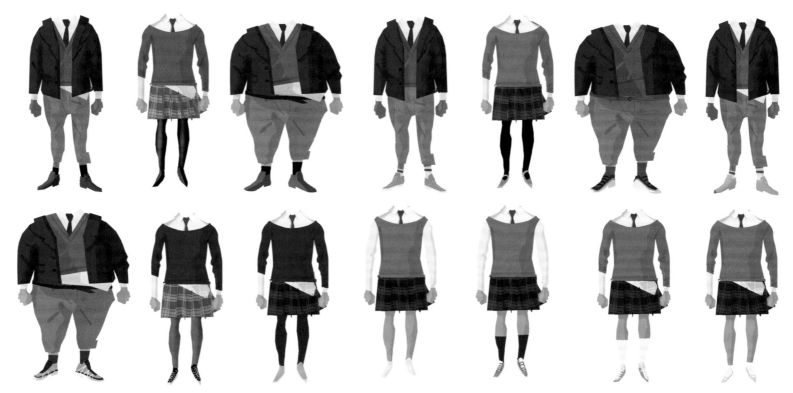

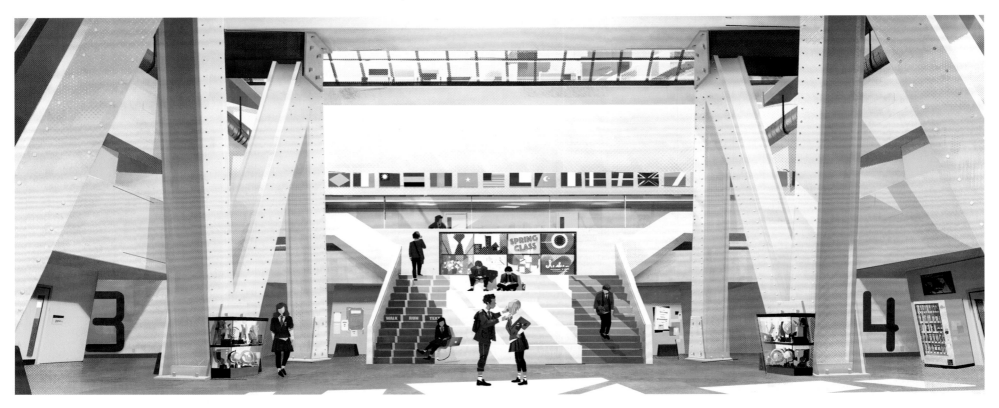

ABOVE: Design by Alberto Mielgo and paint by Dean Gordon. **BELOW:** Artwork by Chin Ko.
NEXT PAGE: Artwork by Peter Chan and Zac Retz.

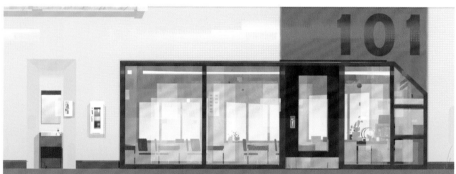

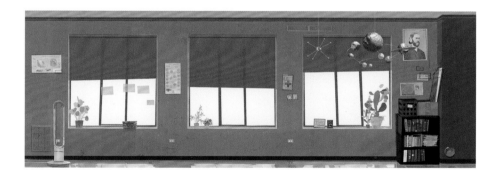

In their mission to capture authentic backdrops for the movie, the creative team visited big charter schools in Los Angeles and New York and took numerous photo references. "We wanted the audience to empathize with Miles' parents who simply want a better life for their kid," adds production designer Justin K. Thompson. "The school is literally a bridge between two worlds. I imagined it as an old building in Brooklyn that has been purchased by a charter school, who then hired a Los Angeles architectural firm to completely modernize it, while leaving some of the old Brooklyn charm integrated into it. Past, present, and future all coming together in one place. An aspirational place that offers unlimited opportunities that Miles eventually learns to love."

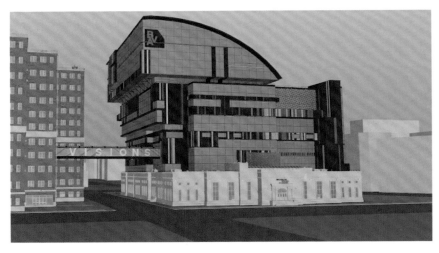
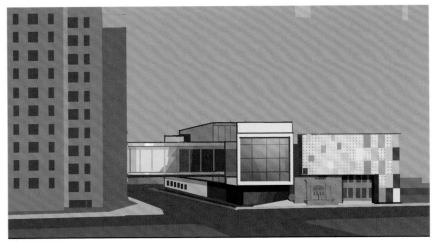
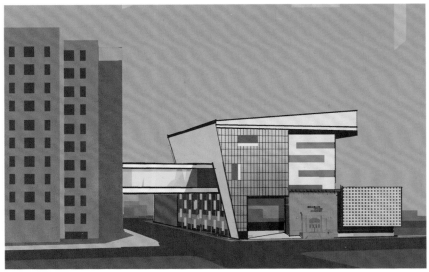
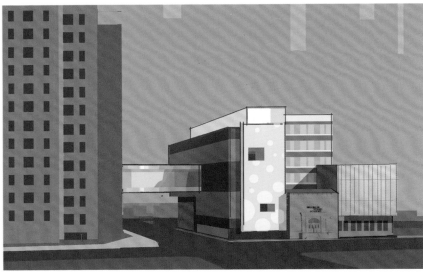
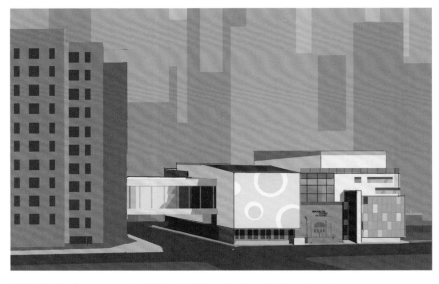
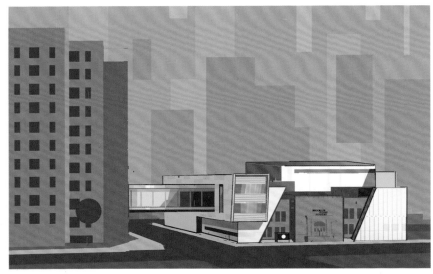

ABOVE: Early concepts of the building design by Tony Ianiro.

"Our hero is a very young kid who has this sense of wonder. This is a super hero story that is not about fitting the mold or being a genius. This is a story about being a reluctant young hero who wants to be a kid first."

Avi Arad, *Producer*

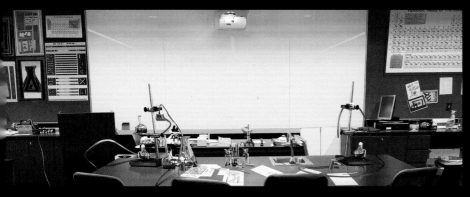

THIS PAGE: Concept art by Robh Ruppel, Bastien Grivet, and Jessica Rossier.

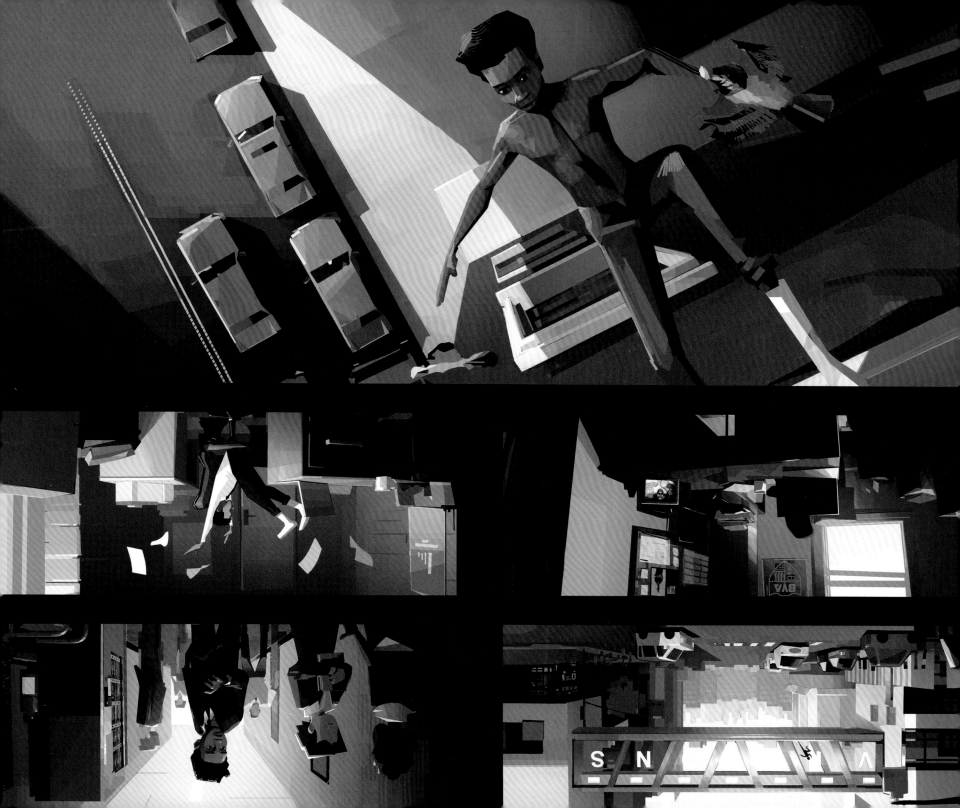

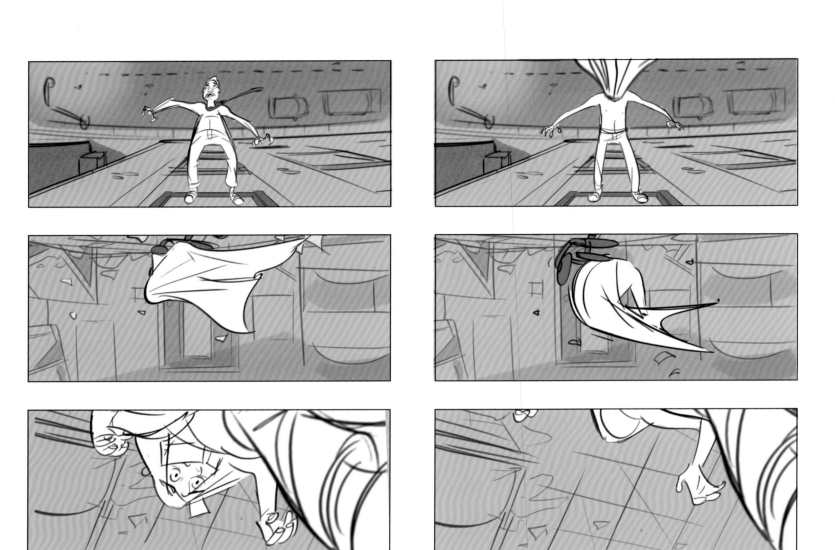

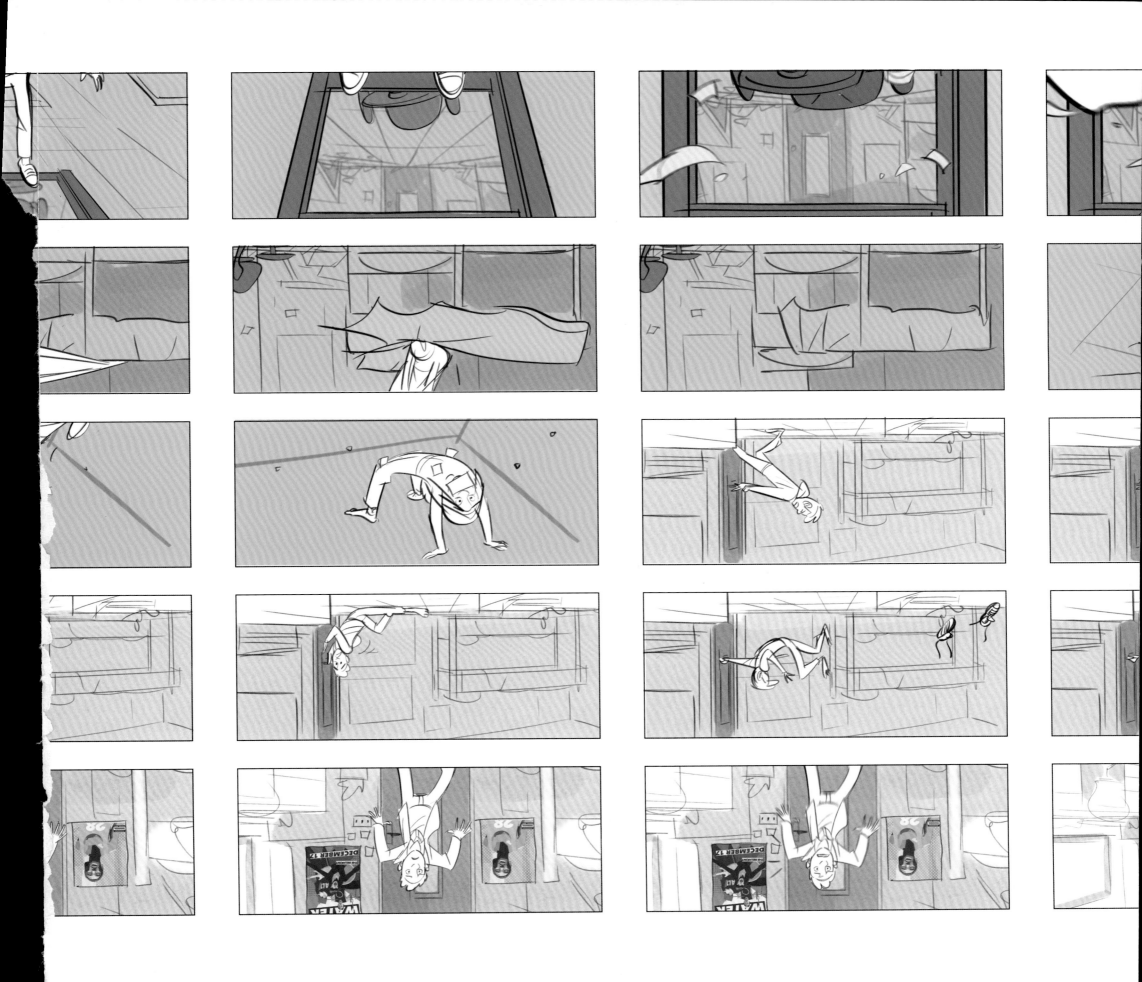

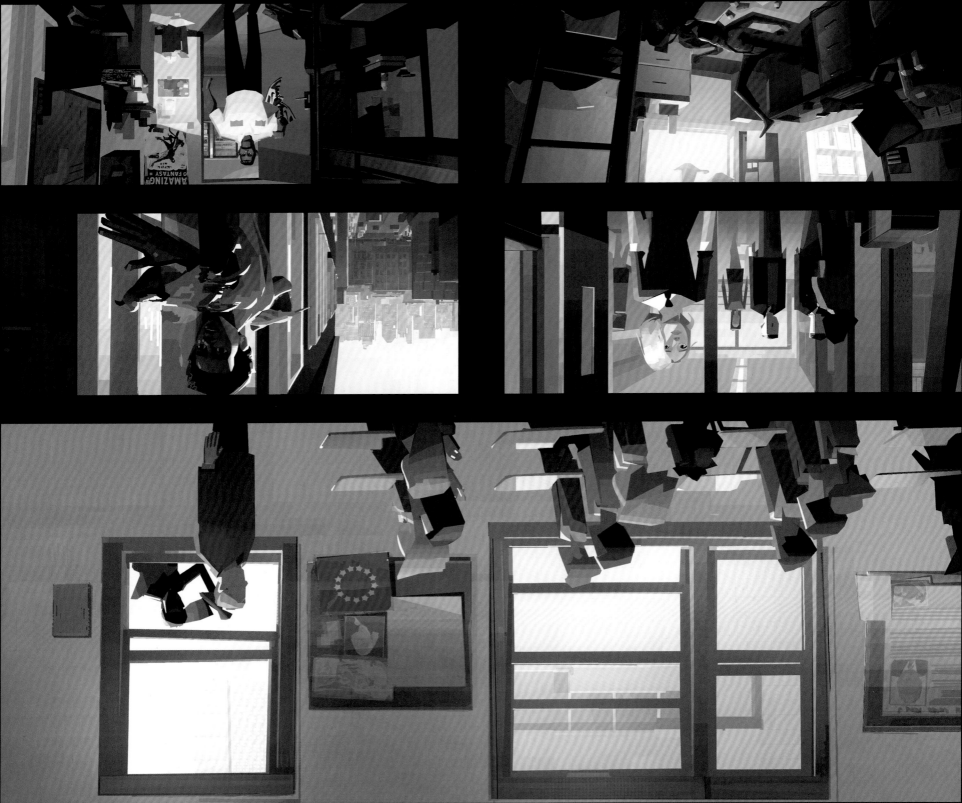

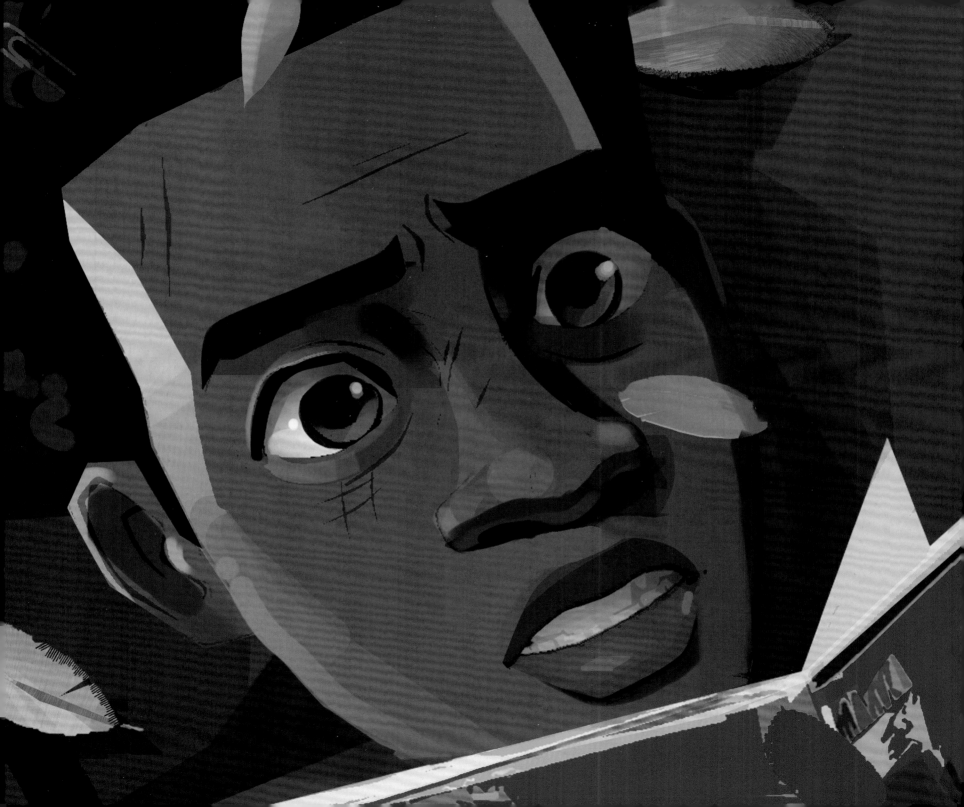

After Miles begins to suspect that he has developed superhuman abilities, he happens to come across a *Spider-Man* comic book that details the origins of the famous super hero. The filmmakers thought this would be the perfect opportunity to pay homage to the source material by including a specially created comic book in the actual movie.

To realize this vision, production designer Justin K. Thompson asked artist Marcelo Vignali, a Sony Pictures Animation veteran, to draw several comic book pages, paying homage to the classic version of the property.

"I was so excited when Justin asked me to come on board with this

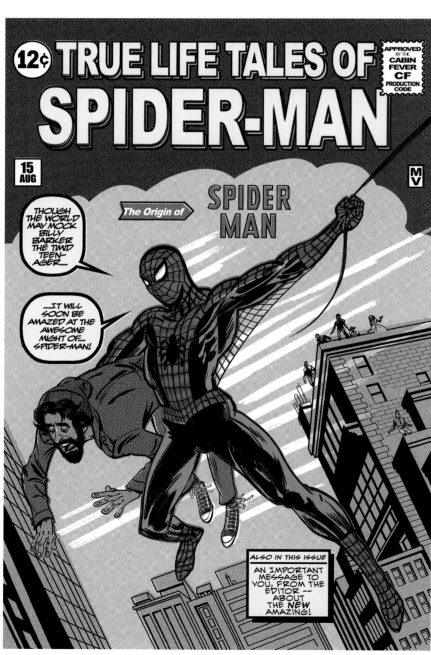

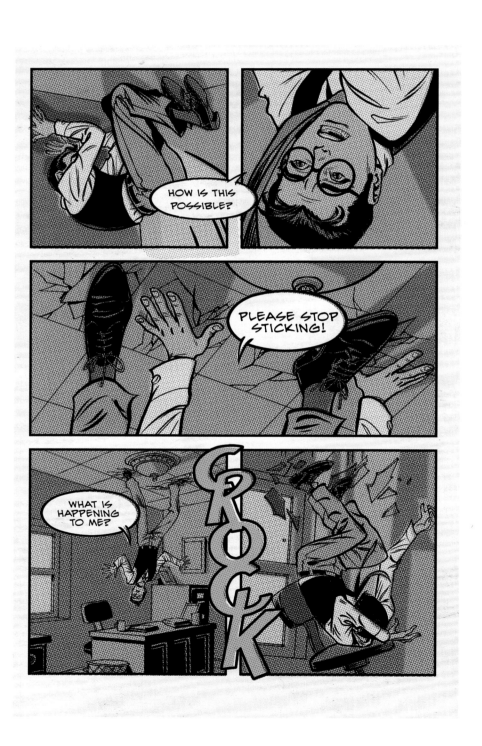

FOLD-OUT: Storyboards by Ryan Savas.
FOLD-OUT: Lighting keys by Wendell Dalit.
THIS SPREAD: Hand-inked comic book pages created by Marcelo Vignali.

assignment," says Vignali, who was production designer on *Hotel Transylvania* and art director on *Surf's Up* and *Smurfs: The Lost Village.* "This project was so secretive, that although I work at the studio, I hadn't seen any artwork or character designs. The only thing I'd seen was the trailer, which was loved by everyone."

Vignali, who was a huge fan of the first animated *Spider-Man* TV series (1967–1970), says he was very excited to tackle the challenging job. "They didn't want a modern look for the comic, so we went back to Steve Ditko's classic version," he notes. "I really marvel at the look Ditko established, which has remained constant, but those first issues didn't have a lot of detail about the origins of Spider-Man. I had no drawings of Peter Parker, and there wasn't much to hang my hat on. So, I also referred to John Romita Sr.'s work, which had more details about the origins story."

Vignali's art recreates the pulpy look of the beloved property with thick dot screen effects, revealing how the film's Peter Parker developed his powers twenty years before the events of the *Spider-Verse* movie. A fan of the Golden Era of comic book illustrations, Vignali says he was thrilled to be able to actually hand ink the comic book the way the old masters did. "Working in computers is easier for large images that fill the big screen, but the result has a certain look that wasn't right for this task. After the inking was done, we had to fake the offset lithography and map it on the film digitally to replicate that old pulp quality."

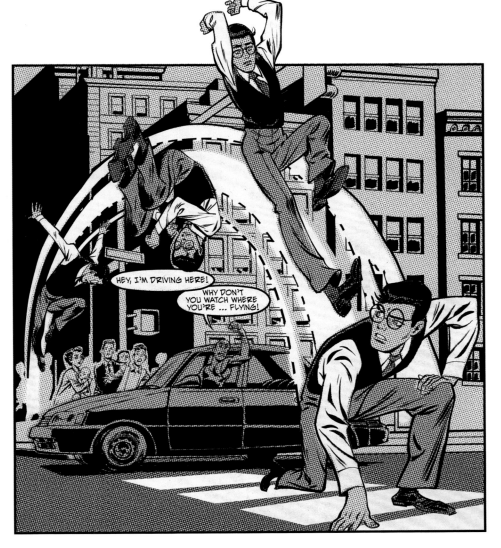

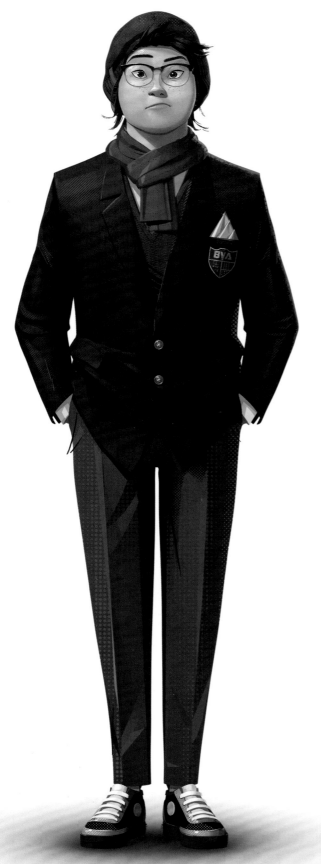

In contrast to Miles, his Academy roommate Ganke is extremely happy to be at the school. He is looking to take full advantage of the academic opportunities there. Originally, Ganke had a bigger role in the movie, but the filmmakers decided to develop his storyline in future movies about Miles Morales. "He is one of the most gifted students at the Academy," says Justin K. Thompson. "We see him stay up all night working on his quantum entanglement thesis. He's so single-mindedly focused that he seems completely oblivious to anything his roommate might be up to."

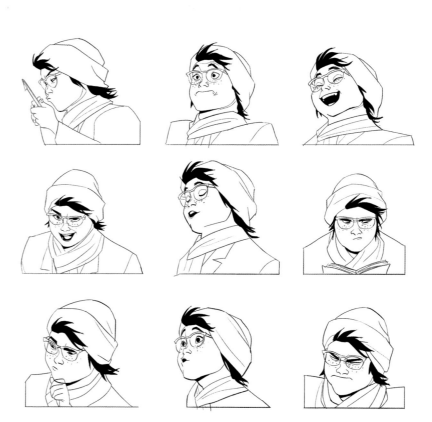

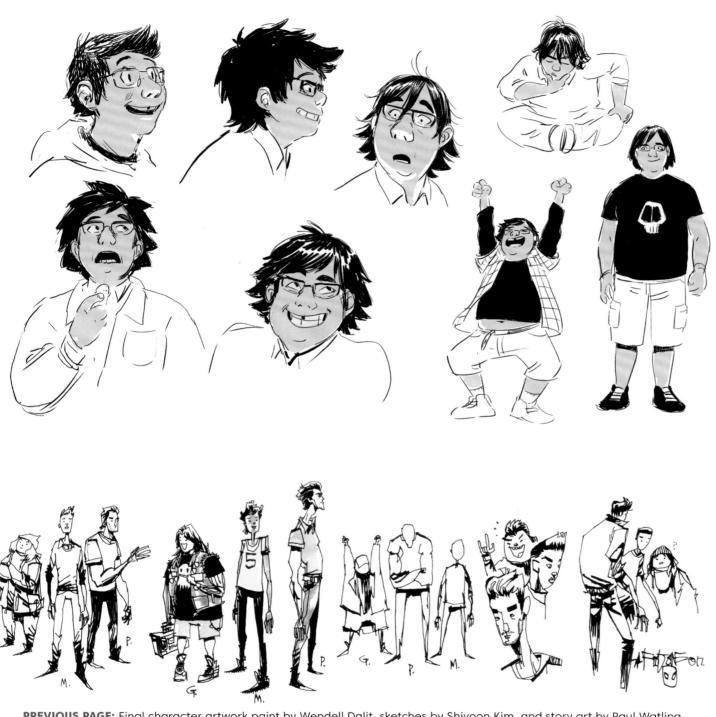

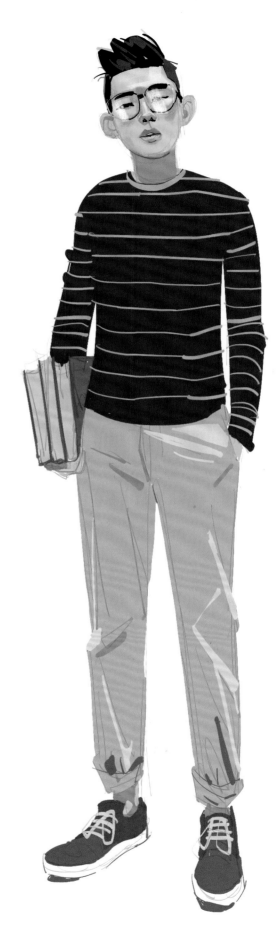

PREVIOUS PAGE: Final character artwork paint by Wendell Dalit, sketches by Shiyoon Kim, and story art by Paul Watling.
THIS PAGE: Early concept sketches by Sei Riondet, Jim Mahfood, and Jesús Alonso Iglesias.

Ganke is essentially the ultimate overachiever, in sharp contrast to Miles who doesn't know if he really wants to achieve anything. He is also a big Spider-Man fan—and it's only in the final sequence of the movie that he realizes the truth about his roommate. "That is really the beginning of their friendship," adds Thompson.

BELOW AND FAR RIGHT: Early character development sketches by Shiyoon Kim.

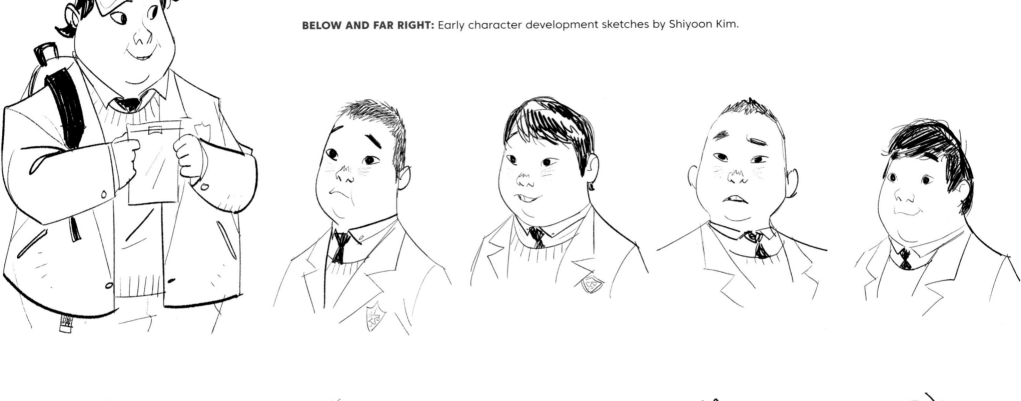

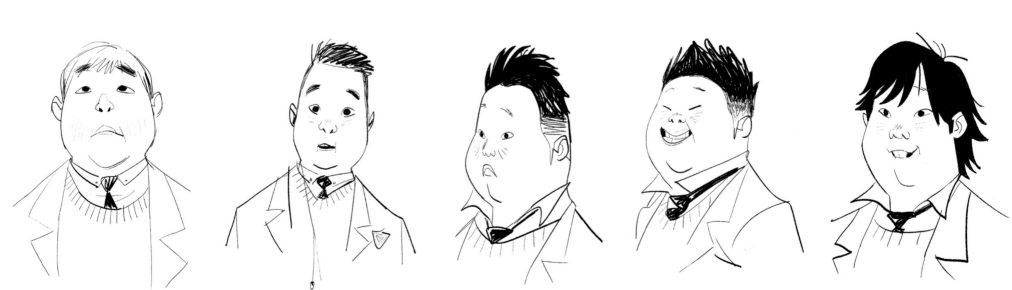

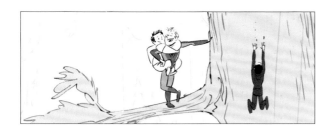
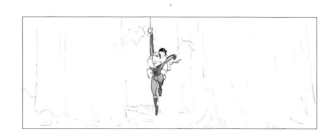

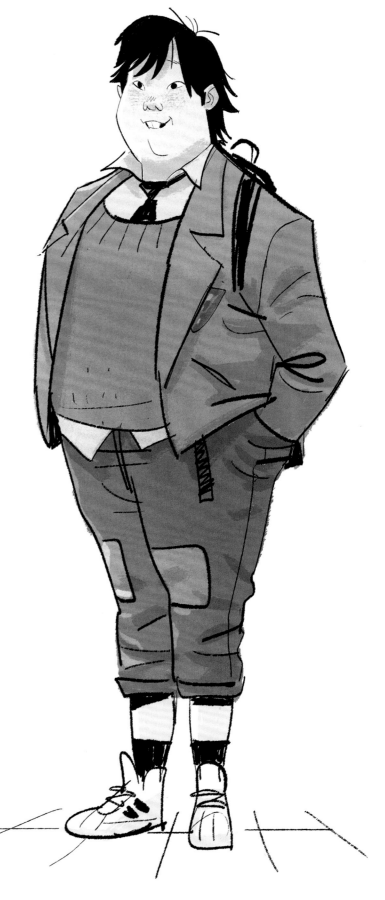

ABOVE: Storyboards by Riccardo Durante from a cut scene show Ganke's earlier involvement in the adventure.

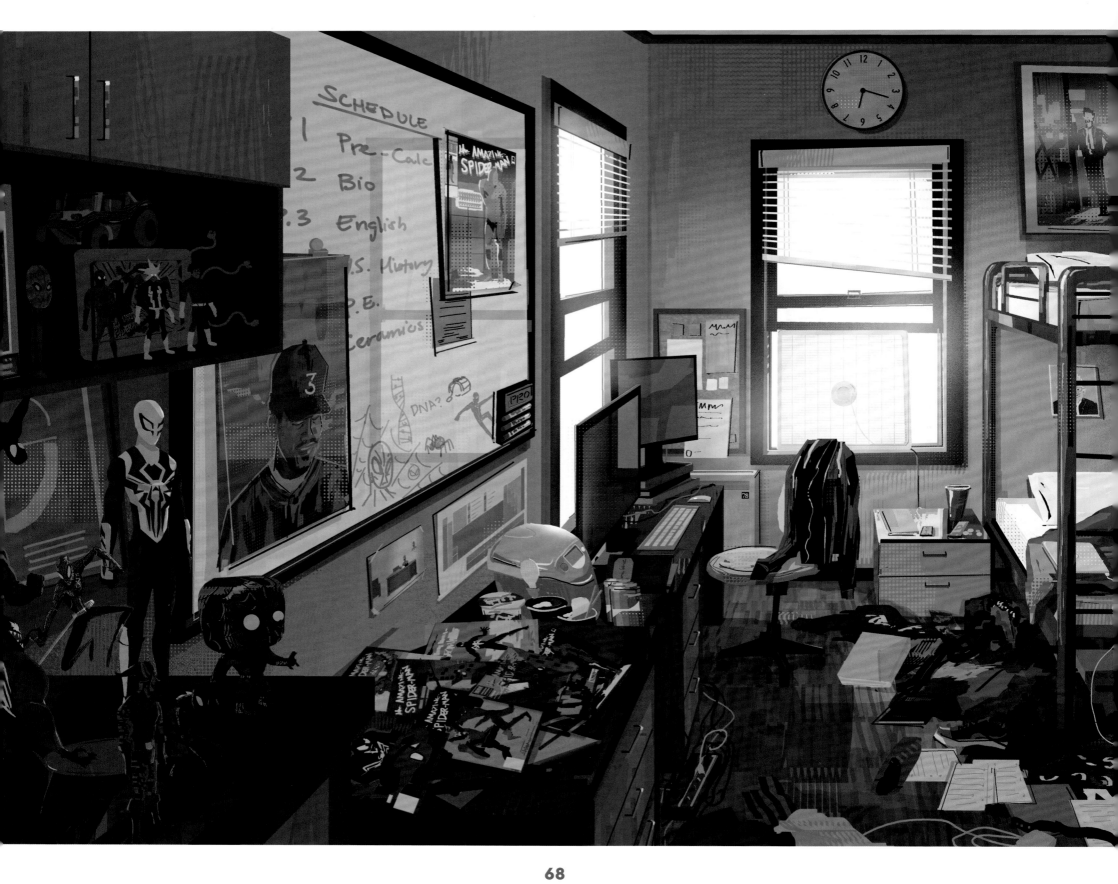

Miles is your typical messy teenager, and his dorm room at the Academy reflects his nature and pop culture tastes. "This set is the first glimpse we get of Miles' soul," says artist Yuhki Demers. "With echoes of his uncle's apartment, the backdrop really cements the idea that, for the most part, Miles is a normal teen with normal problems associated with that age. We worked hard to make it feel just messy enough!"

LEFT: Final artwork of Miles' dorm room by Yuhki Demers.
ABOVE: The store-bought Spidey suit. Artwork by Patrick O'Keefe.

MILES MEETS THE
SPIDER-MEN

When Miles discovers the Collider world under the subway, his experience echoes that of Alice as she falls through the rabbit hole. He enters an unusual realm unlike anything he has seen before.

"When Miles gets pulled into the action, the Green Goblin and the original Spider-Man are right in the middle of fighting inside this big, abandoned, underground subway train depot," recalls production designer Justin K. Thompson. "The filmmakers imagined that engineers had been using the abandoned tracks of transport equipment and materials underground. When Miles falls into the scene, he's simply trying to avoid being crushed by the gigantic Green Goblin. We made sure to add plenty of obstacles for Miles to hide underneath as the fight rages around them."

BELOW: The room where Miles first encounters Spider-Man by Zac Retz.

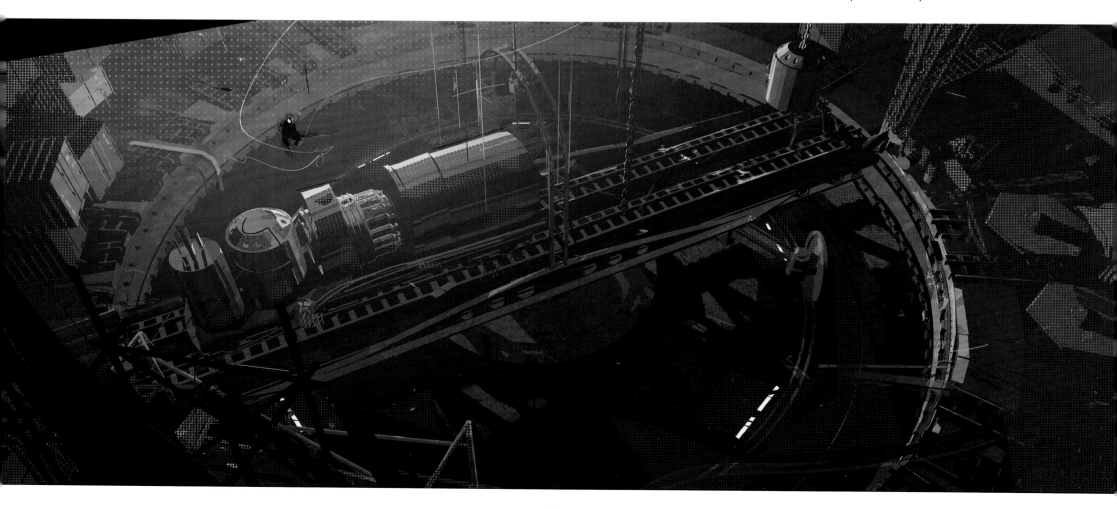

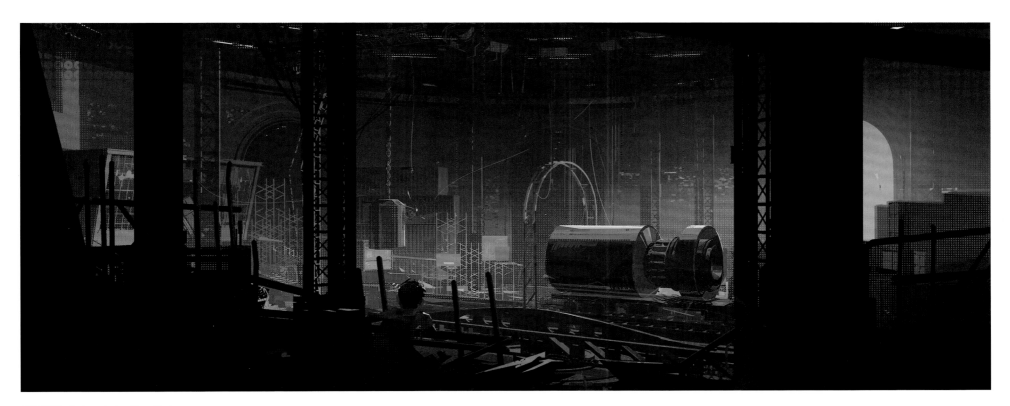

ABOVE: Artwork by Zac Retz.
BELOW: Concept art of the subway tunnels by Craig Mullins.

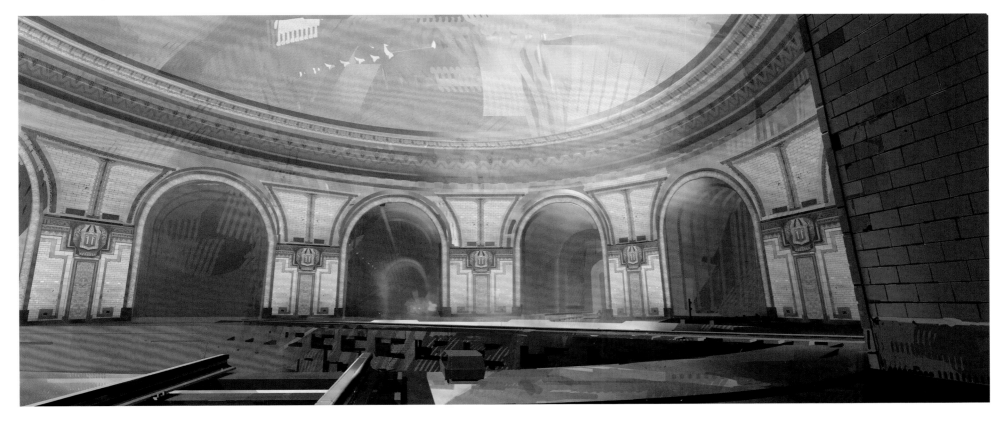

ABOVE AND RIGHT: Spidey-sense concept art by Dean Gordon. **BELOW:** Concepts by Zac Retz.

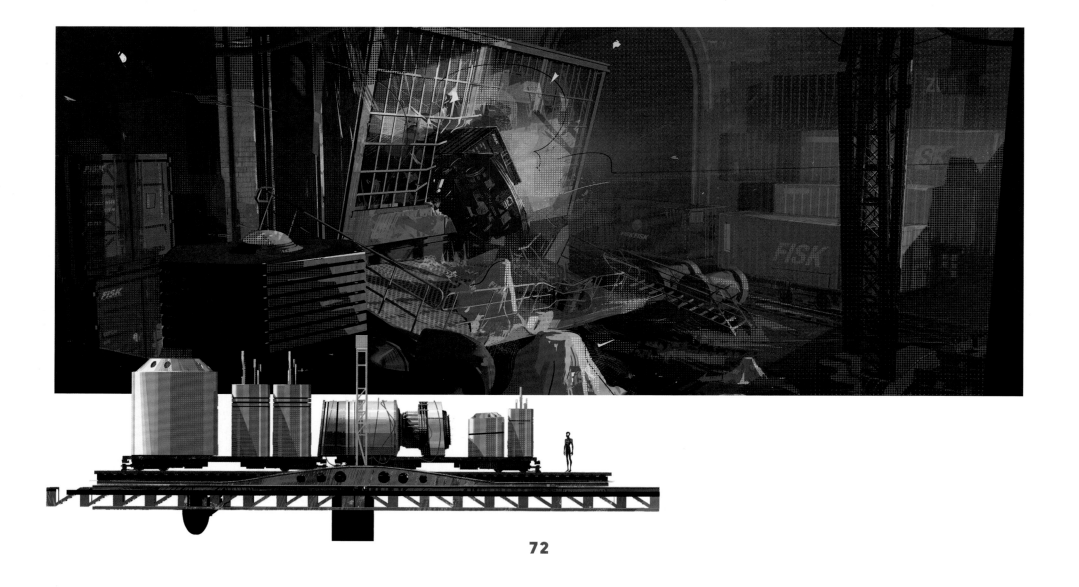

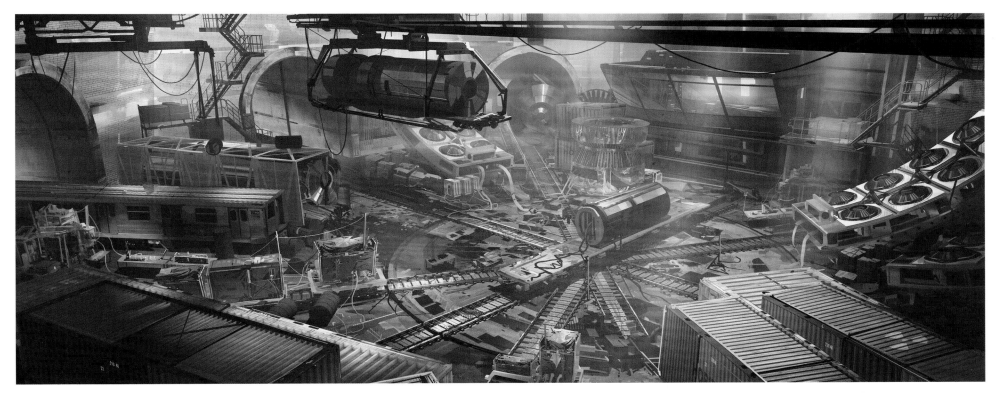

ABOVE: Train room concept by Bastien Grivet and Jessica Rossier.

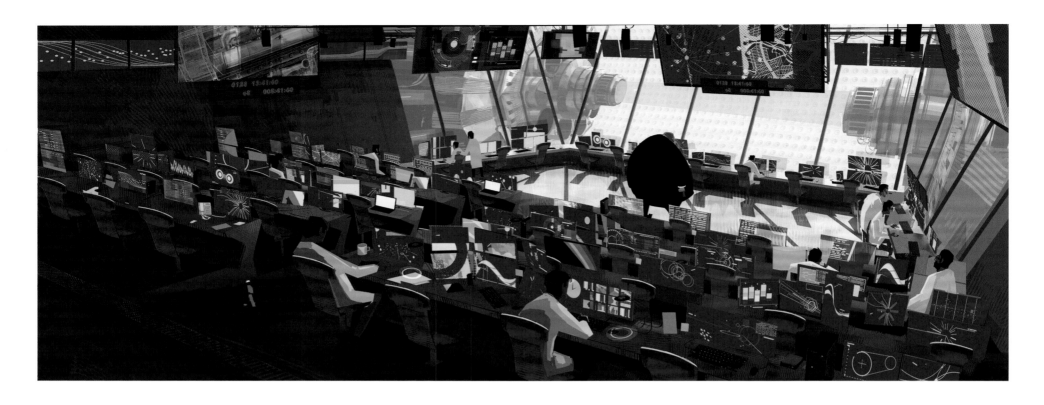

ABOVE: Artwork by Patrick O'Keefe.

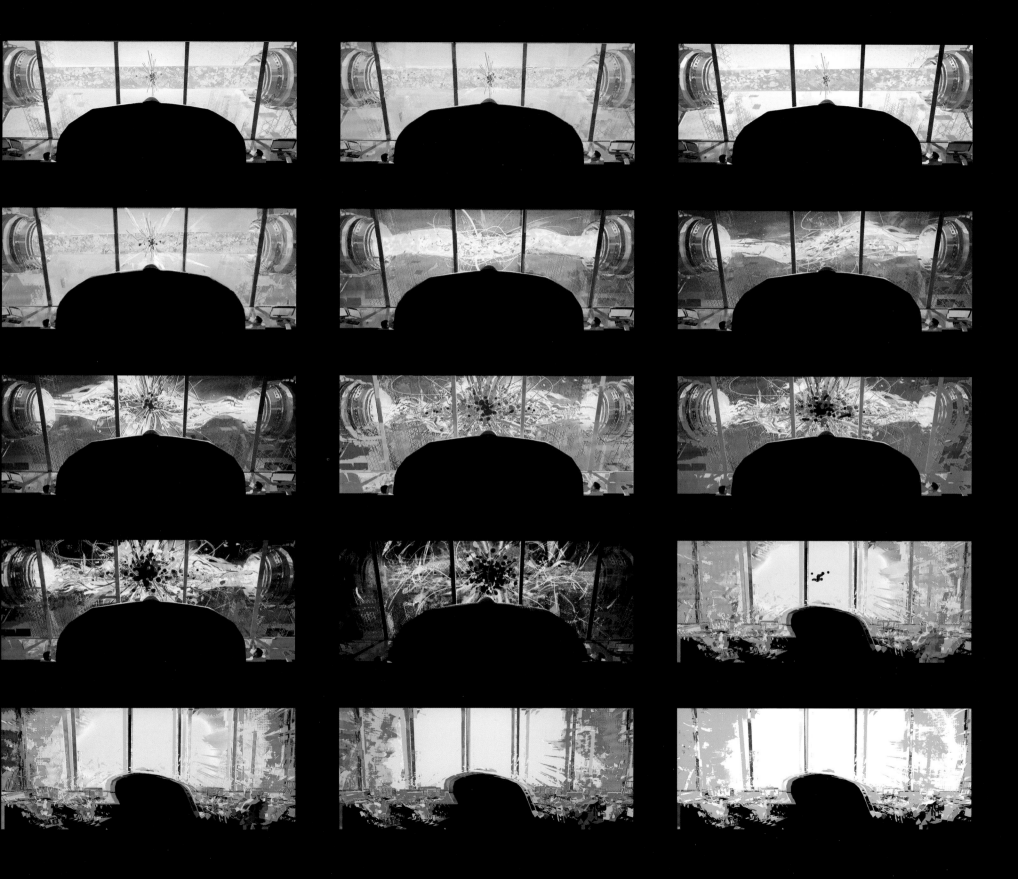

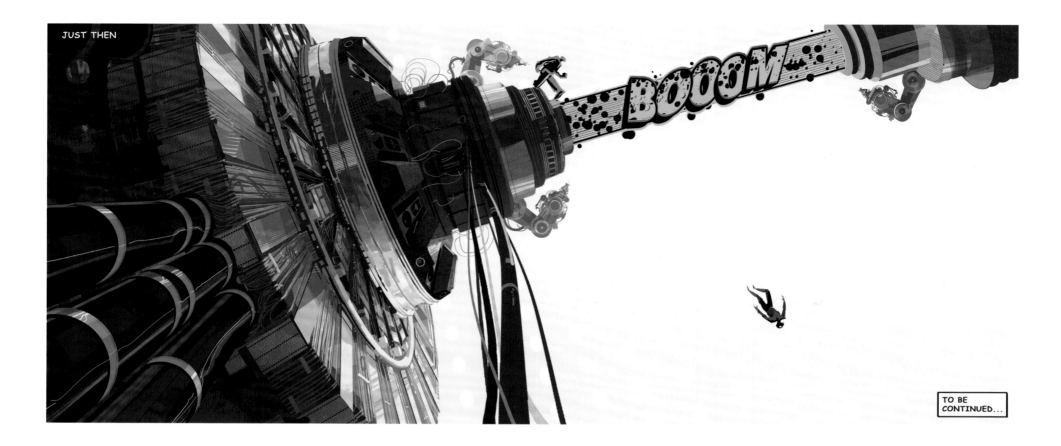

Miles believes that he is running towards the exit, but he only gets pulled deeper into the rabbit hole. He goes down the wrong path and ends up deep inside the Collider. The Atlas Room is the main room that houses the Collider. In the original comic books by Brian Michael Bendis, the Collider is a smaller hand-held device, but the filmmakers needed a much more cinematic device for the movie. "The comic introduced audiences to the Multiverse, but we wanted to go much bigger for our version of the Collider. We looked closely at the Large Hadron Collider in Geneva, which is the world's largest and most powerful particle collider. [It lies in a tunnel that is 17 miles in circumference and 574 feet deep!] But we knew, ours had to be more fantastical and magical."

The designers wanted to take advantage of the real-world references. "We were fascinated by the highly reflective materials we saw covering the real-world colliders," notes Thompson. "I wanted it to be a kaleidoscopic array of colors—with the bright, saturated blues, yellows, and reds reflecting off of the mirror-like gold and the chrome. I felt like it worked out better than I hoped when we started to see reflections of Miles, Peter Parker, and the Green Goblin on the surfaces, all echoing the Multiverse itself."

ABOVE AND NEXT PAGE: Concept paintings by Patrick O'Keefe.
NEXT SPREAD: Painting by Patrick O'Keefe.

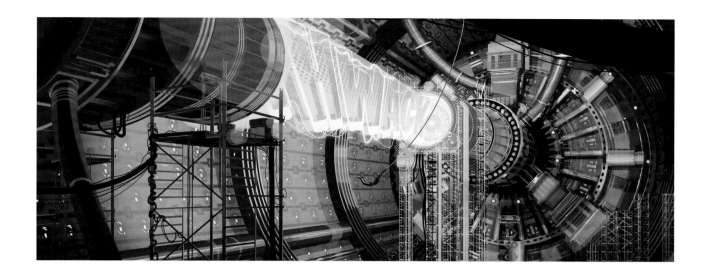

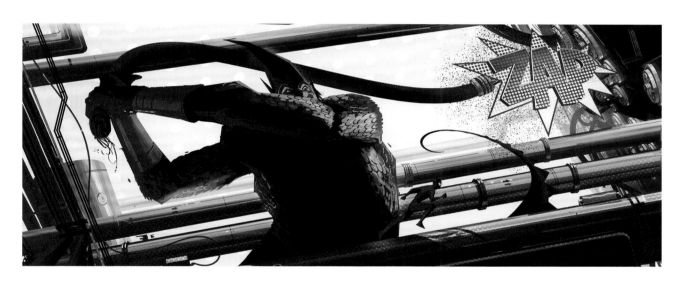

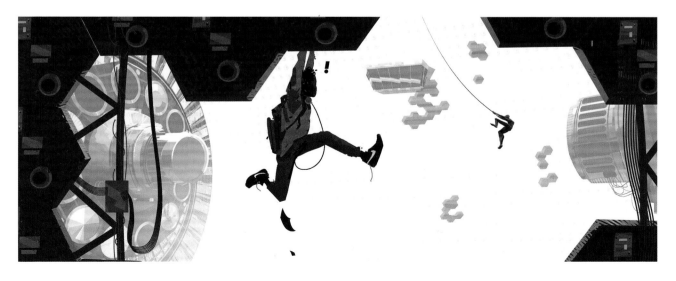

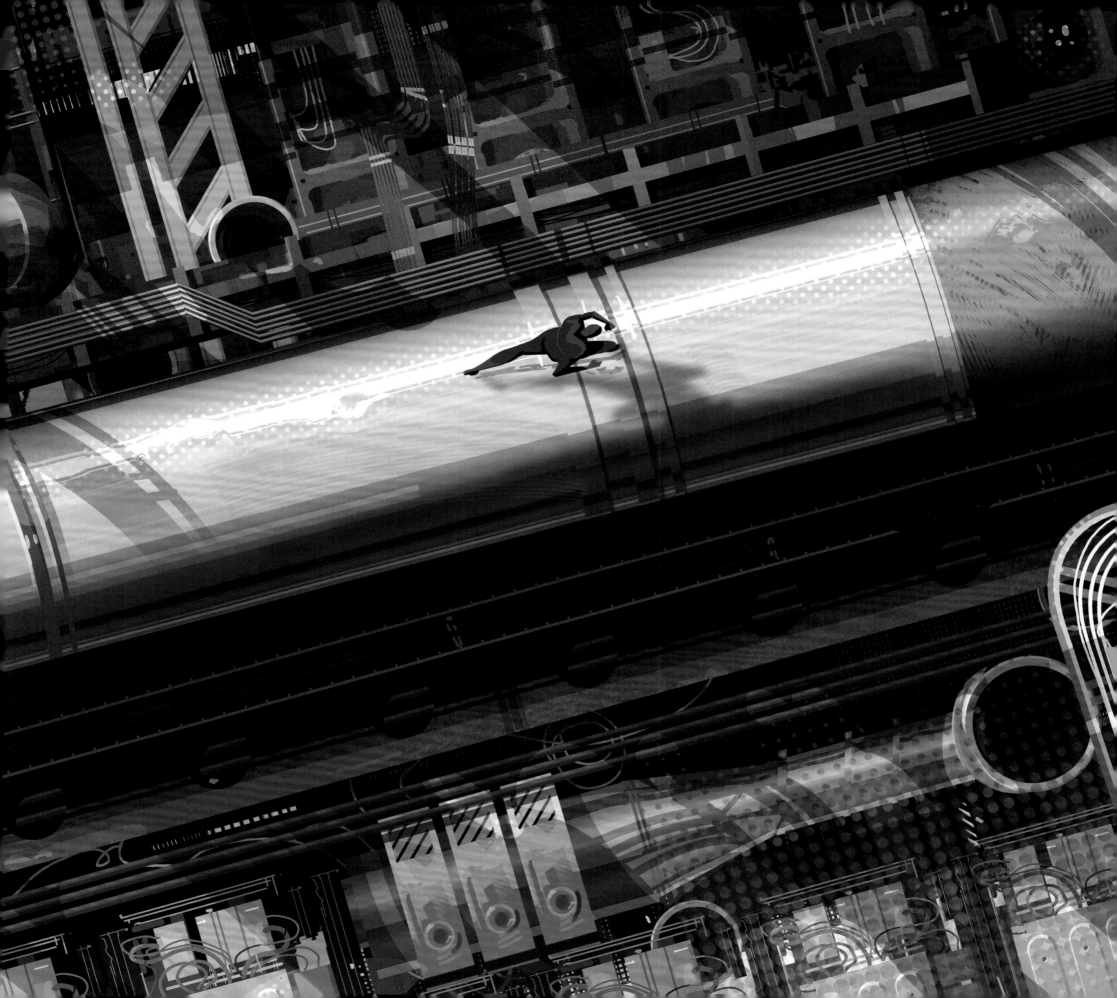

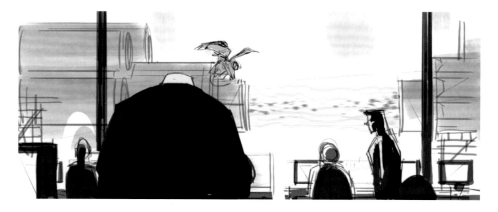

Considered by many to be Spider-Man's most engaging and powerful archenemy, the Green Goblin is one of the first villains we encounter in the movie. The character, which has had many incarnations in the comic books, is first spotted by a bewildered Miles in the Assembly Room fight scene with Peter Parker's Spider-Man. In the original Mile Morales comics by Brian Michael Bendis and Sara Pichelli, the Goblin was more of a monster—not merely a powerful guy in a suit.

"In an animated movie you can play around with the limits of reality," explains production designer Justin K. Thompson. "Green Goblin doesn't have a big part in the movie, but we thought we could kick things up a notch by making him about twenty-two feet tall."

He adds, "We already saw Andrew Garfield fight a lizard, so we thought it would be cool to have Spider-Man fight a Godzilla-like monster. We only had him for this one scene before he blows up, so the filmmakers wanted to have as much fun with him as possible. They wanted to introduce him like the T-Rex in *Jurassic Park*. The audience can see his outline getting closer, and he's this giant figure looming over them. Miles is in awe and just trying not to get crushed by the monstrous Green Goblin that Spider-Man is fighting. It's an amazing cinematic scene that takes full advantage of making him into a giant monster."

ABOVE: Story art by Peter Ramsey. **BELOW LEFT AND CENTER:** Color concepts for the Green Goblin by Jesús Alonso Iglesias. **BELOW RIGHT:** Color concept by Alberto Mielgo.

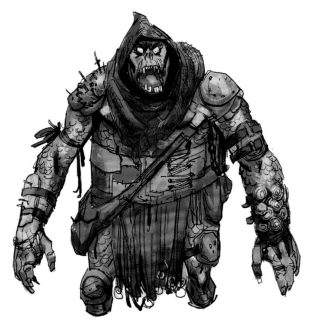

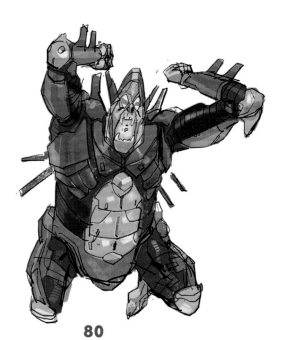

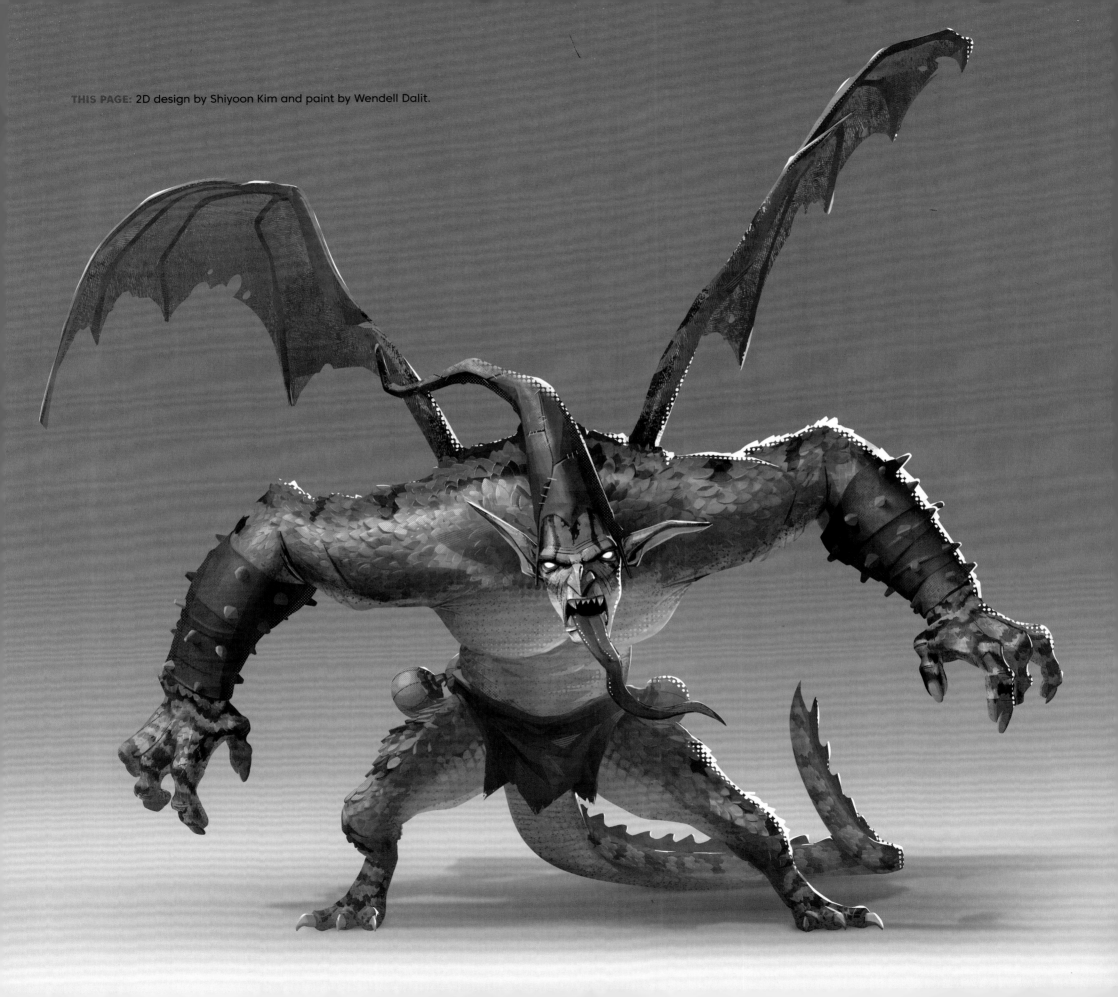

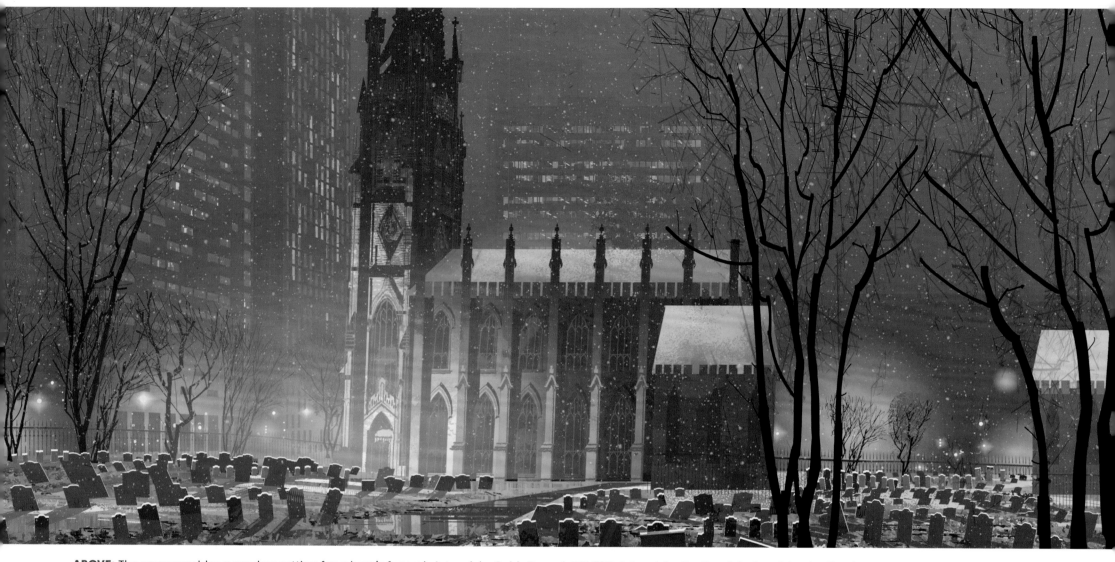

ABOVE: The snow provides a somber setting for a hero's funeral. Artwork by Robh Ruppel. **BELOW:** Artwork by Bastien Grivet and Jessica Rossier.

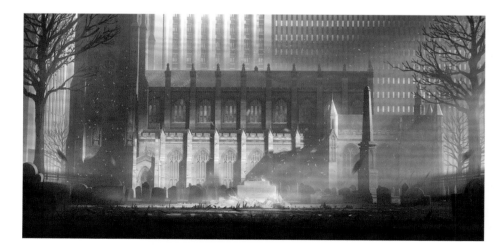

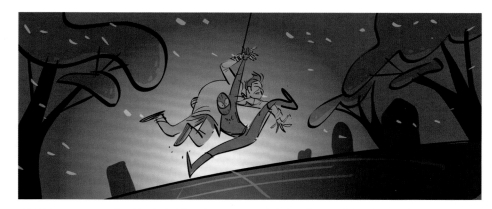

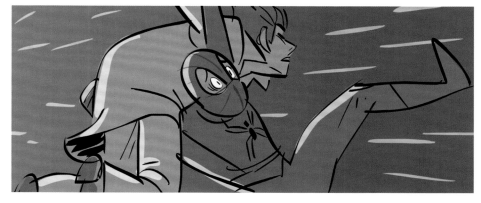

ABOVE: Story art by Mark Ackland. **BELOW:** Lighting keys of the funeral scene by Robh Ruppel and Seonna Hong.

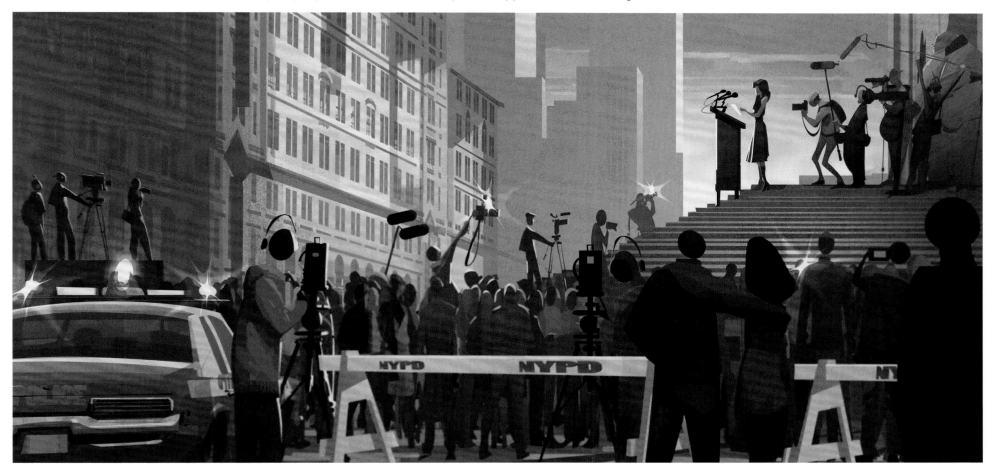

Peter Parker's love interest and (sometimes) wife, Mary Jane Watson makes an appearance in the movie. The character, who was originally introduced in 1965, doesn't have a big role however, the filmmakers thought it would be fun for fans to spot her. "She's an extremely important character in the Spider-Man canon, but she had very little screen time," says Justin K. Thompson. "So, I wanted her to have a classic, iconic look that would be instantly recognizable. She is beautiful, with striking red hair, and a very specific jagged cut on her bangs for which she's known. When Peter Parker sees her, he immediately recognizes her and so do the fans."

LEFT: Color concept by Alberto Mielgo.
RIGHT: 3D design by Omar Smith and paint by Yashar Kassai.

The Spider-Man that the Collider brings to Miles Morales' world is certainly not the Peter Parker he or any of his fans are familiar with. This thirty-something version of the web-slinger (voiced by Jake Johnson) is a bit jaded, not in the greatest of shapes, and is dreaming of a happy, carefree retirement in Costa Rica.

"Although he has the musculature of a super hero, he also has a little bit of a beer belly," says character designer Shiyoon Kim. "He has been through a couple of decades of crime-fighting, and it shows. He pushed his nose to the side a little bit... I thought it was a great way to connect with the fans of the comic book who have been following this character through the years. He feels authentic and appealing."

Director Peter Ramsey says he also found it interesting that this older Spider-Man has paid a heavy cost for being a super hero. "He has lost a lot, and is starting to wonder whether it has all been worth it," he says. "Helping Miles, who is a kid just beginning his life as Spider-Man, also restores his faith. It's a pretty complex and powerful storyline."

The way production designer Justin K. Thompson sees it, "Peter is playing Mr. Miyagi to Miles' Karate Kid, and he reluctantly agrees to teach him a few things. But he doesn't have to prove anything anymore—he's like LeBron James at the end of his career: we all know he's the greatest."

RIGHT: Final character artwork paint by Yashar Kassai.
FAR RIGHT: Concept sketches by Justin K. Thompson and Jesús Alonso Iglesias.

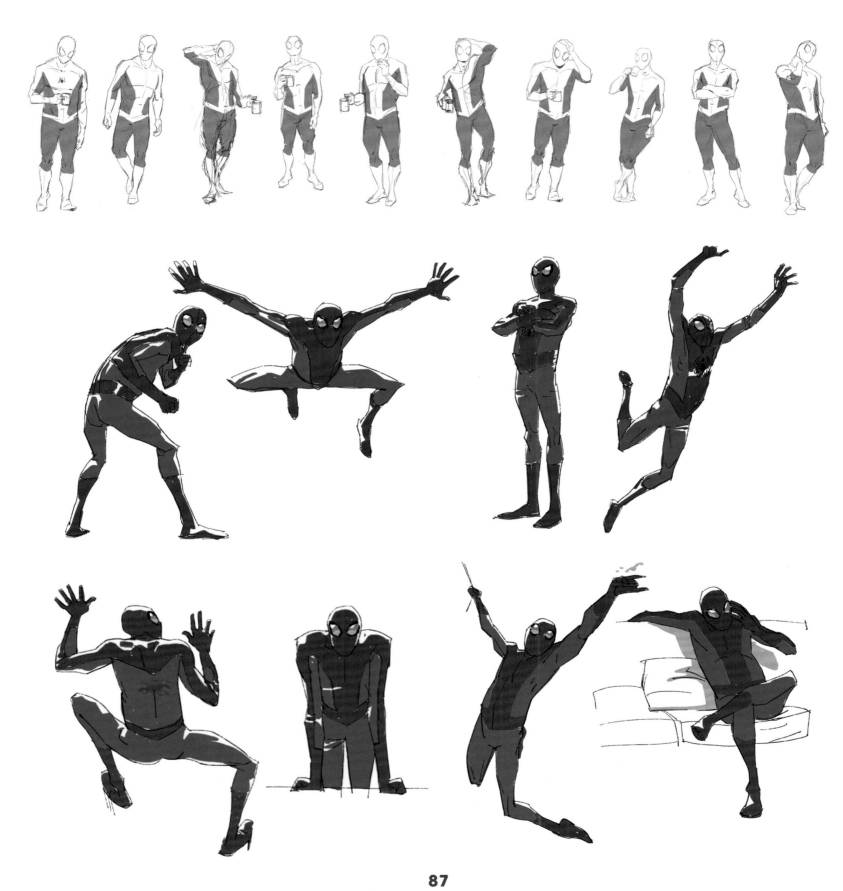

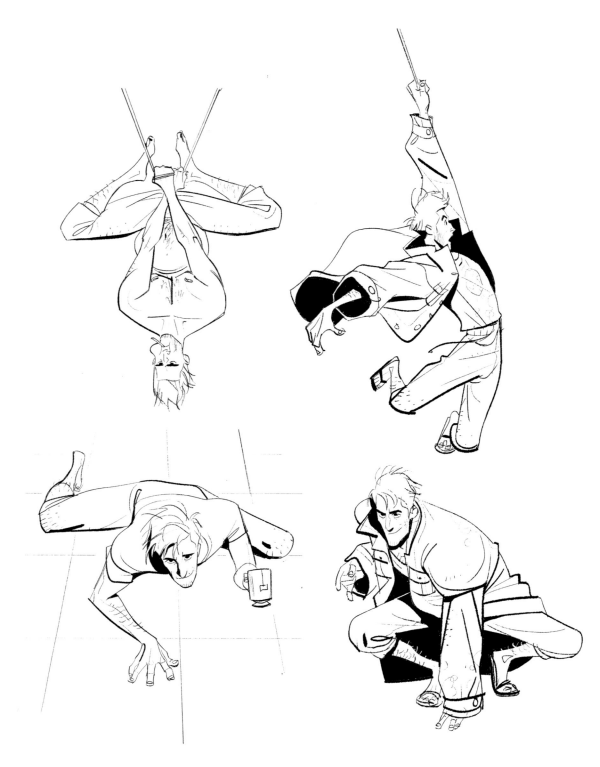

ABOVE: Sketches by Shiyoon Kim.
NEXT PAGE: Sketches (top) by Shiyoon Kim. Final artwork (bottom left) 2D design by Shyioon Kim, 3D design by Omar Smith, and paint by Robh Ruppel. Artwork (bottom right) 2D design by Shyioon Kim, 3D design by Omar Smith, and paint by Wendell Dalit.

"We are all lucky to be working
on a property that has such
a huge audience invested in it.
That's why we could be riskier with
our choices and make the movie
visually different from what
a summer or winter blockbuster
is expected to look like."

Bob Persichetti, *Director*

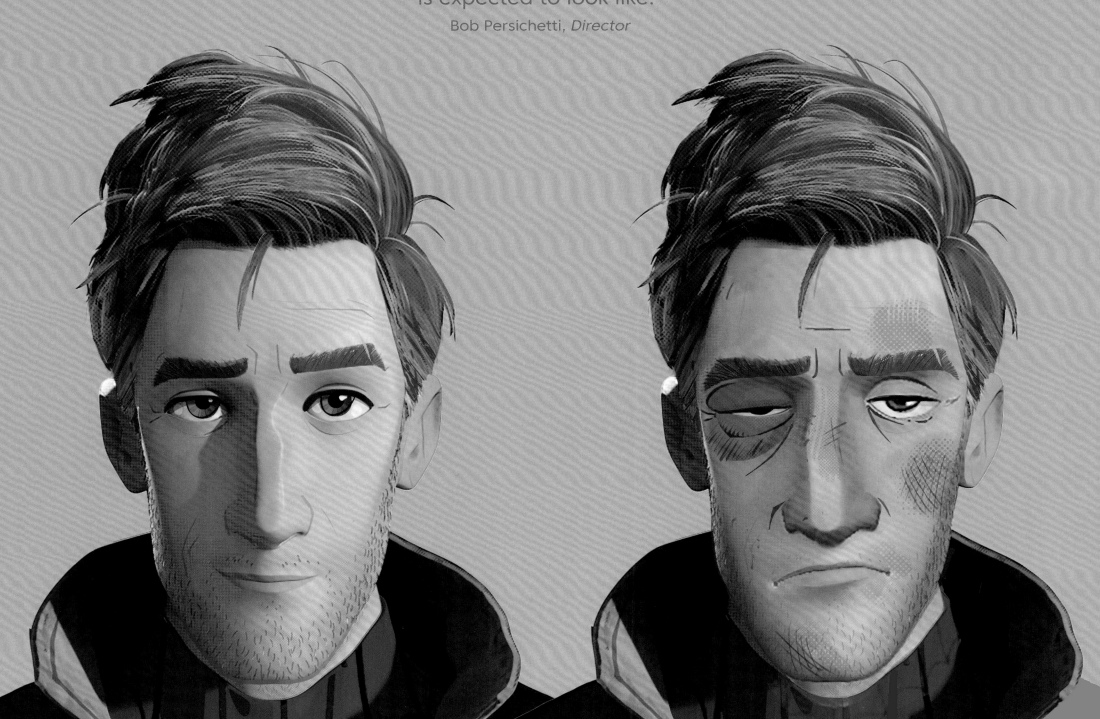

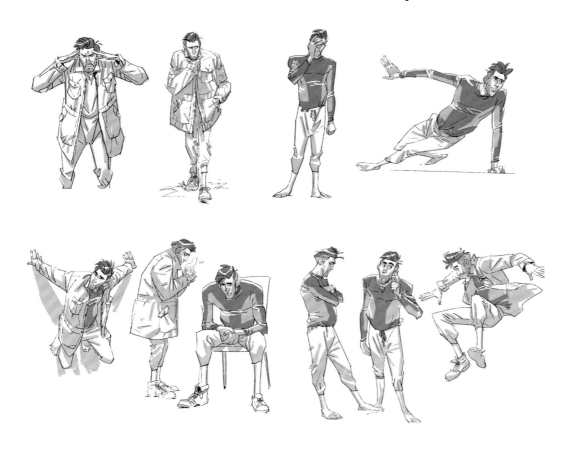

THIS PAGE: Concept art by Jesús Alonso Iglesias.
NEXT PAGE AND SPREAD: Artwork by Alberto Mielgo.

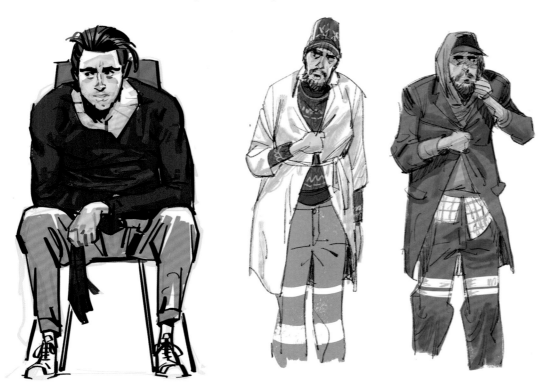

OUT OF THE
CITY

The cool, reflective Alchemax Labs are where the shocking reveal of Dr. Octavius takes place. To design this important location, the artistic team were inspired by real-life tech spaces such as the Jet Propulsion Lab in Pasadena and various NASA facilities. "Much like the character reveal of Dr. Octavius, I wanted the location to have a modern façade of altruism, while its true intentions are deeply sinister," says vis dev artist Patrick O'Keefe. "I used a mixture of highly reflective material to parallel the Multiverse aspects of Doc's research. The main research lab was designed as a very high-tech playground for our characters."

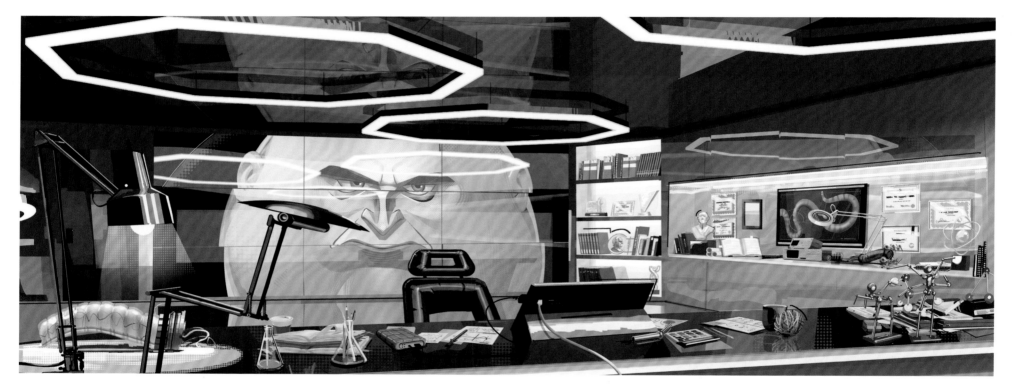

THIS AND NEXT SPREAD: Paintings of Doc Ock's lab by Patrick O'Keefe.

94

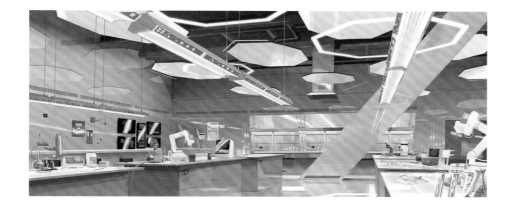

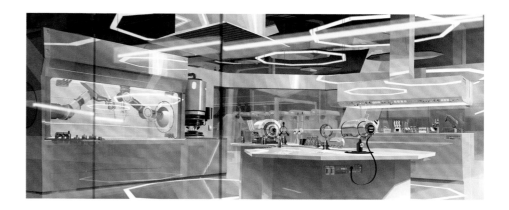

Cold and sanitized—those are the words production designer Justin K. Thompson uses to describe the labs. "A lot of times in science fiction movies, there is a tendency to go super high-tech, but we wanted to be believable as well," he says. "You have to believe that this is a place where scientists can actually do their work. When Spider-Man and Miles are walking through the lab, we wanted to emphasize the reflective surfaces. It's a subtle hall of mirrors effect. There's also a green tint to the space because we chose green to be the color of evil, discomfort, and apprehension in our film. It's our way of cuing the audience that bad things are about to happen."

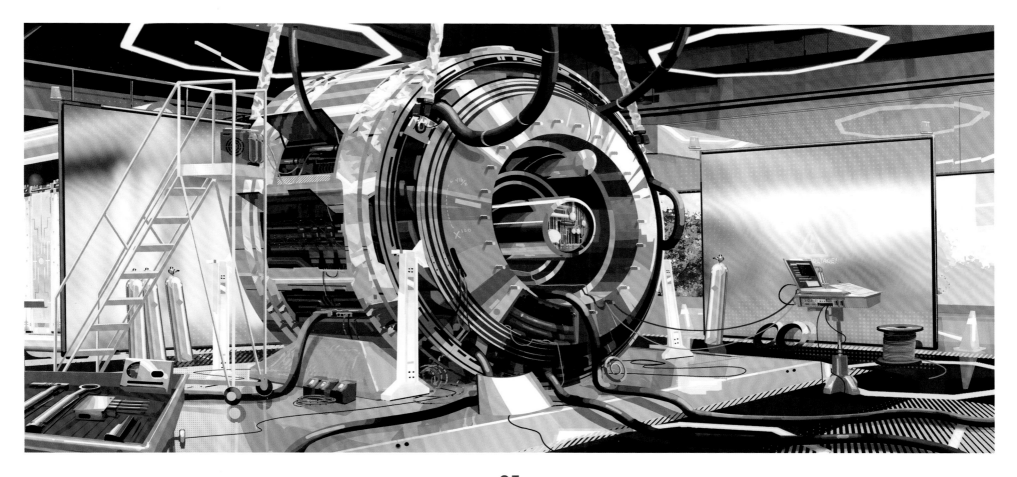

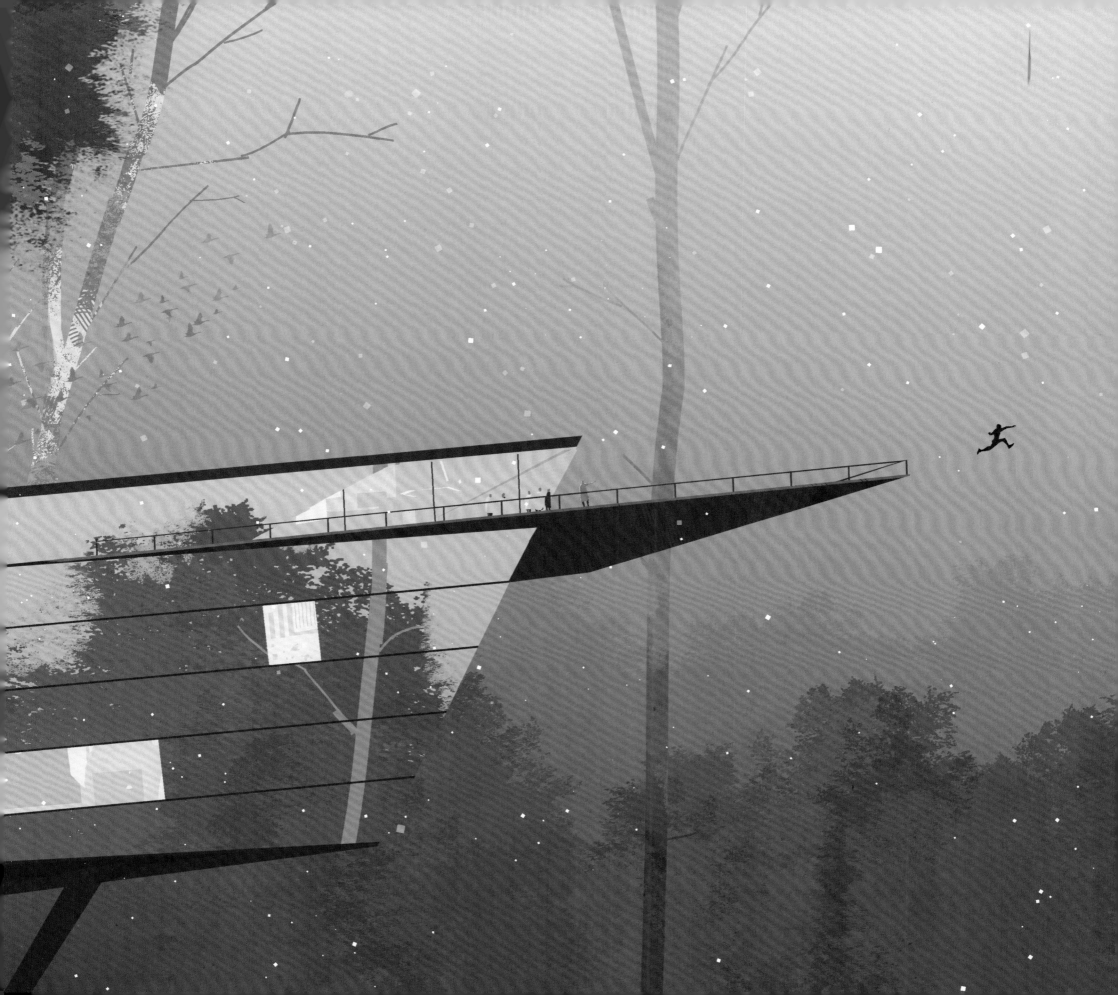

"At some point, you are watching this classic Spider-Man movie through the eyes of one of the characters standing on the sidelines. It's great to have this fresh perspective of someone looking at the sequence from a hundred yards away."

Chris Miller, *Executive Producer*

ABOVE AND RIGHT: Concept art by Robh Ruppel developing the style of Doc Ock's lab.
NEXT SPREAD: Painting by Patrick O'Keefe.

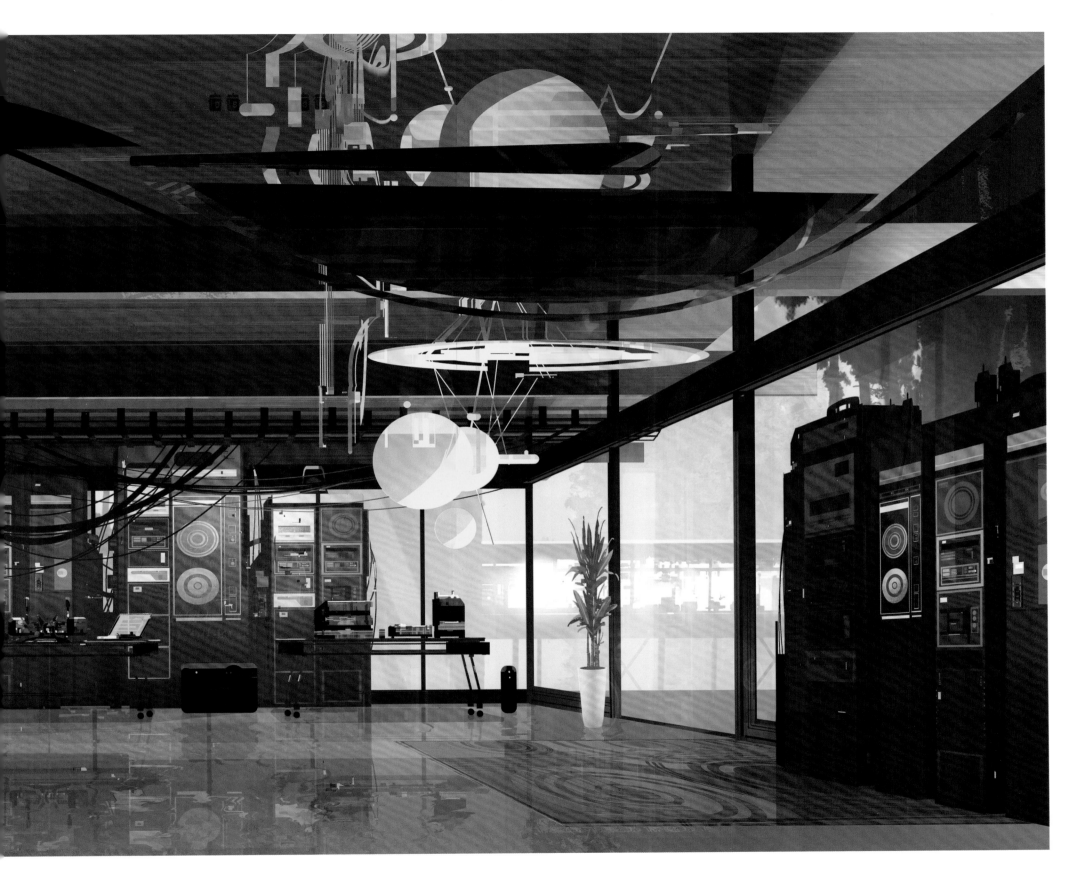

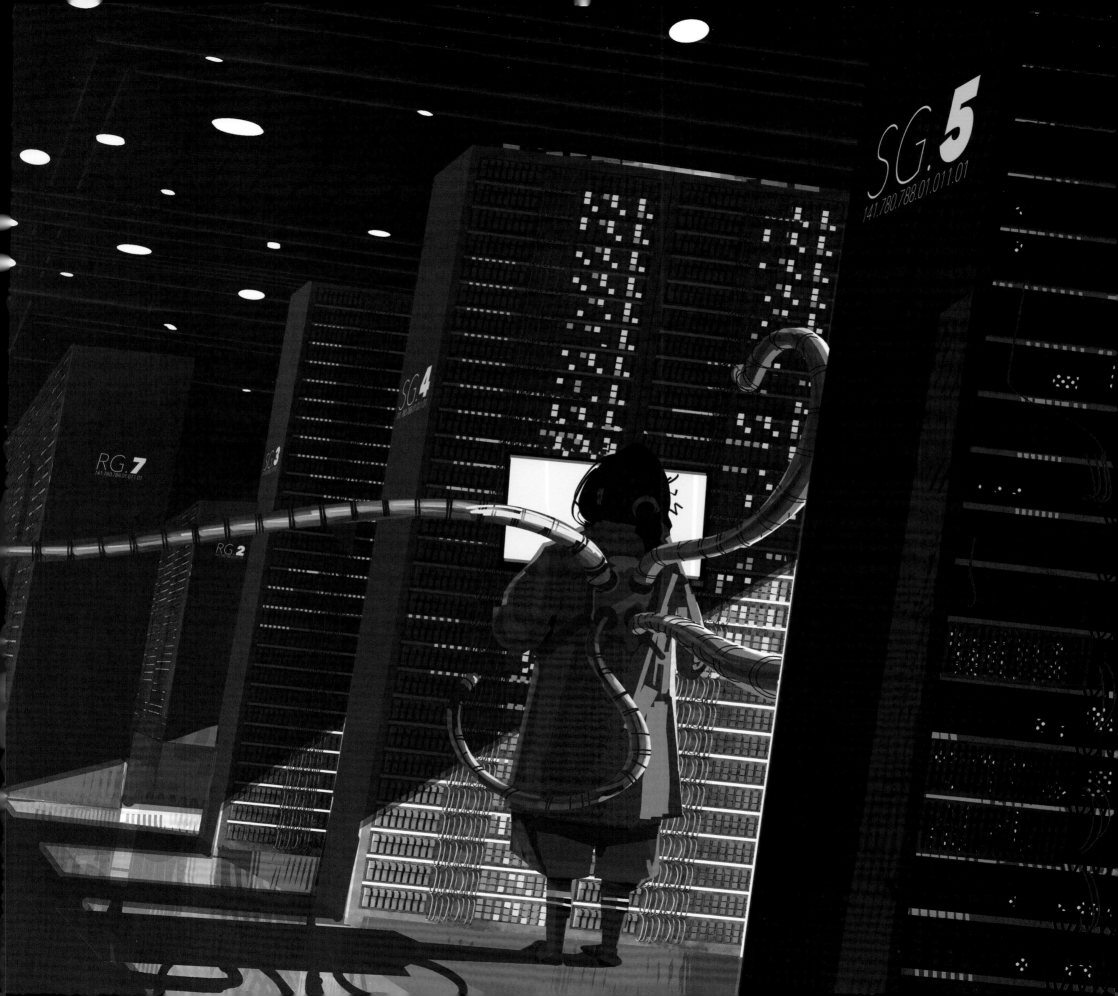

Doctor Octopus is the archetypal mad scientist who first appeared in *The Amazing Spider-Man* comic book in July of 1963. Fans of the live-action Spider-Man movies will remember Doc Ock as portrayed by Alfred Molina in the 2004 movie *Spider-Man 2*. The Doc Ock we see in this movie is something entirely new and original—a super intelligent and ambitious woman who is blinded by the possibilities of science.

Character designer Shiyoon Kim recalls that from the start Chris Miller and Phil Lord wanted her to look and feel like a regular scientist. The creative team took a page from *Particle Fever*, the celebrated documentary which looked at the experimental physicists who worked at the Large Hadron Collider in Switzerland. "They wanted to convey the authenticity of these scientists who are so passionate about science that it can sometimes outweigh their ethics," says Kim. "They pushed us to look at real scientists to duplicate that same visual."

Production designer Justin K. Thompson adds, "When you look at real experimental, cutting edge science you'll see that most of the early prototypes aren't actually that slick. The technology isn't covered up with slick plastic and doesn't look like an iPod. We wanted Doc Ock's world to feel cold, sanitized, utilitarian, and experimental, which gives everything a heightened sense of eeriness for an animated movie."

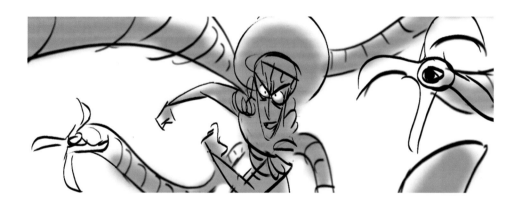

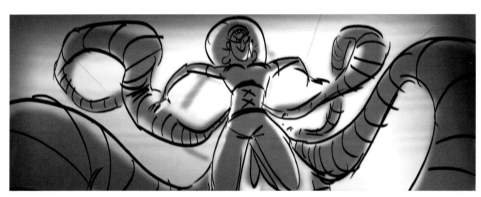

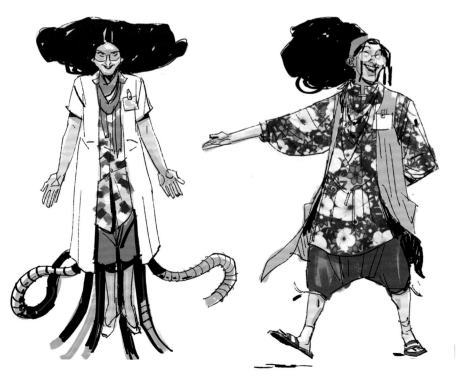

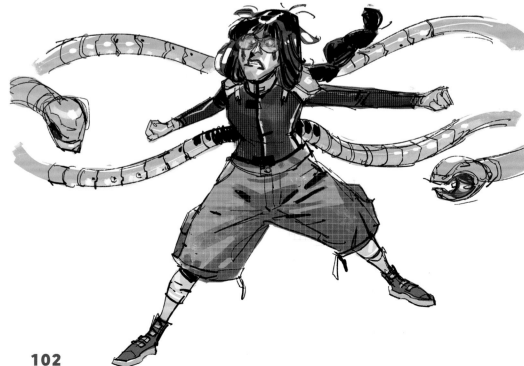

Thompson and the visual development artists came up with new ways to depict the villainess' tentacles, using synthetic semi-transparent silicon material that expands and contracts like membranes. "We didn't want her to wear anything slick or revealing. Instead, we wanted the audience to be genuinely disturbed by how unrefined she seems. Her costume feels like something that hasn't been finished," says the production designer. "She is overly excited about the Multiverse and isn't really aware of how crazy she looks. She has wild hair with purple highlights. And I really wanted her organic, slimy tentacles to freak the audience out when they slide across Spider-Man's face. She's creepy and intimidating and she stands in high contrast with Spider-Man who is just a guy in tights."

PREVIOUS PAGE: Story art by Eva Bruschi. Concept art by Jesús Alonso Iglesias.
THIS PAGE: 2D design by Shiyoon Kim, 3D design by Omar Smith, and paint by Wendell Dalit.

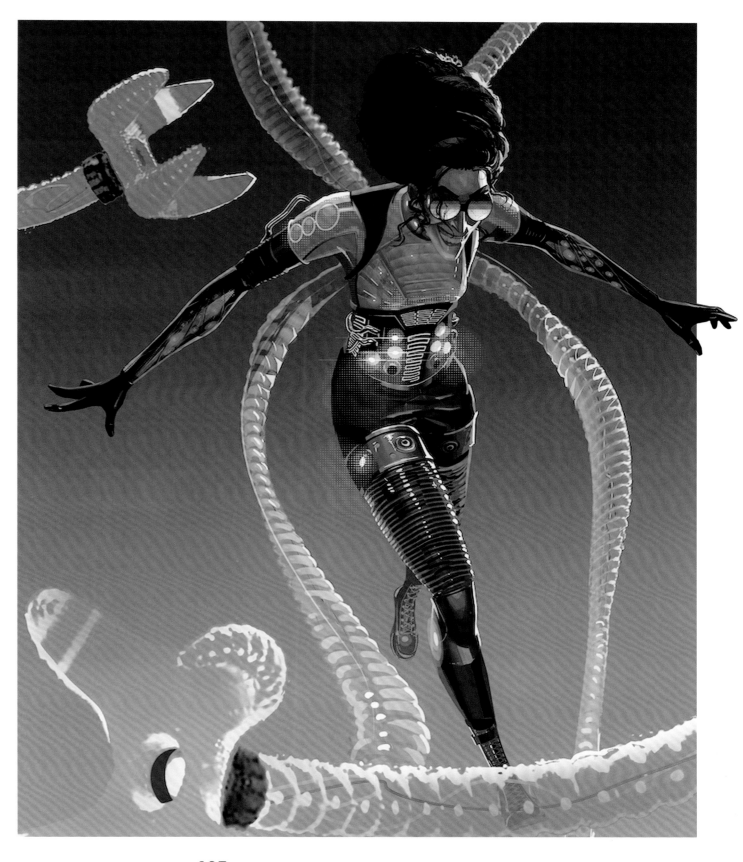

The Art of Spider-Man: Into the Spider-Verse

The creative team for the movie were searching for ways to give Spider-Man new experiences and put him in fresh, new locations. Since the audiences had seen Peter Parker swinging from skyscrapers and jumping on subway trains before, the new movie takes Miles and Peter to the Hudson Valley Forest in upstate New York, a beautiful new location, filled with the orange and red-colored leaves in the fall.

"Phil and Chris were looking for an organic way to get Spider-Man out of the city," recalls Justin K. Thompson. "We wanted to see him swing in the forest, and what better way to take him to the beautiful high-tech lab, nestled in the hills of the Hudson Valley. This is also where we revealed Spider-Gwen to the audience for the first time as well."

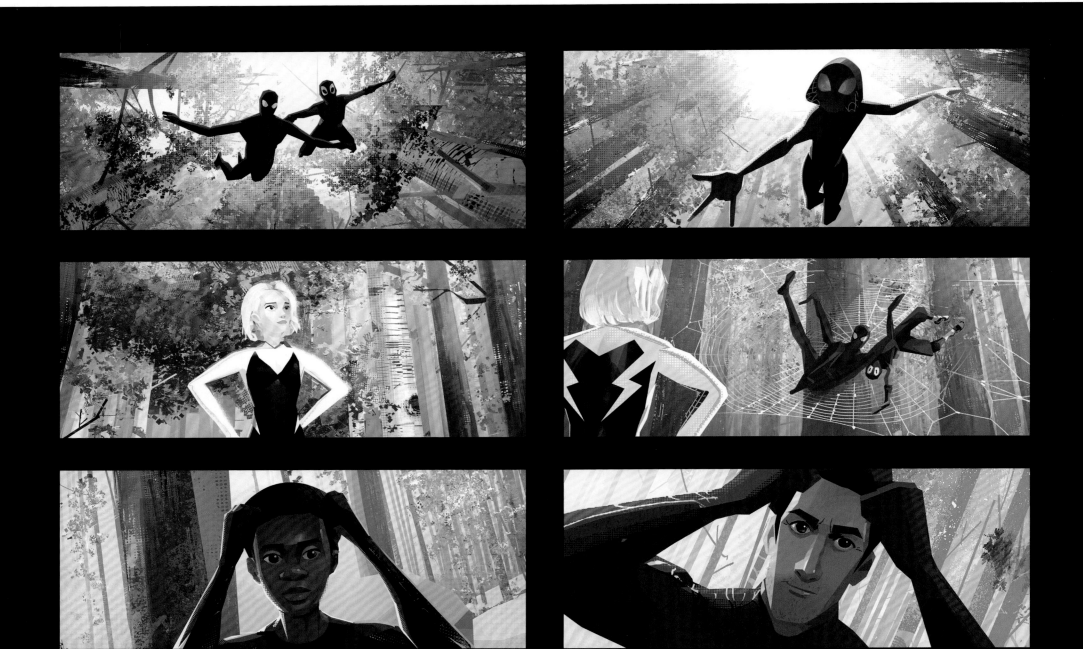

PREVIOUS PAGE: Artwork by Wendell Dalit. THIS PAGE: Artwork by Patrick O'Keefe.

Artist Patrick O'Keefe points out that it was decided to triple the size of the trees, while keeping it as graphic as possible. "As with most sets in the film, it was always about seeing how far we could reduce the world around us and how much we could get away with," he notes.

"Many of the tree limbs are disconnected, and most of the foliage is still floating. I was very inspired by Bill Watterson's forest from the *Calvin and Hobbes* strip. There is a clustering of shapes and details that describe the whole forest as a single vignette."

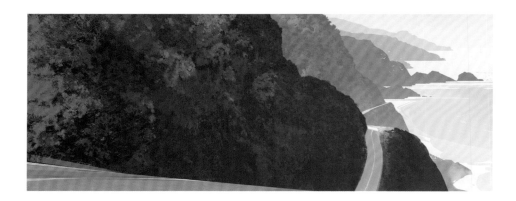 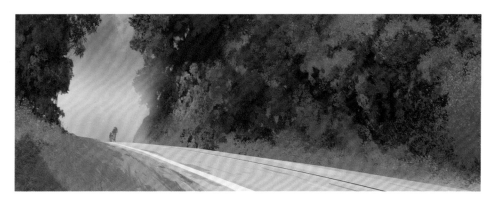

THIS SPREAD: Concepts for the Spider-Men's trip out of the city by Neil Ross and Mike Winkelmann.

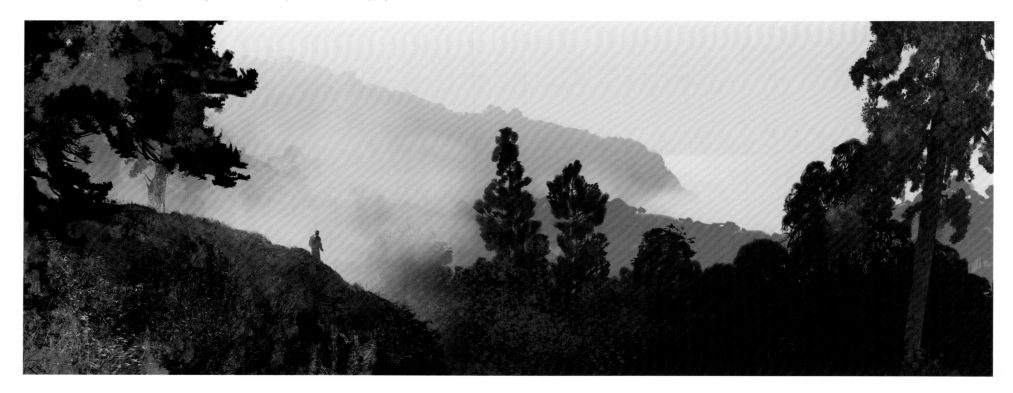

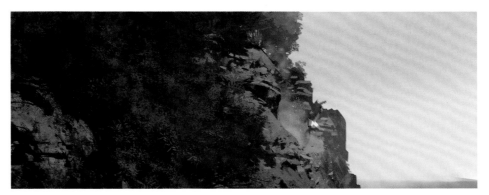

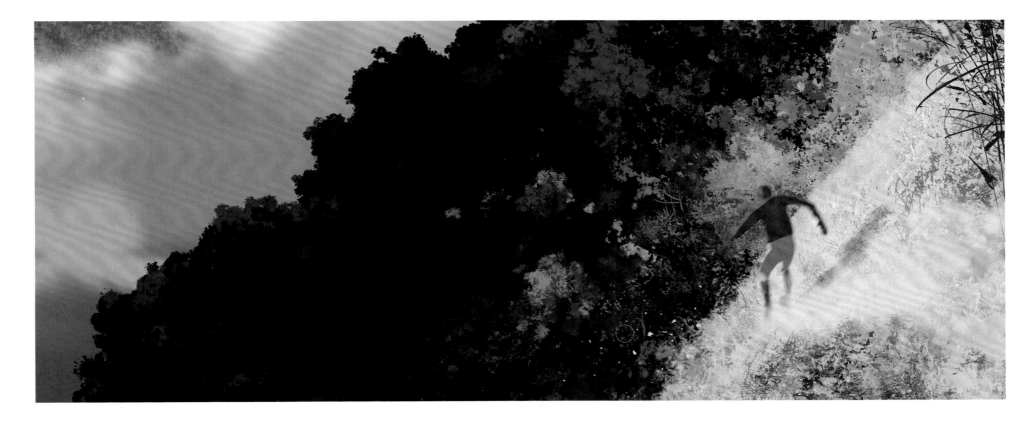

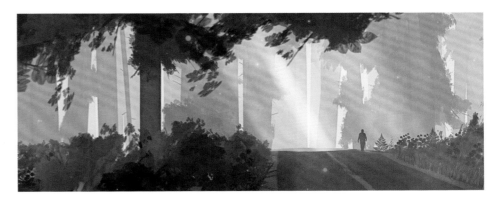

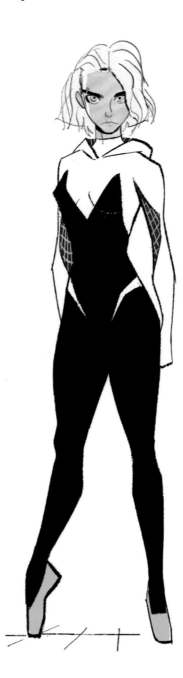

Bright, extremely athletic and at the top of her game, Spider-Gwen is seen by many as the most reliable and capable of all the Spider-characters in the movie. "Nobody is cooler than Spider-Gwen," says Kristine Belson, president of Sony Pictures Animation. "She is such a bad-ass. She is a tough fighter, but she also has this costume that makes her look genuinely feminine, which culminates in these elegant pointe shoes. It's like martial artist meets ballet dancer style. She is remarkably graceful, but you also don't ever want to mess with her. Her costume reflects that duality—this great mix of elegance and forceful spirit."

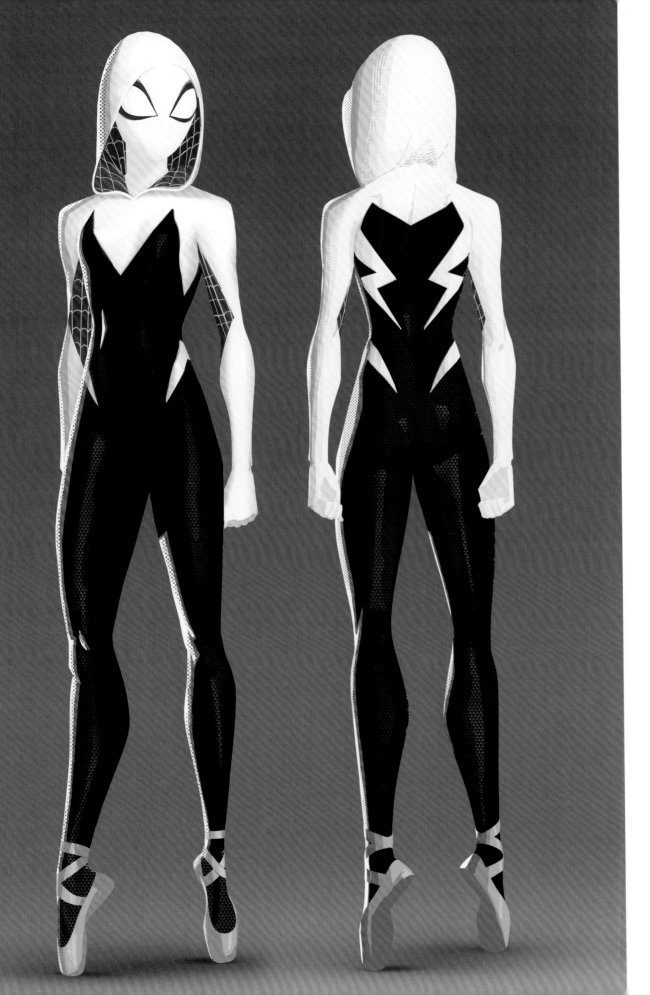

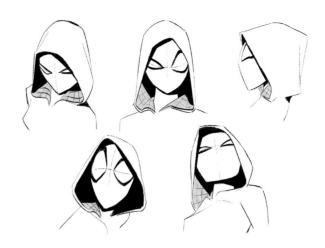

PREVIOUS PAGE: Early concept by Shiyoon Kim.
LEFT: 2D design by Shiyoon Kim, 3D design by Omar Smith, and paint by Naveen Selvanathan.
ABOVE AND BELOW: Art by Shiyoon Kim and Justin K. Thompson.

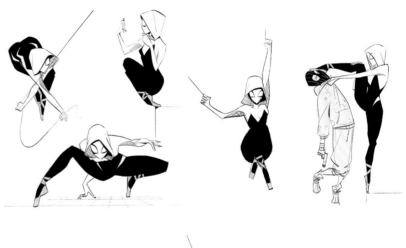

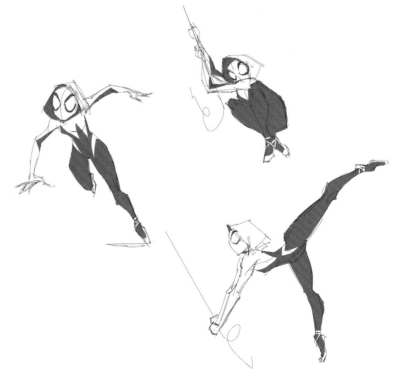

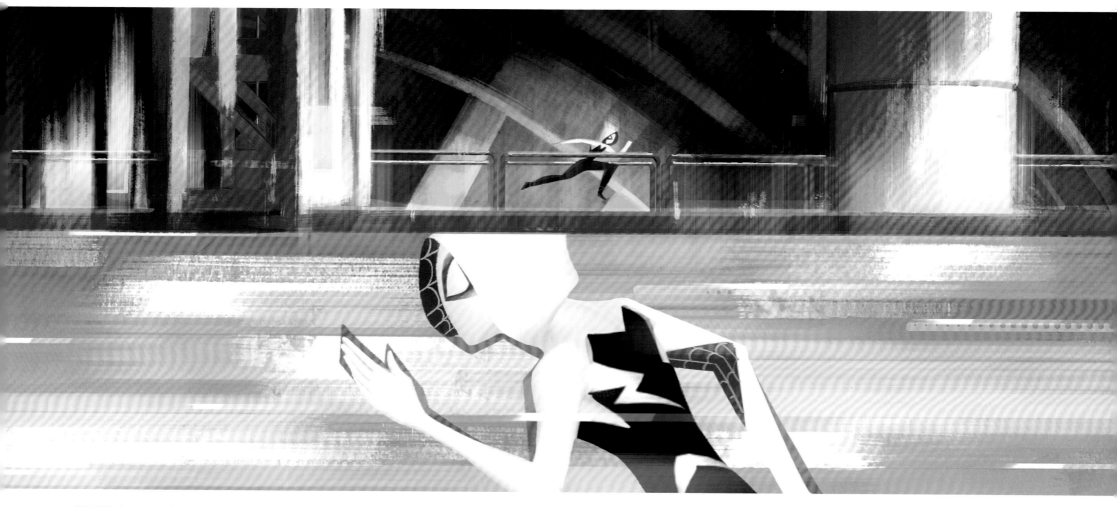

ABOVE: Concept design by Joey Chou. **BELOW:** Facial expression development by Shiyoon Kim.
NEXT PAGE: Artwork by Alberto Mielgo.

Character designer Shiyoon Kim recalls doing the initial sketches for the character. "She is pretty awesome, and we had a great sculpt done based on the sketches by Andrea Blasich and vis dev artist Omar Smith created the final design," notes Kim. "The final rendition looked really appealing and very different from your typical animated female characters. She is not just a pretty blonde girl with your typical thin princess body. We wanted her to look like a ballet dancer—tall, muscular, and powerful."

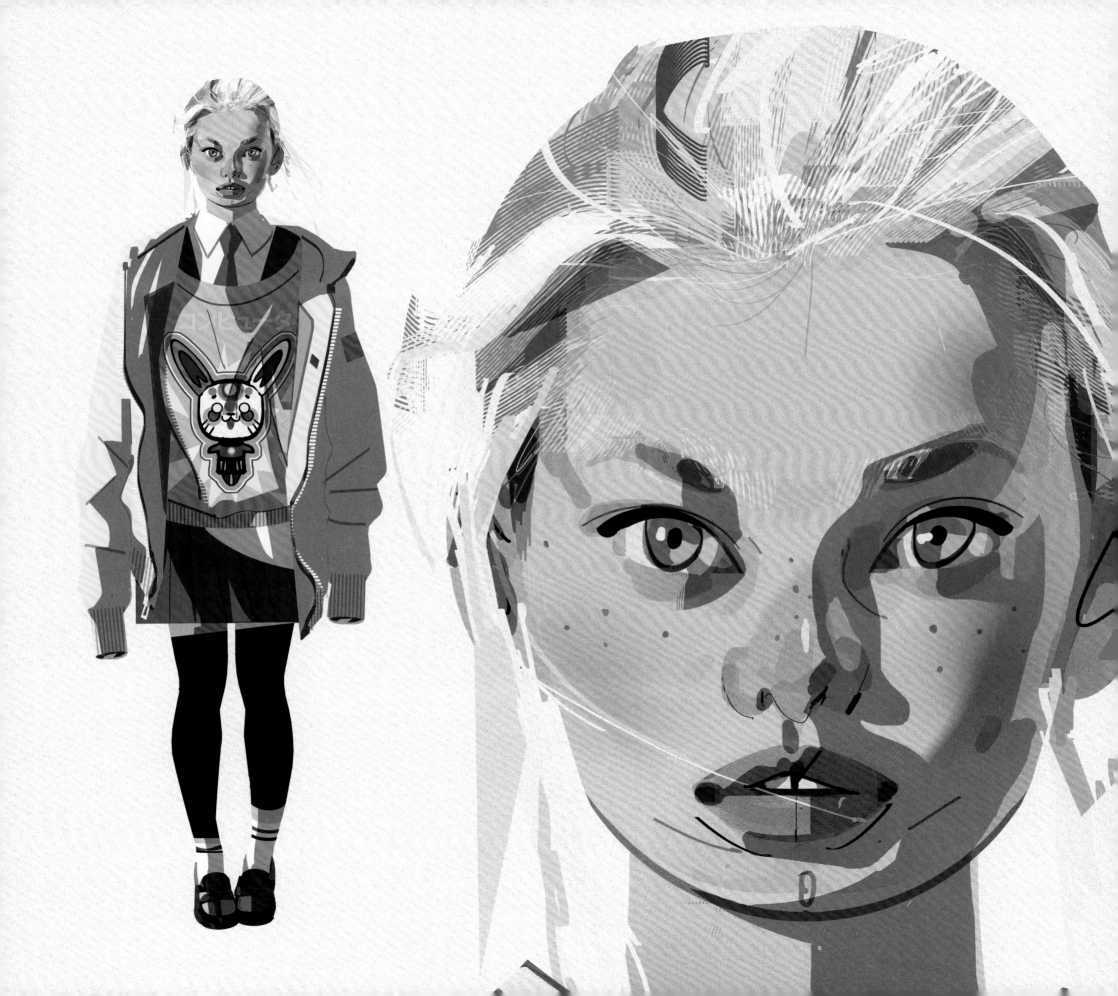

ABOVE: Sketches by Borja Mcntoro. **RIGHT:** 2D design by Shiyoon Kim, 3D design by Omar Smith, and paint by Wendell Dalit. **BELOW:** Paint by Naveen Selvanathan.

ABOVE: Character sketches by Shiyoon Kim. BELOW: Facial expression development by Borja Montoro.

SPIDER TEAM
SUIT UP

BELOW: Spidey's hideout artwork by Yuhki Demers.

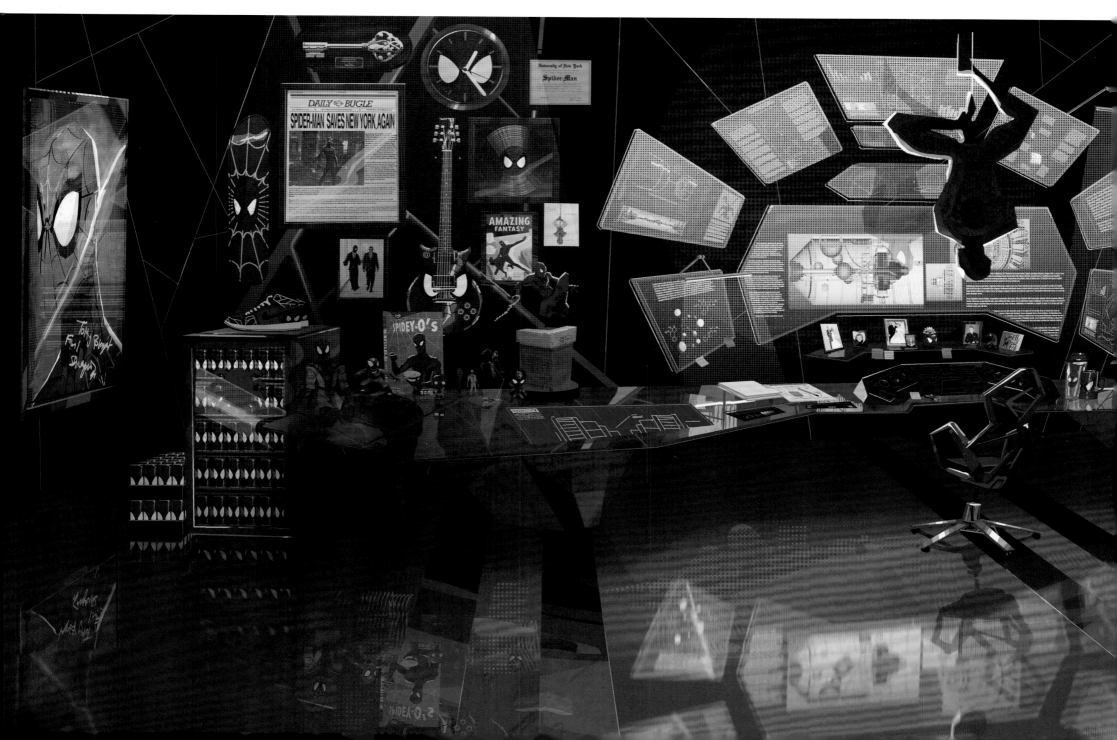

Spider Team Suit Up

What would a Spider-Man hideout look like if Peter had realized his full potential? That was the central question that led to the design of Peter Parker's lab in the movie. Artist Yuhki Demers explains, "On the surface, it paints this Peter as an arrogant, sell-out egomaniac, but when you look deeper, we notice that this path has let him become a better, near-perfect Spider-Man and it will serve to inspire the rest of the team."

To get real-life inspirations for the space, the artistic team looked at a lot of modern architecture and the workplaces of various successful people. "We tried to strike a balance between a place that's too pretty to work in and a place that actually functions," says Demers. "Here we see that beneath all the sponsored swag, this Peter had dedicated his life to keeping the city safe."

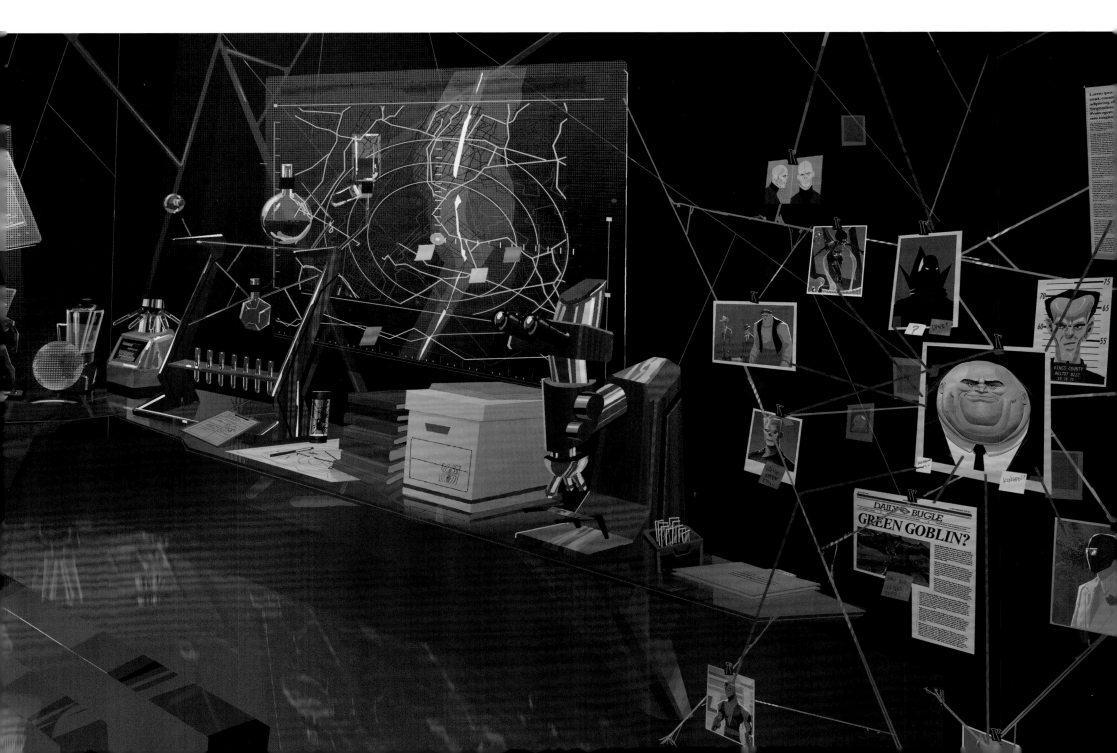

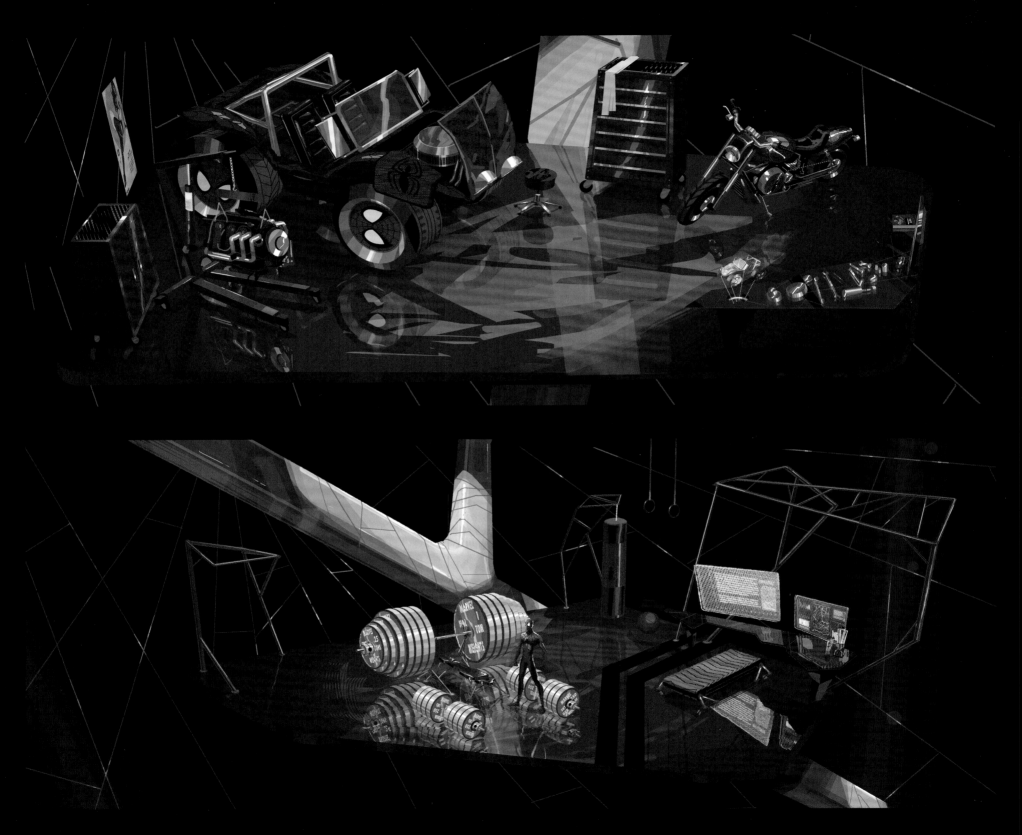

ABOVE: Paintings by Yuhki Demers.

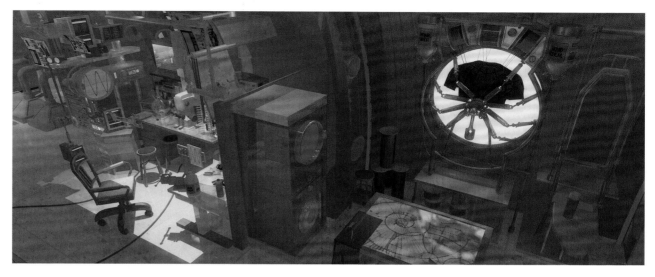

ABOVE: Spidey's hideout filled with super hero gadgets. Artwork by Ernie Rinard.

BELOW: A walk with the president, a wedding photo, mugshots, a hand-drawn thank you card, and multiple newspaper cut-outs. Artwork by Yuhki Demers.

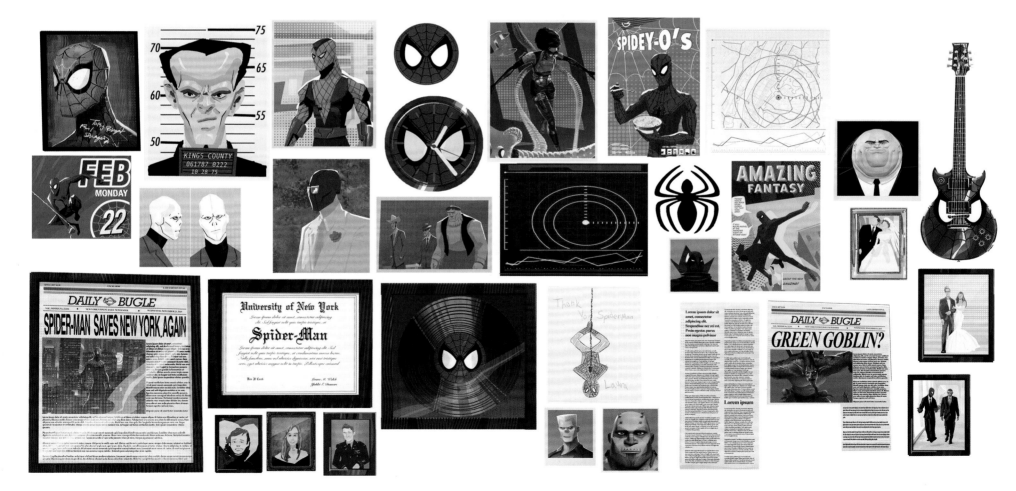

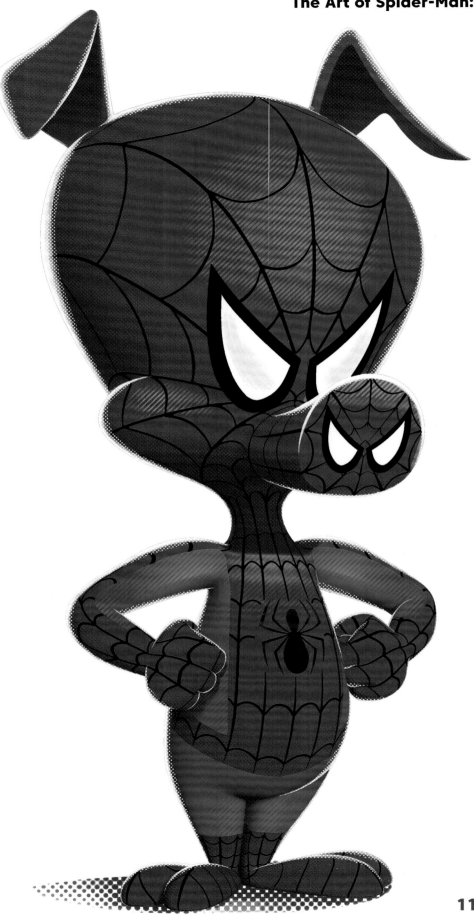

Clearly one of the wildest and funniest incarnations of the super hero, Spider-Ham was first introduced in Marvel comics by creators Tom DeFalco and Mark Armstrong in 1983. An homage to classic Looney Tunes characters, this version of the character allowed the artists to have a lot of fun with rubber-hose style animation and visuals that are loose and graphic and stand out from the other figures in Miles' universe. Spider-Ham follows the rules of his own animated universe. He can throw a black circle on a wall and climb right through it.

As producer Phil Lord points out, "We just follow the possibilities that are inherent in the concept, but we also do stuff that we're usually not allowed to. We have an anime character interacting with Spider-Ham, who is something out of a *Rocky and Bullwinkle* cartoon, next to a black-and-white character. You think to yourself, 'Wow, it feels like nobody is supervising us. We're not supposed to do this.' That level of fun and freedom gives us a lot of joy!"

"We have included a lot of line work in the characters' performances. We wanted to break up forms in a way that audiences can't quite tell whether something is 3D or not."

Josh Beveridge, *Animation Supervisor*

LEFT: 2D design by Craig Kellman, 3D design by Omar Smith, and paint by Justin K. Thompson.

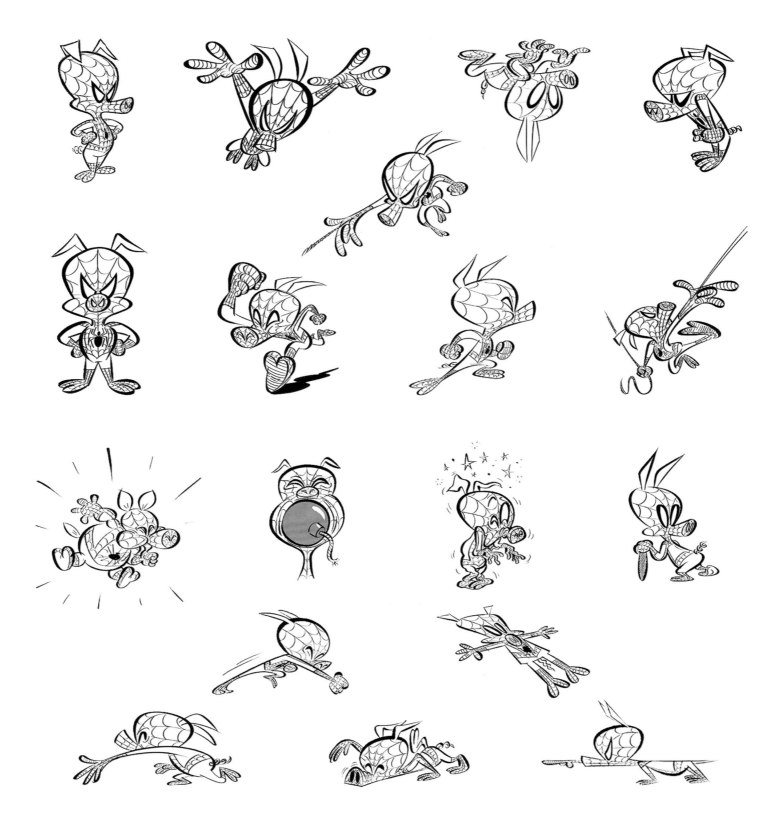

ABOVE: Character sketches by Craig Kellman.

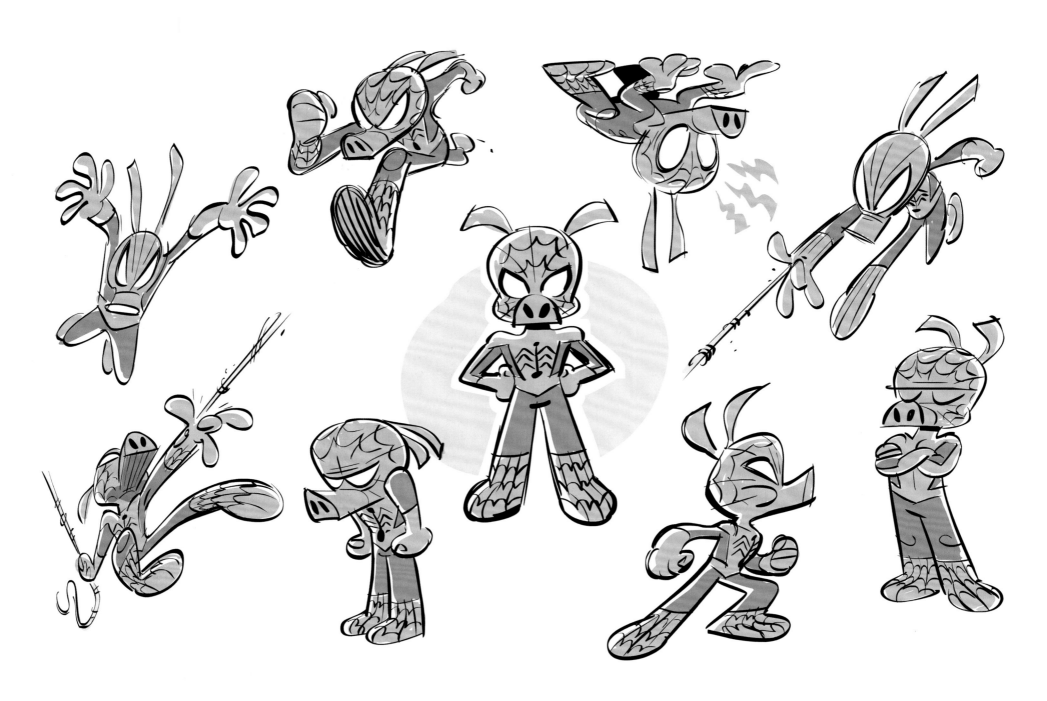

THIS SPREAD: Character sketches by Mark Ackland (above) and Jim Mahfood (right).

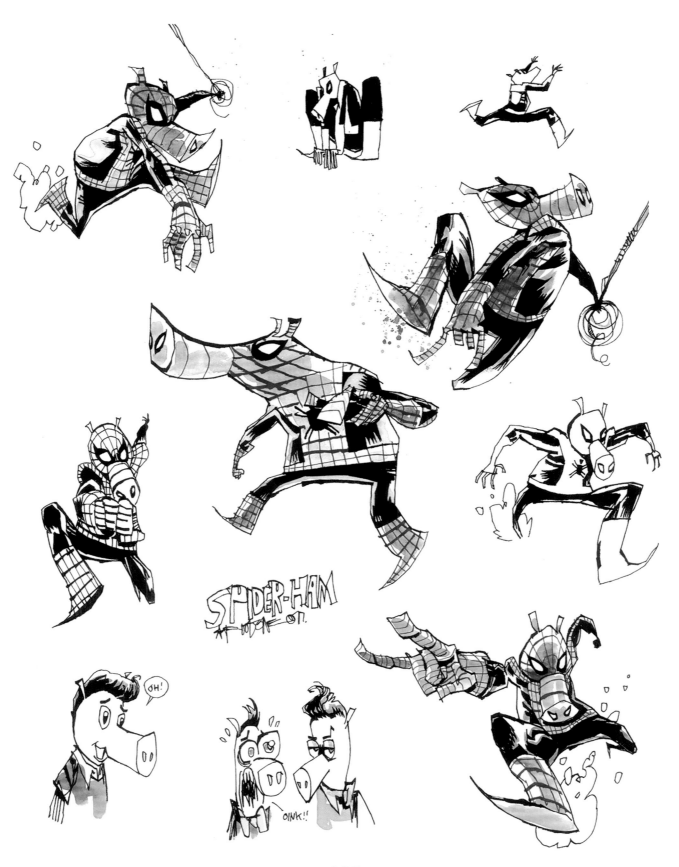

Another creative twist on the Spider-Man character, Peni Parker is a fourteen-year-old girl and pilot of a mech suit called SP//dr. The suit's head is also the home of a radioactive spider that shares a psychic link with the pilot. First introduced in Marvel's *Edge of Spider-Verse: Miniseries*, this anime-influenced version of the character is another character pulled into Miles' world thanks to Prowler and Doc Ock's experiments with the Collider.

Both familiar and of the future, SP//dr's design pays homage to the original by retaining its humanoid form. As artist Yashar Kassai explains, "He sports two new technologies: a holographic display and a magnetic levitation. SP//dr is an incredible weapon, but for Peni, he is an even better friend. Beneath his anti-ballistic alloy shell, SP//dr can also be a big softy. The display allows SP//dr to show an infinite number

of faces to convey emotions. It was important for us to be able to convey his feelings to the audience visually."

Kassai, who also worked on the early designs of Peni Parker, says he enjoyed adding a feisty Japanese girl from an anime universe to the mix. "One of design's greatest pleasures is stark contrast," he points out. "From her look to her behavior, Peni is anime through and through. To see her standing alongside Miles creates the kind of variety the film embraces. She's two-toned and outfitted in a modern-day school uniform. Because she comes from the thirtieth century, her clothing is made of fabrics from the future. The shirt has a technological sheen, the sweater is laced with reflective components, and the outfit is detailed with luminescent accents throughout. As for the backpack...well, it's just very cute."

ABOVE: Character sketches by Jesús Alonso Iglesias showing the final design for both Peni and SP//dr.

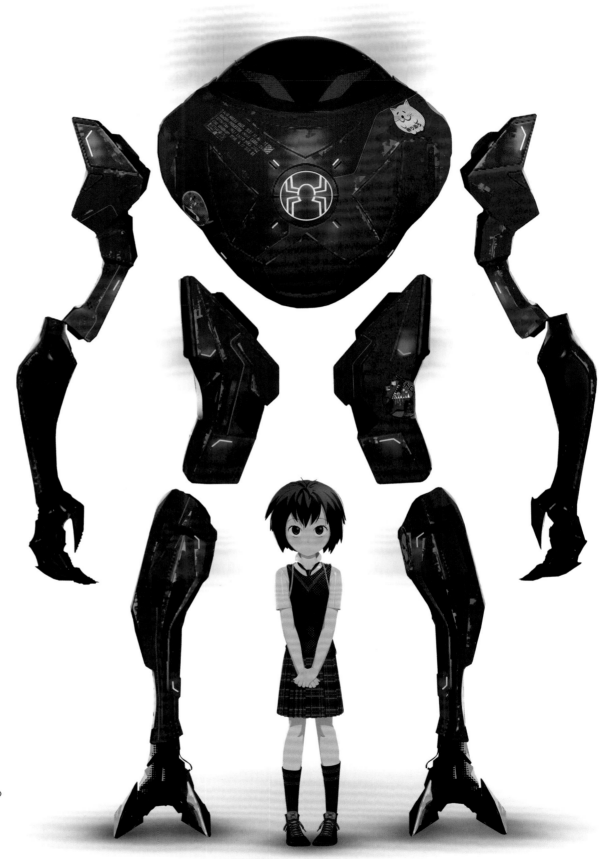

ABOVE: Concept sketches of SP//dr by Yashar Kassai and Tony Siruno (top), and story art by Paul Watling (bottom).
RIGHT: SP//dr 2D design and paint by Yashar Kassai.
Peni 3D design by Omar Smith and paint by Yashar Kassai.

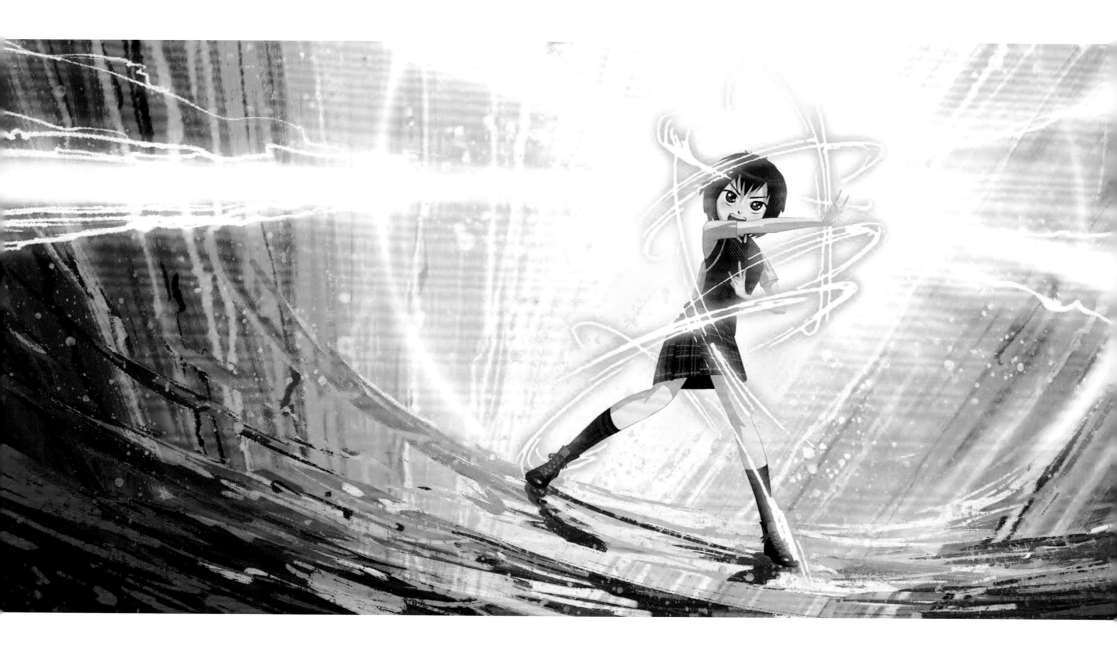

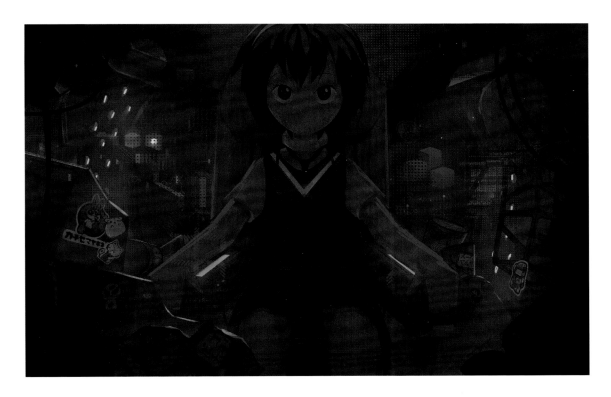

LEFT: Concept by Paul Lassaine.
RIGHT: 3D design by Omar Smith and paint by Yashar Kassai.
BELOW: Artwork by Yashar Kassai.
BOTTOM: Early facial expression concepts by Shiyoon Kim.

Created by David Hine, Fabrice Sapolsky, and Carmine Di Giandomenico, Spider-Man Noir first appeared in Marvel comics in 2009. Modeled after an archetypal 1930s gumshoe, he offers a darker take on the all-American, optimistic Peter Parker character. In the movie, he is one of the alternative universe characters that is pulled into Miles' world because of the Collider's ripping of the space-time continuum.

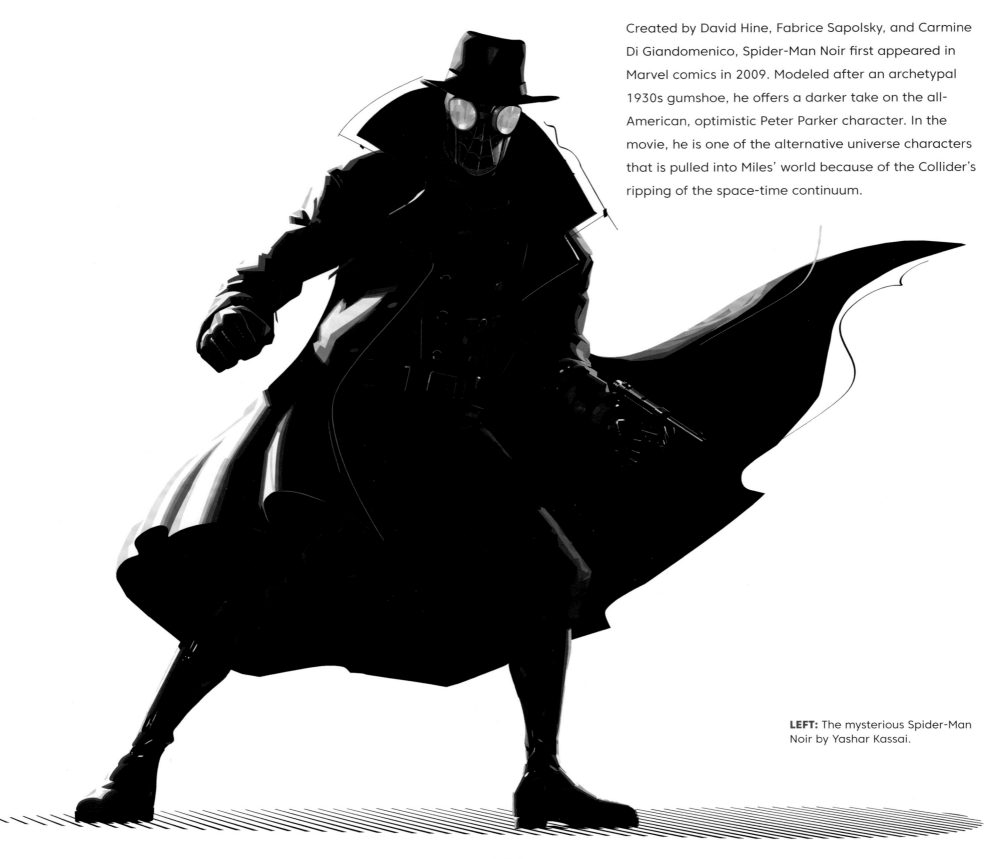

LEFT: The mysterious Spider-Man Noir by Yashar Kassai.

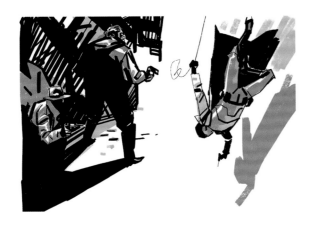
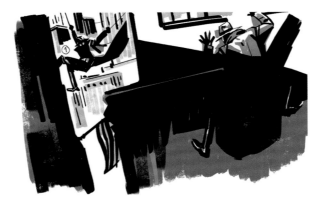

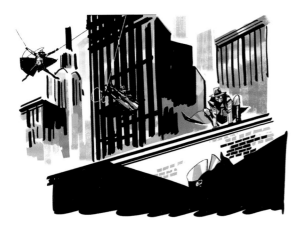
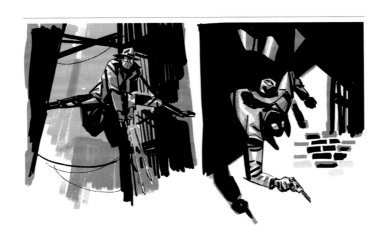
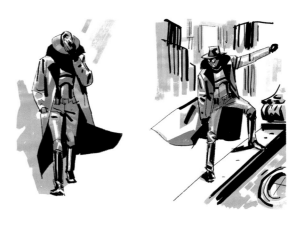
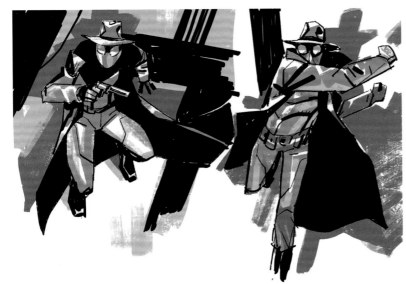

ABOVE: Action concepts of this vintage-style hero by Jesús Alonso Iglesias.

"Animation allows us to experiment with our visual depiction of this gun-wielding version of Spider-Man," says production designer Justin K. Thompson. "We depict him in gritty black-and-white, because that's the world he is coming from. There's a lot of cross-hatching [marking or shading two or more intersecting series of parallel lines] involved with Noir."

"Spider-Man Noir was one of the earliest paintings I did for this production," says development artist Wendell Dalit. "Our original idea was to have these textures that feel like an old comic book or newsprint ink."

PREVIOUS PAGE: Character concept art by Jesús Alonso Iglesias. ABOVE: Comic-style sketches by Vi-Dieu Ngyuen.

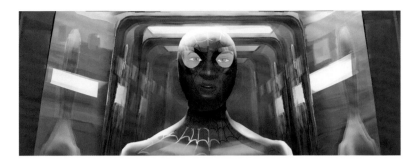

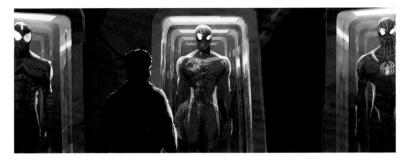

ABOVE: An intimidating moment for Miles recreated in this lighting key by Yuhki Demers. **BELOW:** Visual development paintings by Patrick O'Keefe.

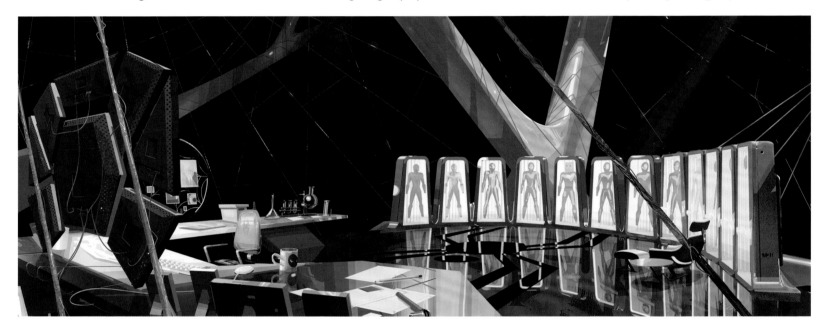

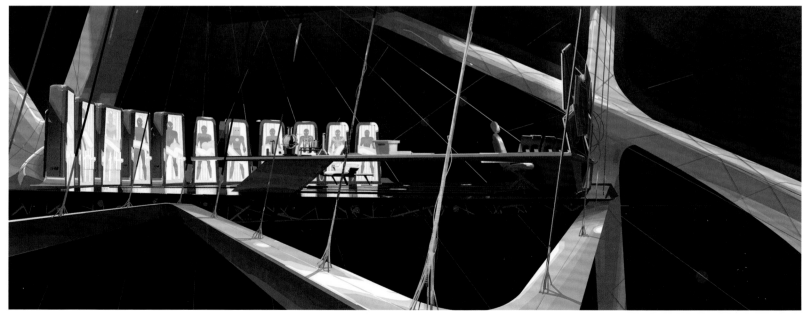

"Miles, like every incarnation of Spider-Man, is someone whose nose is pressed against the window, wanting to be part of something that they think they're not part of. That's a universal feeling for all of us."

Amy Pascal, *Producer*

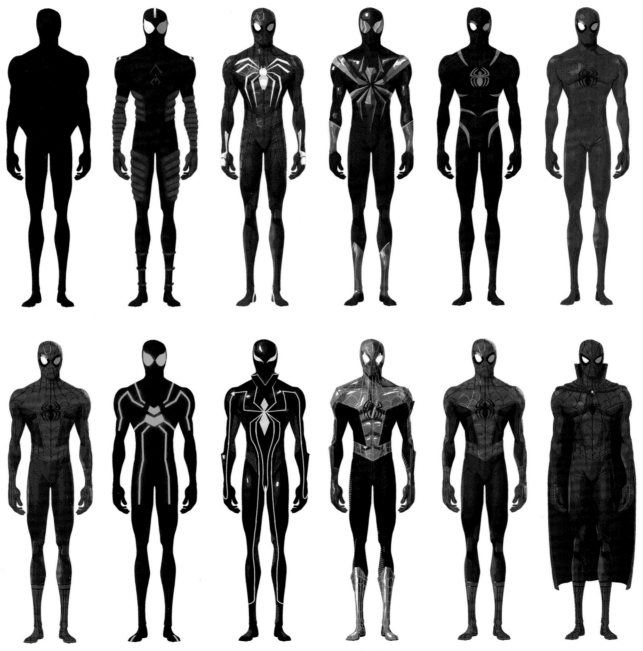

ABOVE: A variety of spidey suits by Yuhki Demers.

ON THE PROWL

"We have been able to play with light and darkness in ways that haven't been done in CG-animated movies before. It has really extended the range of what we've been able to put on the screen, especially when it comes to creating dark and graphic scenes with comic book-style lighting."

Dean Gordon, Art Director

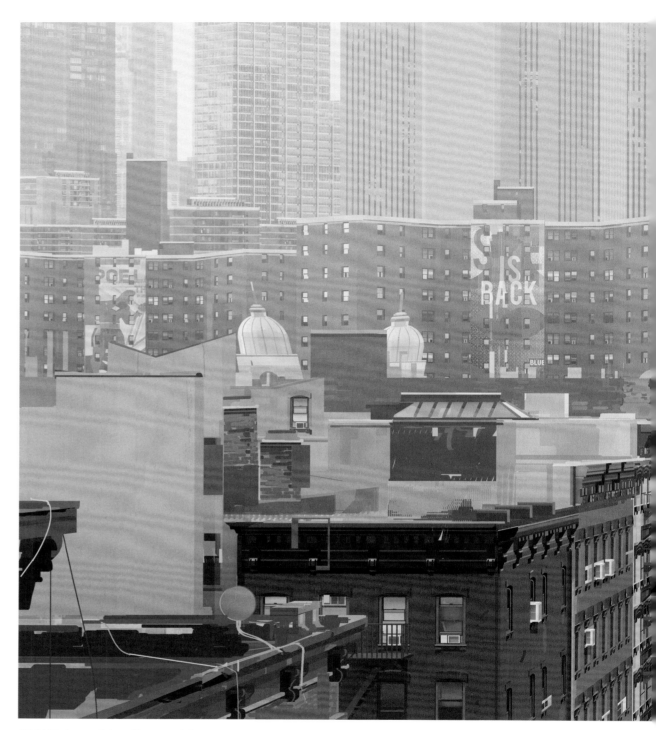

ABOVE: Artwork by Alberto Mielgo.

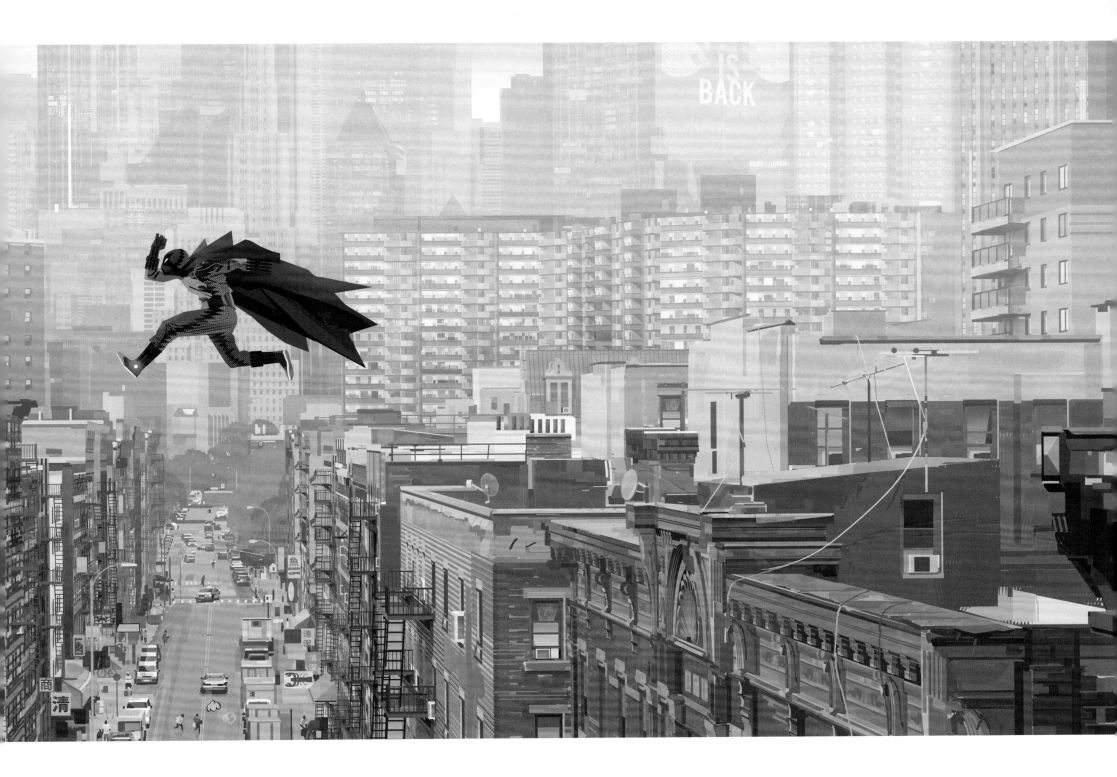

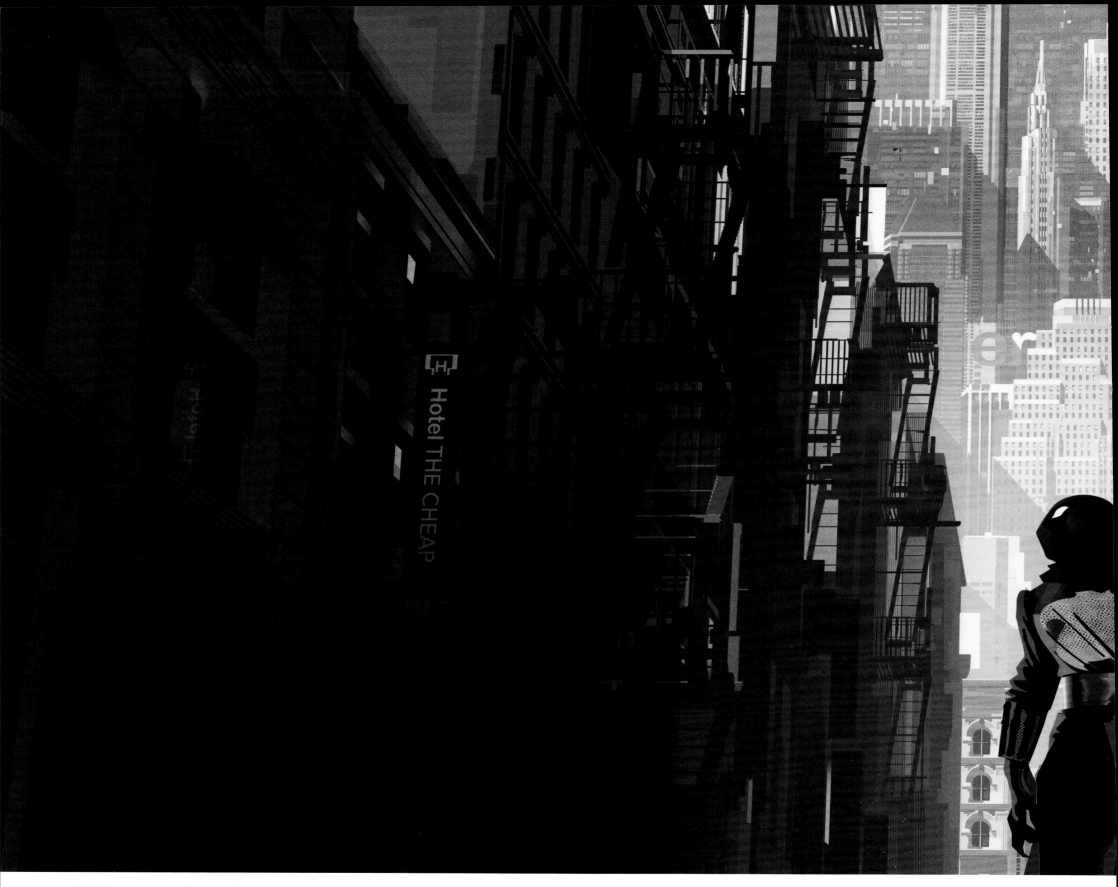

ABOVE: Painting by Alberto Mielgo.

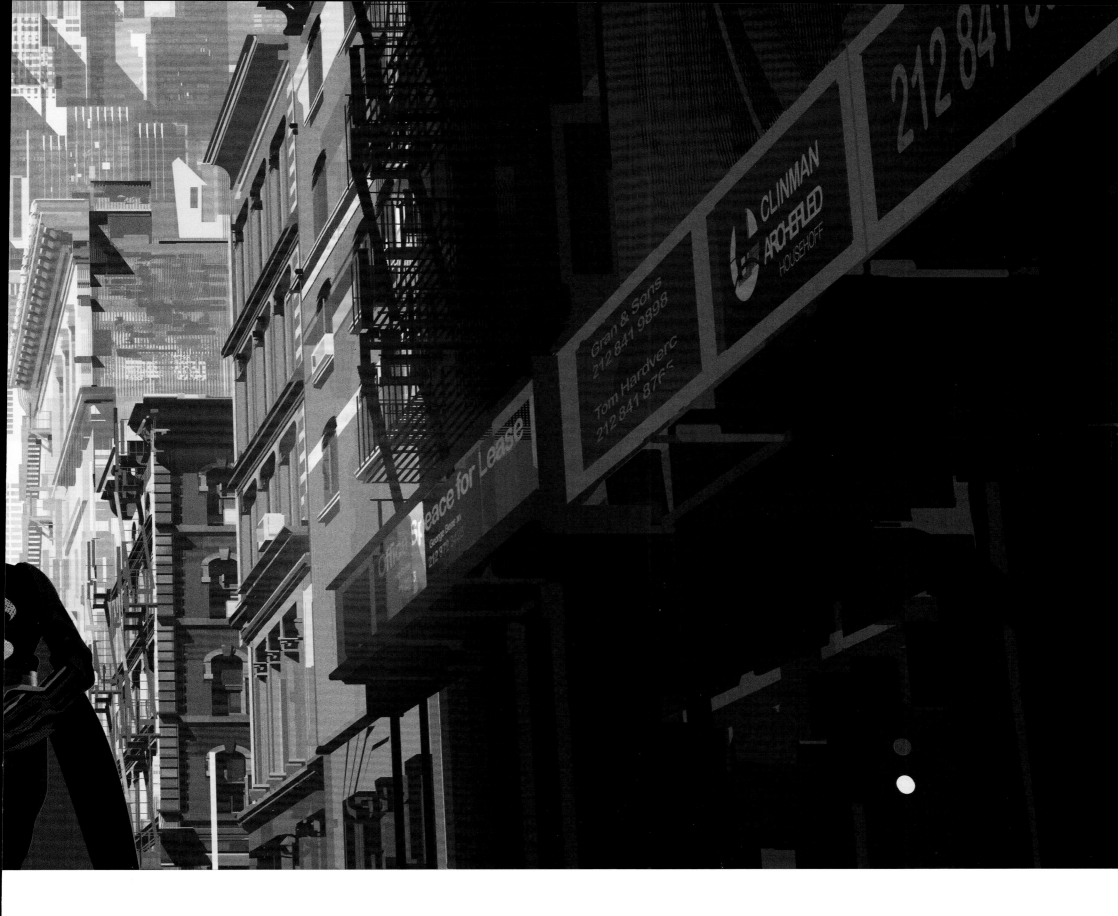

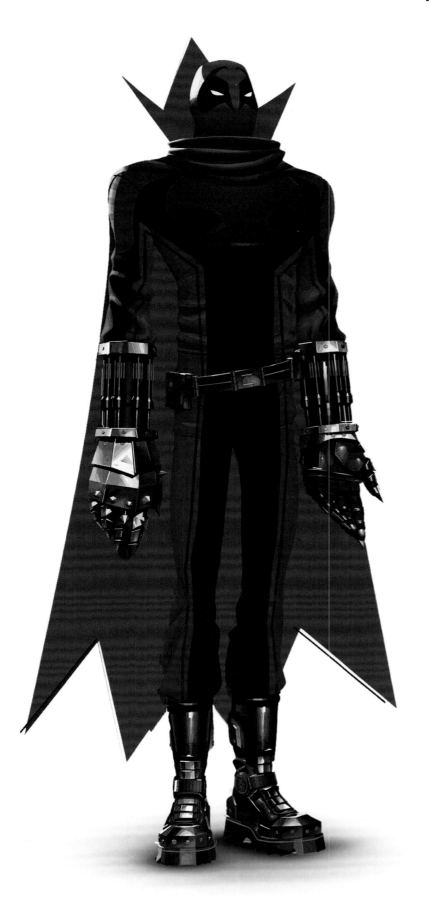

The Prowler is a tall, lanky, ultra-fit, trained assassin who is one of the Kingpin's main henchmen. Of course, the surprising reveal in the first half of the movie, is that he is Uncle Aaron's alter-ego. The designers went back to both the original Prowler costume from the Spider-Man comics as well as the Miles Morales ones, and put their own interpretation on it.

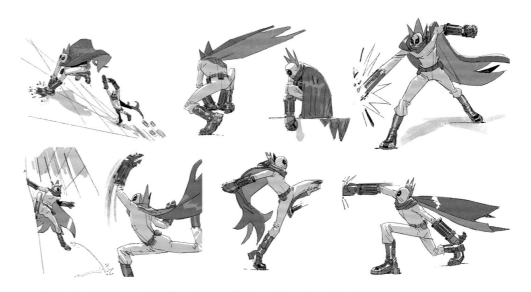

LEFT: 3D design by Omar Smith, paint by Yashar Kassai and Justin K. Thompson.
ABOVE AND BELOW: Concept sketches by Jesús Alonso Iglesias.

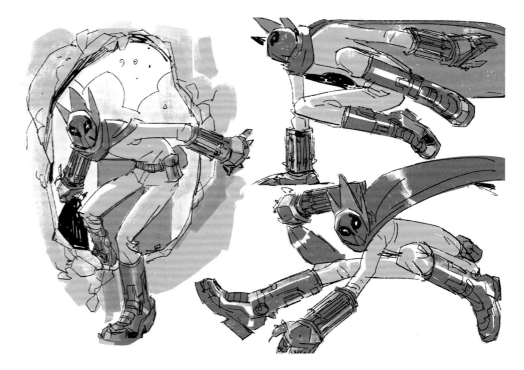

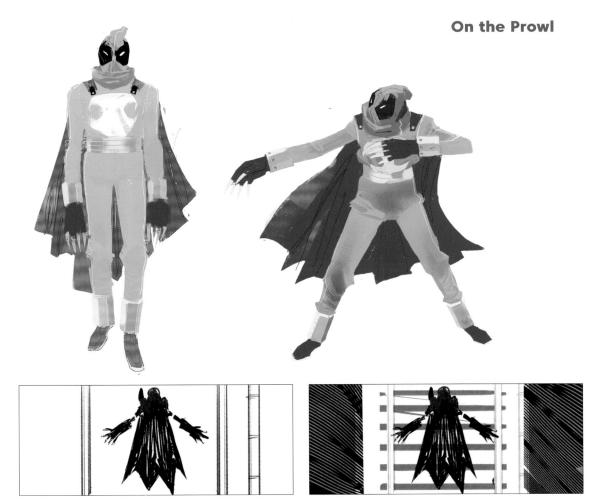

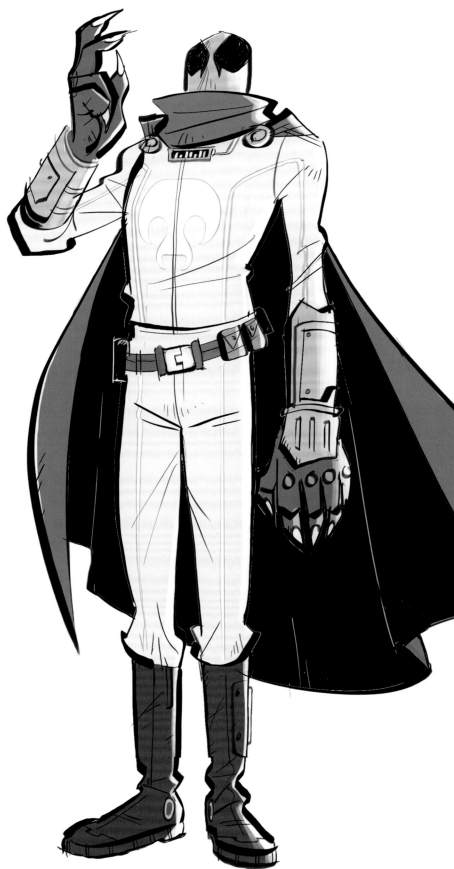

ABOVE: Color concept art by Jesús Alonso Iglesias and story art by Bob Persichetti.
RIGHT AND BELOW: Tony Siruno's concept development gets closer to the final look.

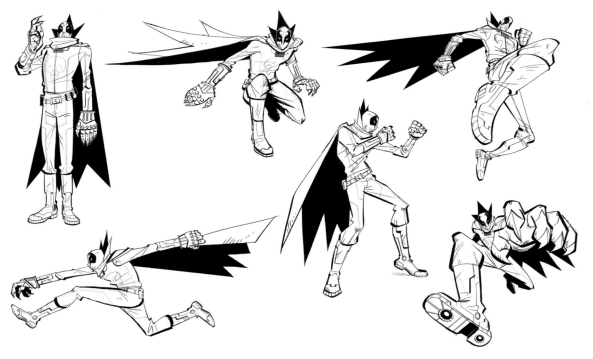

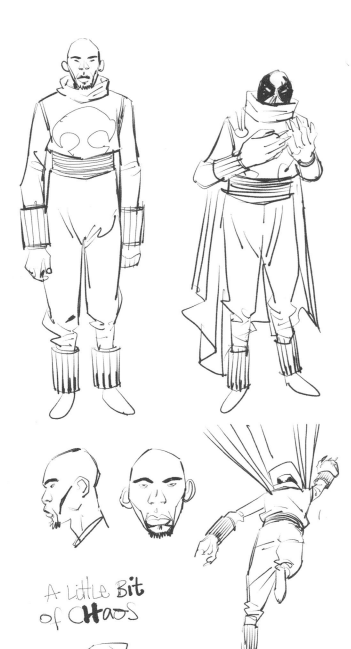

A little Bit of Chaos

"We updated it and personalized the design to fit who we thought Uncle Aaron was," says director Bob Persichetti. "He is kind of the low-fi Iron Man. Prowler has these steel claws that are like gloves, which have power punches in them. He wears pneumatic boots that give him the ability to jump really far, almost fly. He has this giant towel-like glider cape that almost seems comedic, but on him it looks quite gritty. It allowed us to represent him quite graphically in the movie in his design. We have taken out a lot of CG elements and rendered them in a flat way, so we can get a much more graphic representation, and he's one of my favorite designs in the film."

THIS PAGE: Concept art by Jesús Alonso Iglesias.
NEXT PAGE: Paint by Yashar Kassai.

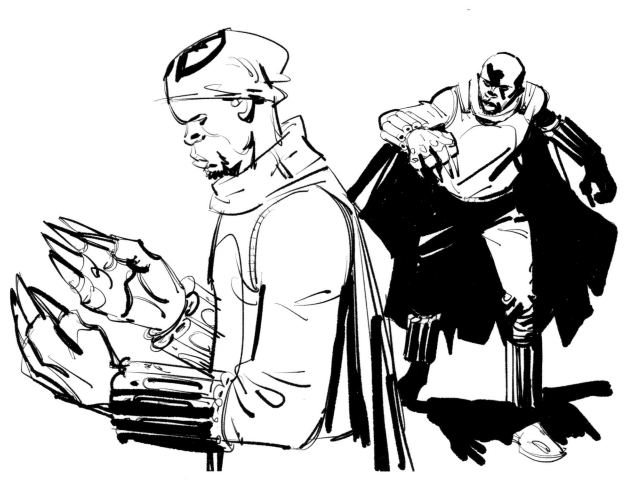

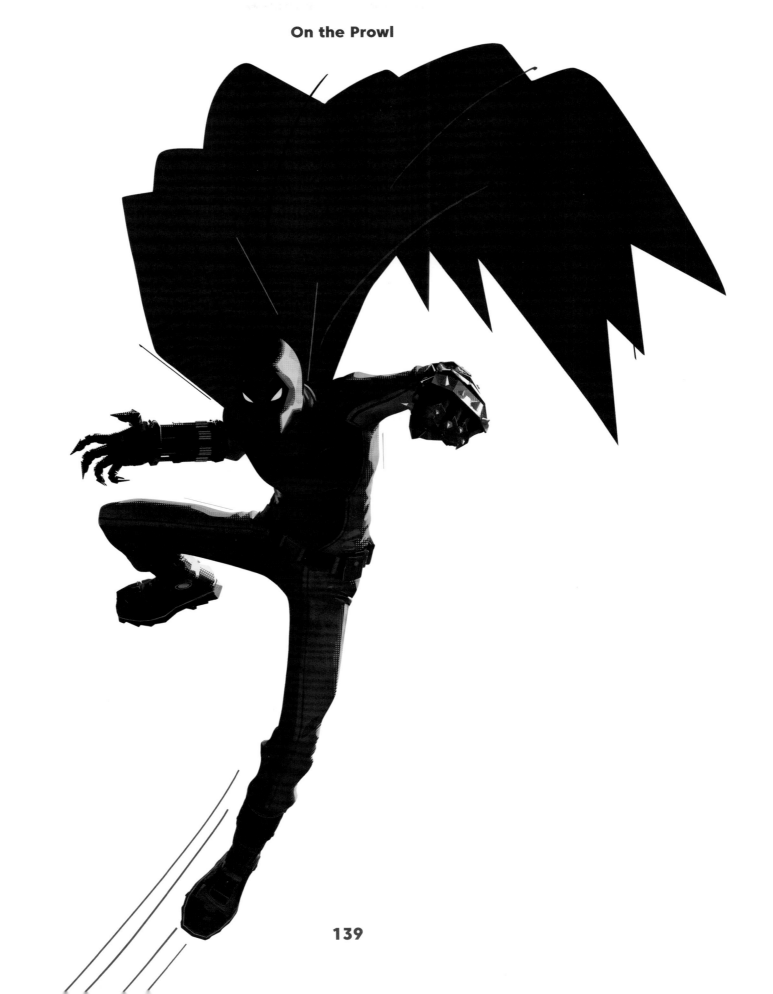

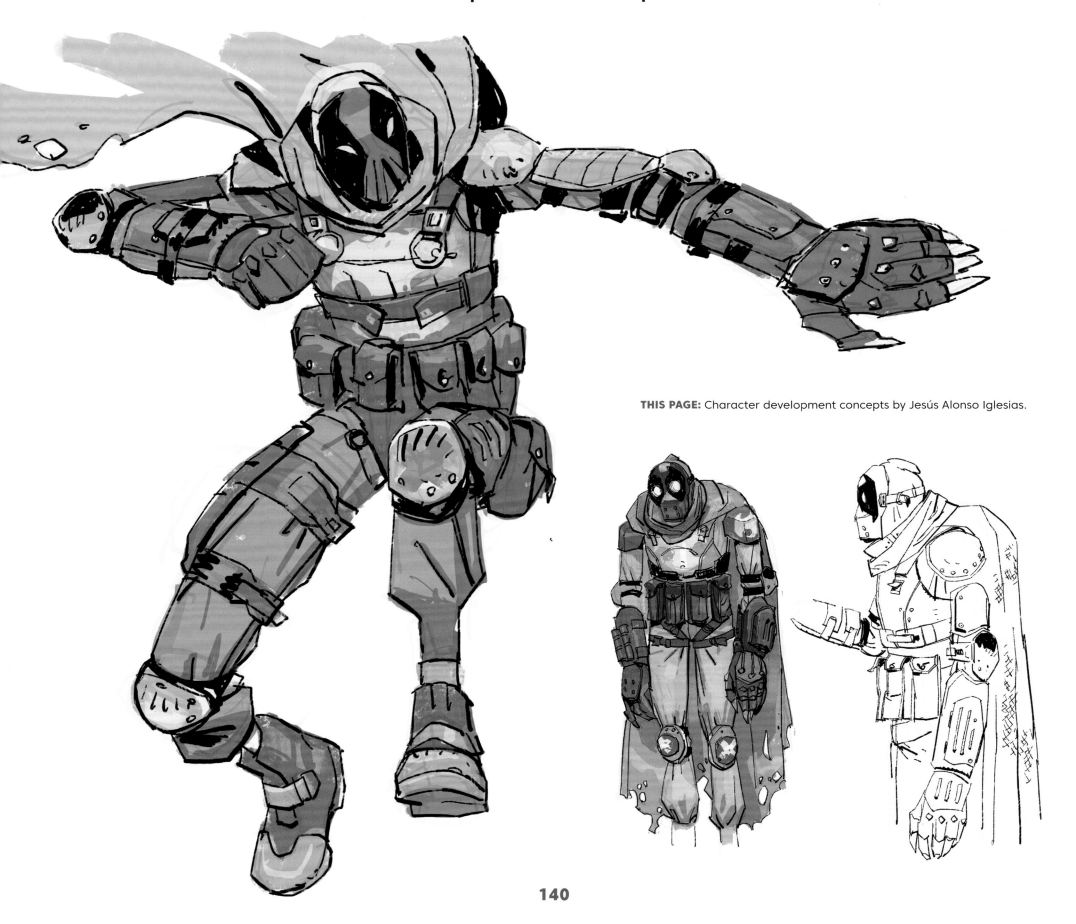

THIS PAGE: Character development concepts by Jesús Alonso Iglesias.

Prowler's motorcycle is basically a highly-modified café racer. Since Uncle Aaron is a clever gear-head, it's clear that he put this slick, light-weight, and minimalistic motorcycle together himself. "Prowler is a brilliant cat burglar who is very good at putting things together," says production designer Justin K. Thompson. "Just like his car, boots, and other gadgets, he put this racer together using found parts. It's functional and super cool."

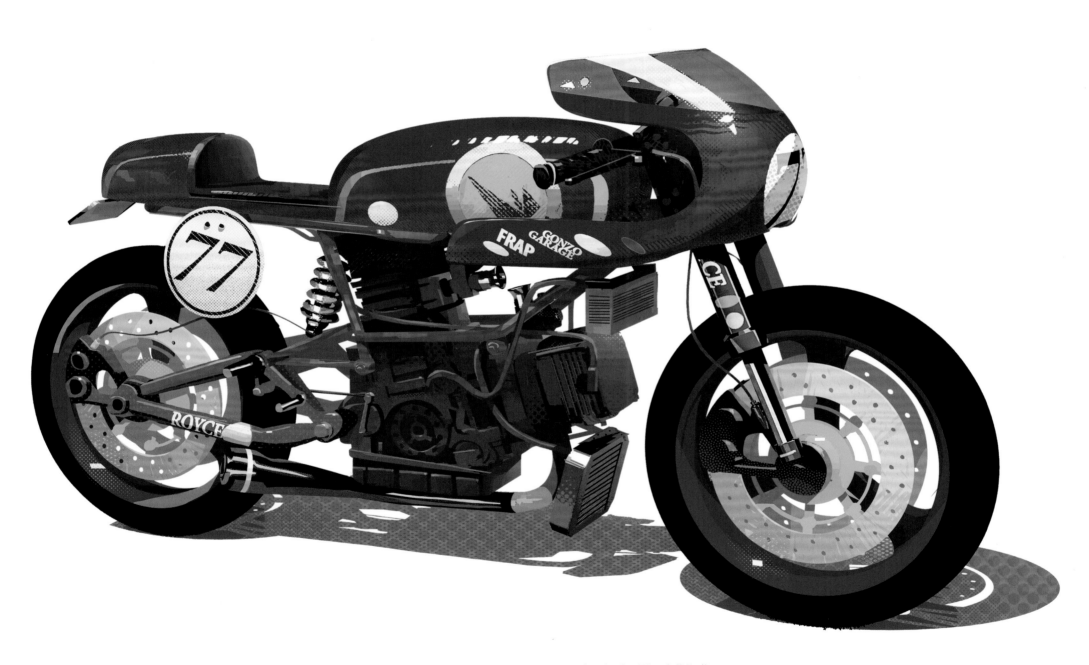

ABOVE: Prowler's motorcycle. 3D design Vaughan Ling and paint by Wendell Dalit.

THE
BATTLE

Aunt May's home had to be as warm and inviting as the character herself. In the words of artist Yuhki Demers, "We wanted it to feel like anyone's grandma or aunt could live there. I like to imagine it smells like homemade chocolate-chip cookies with a hint of mothballs!"

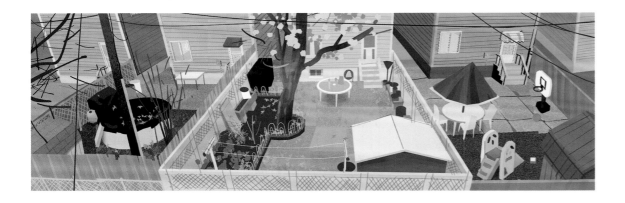

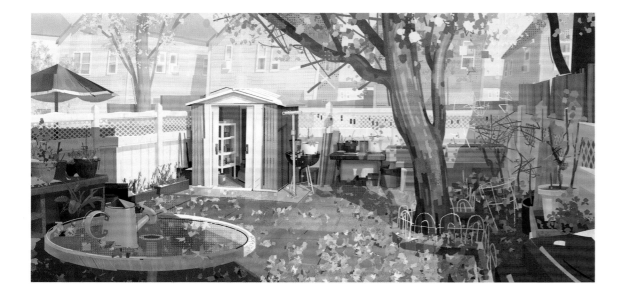

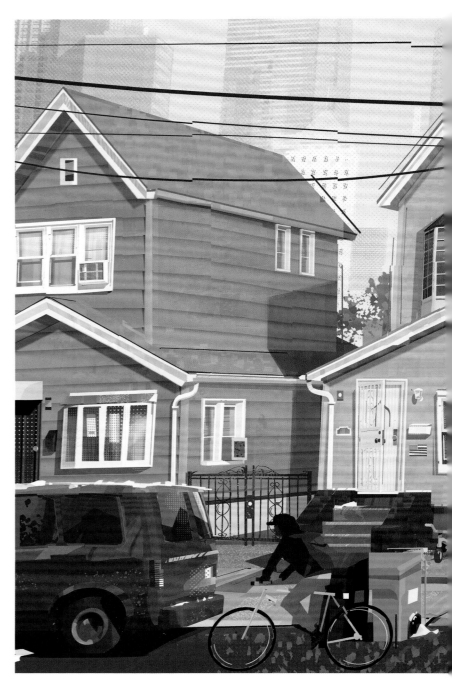

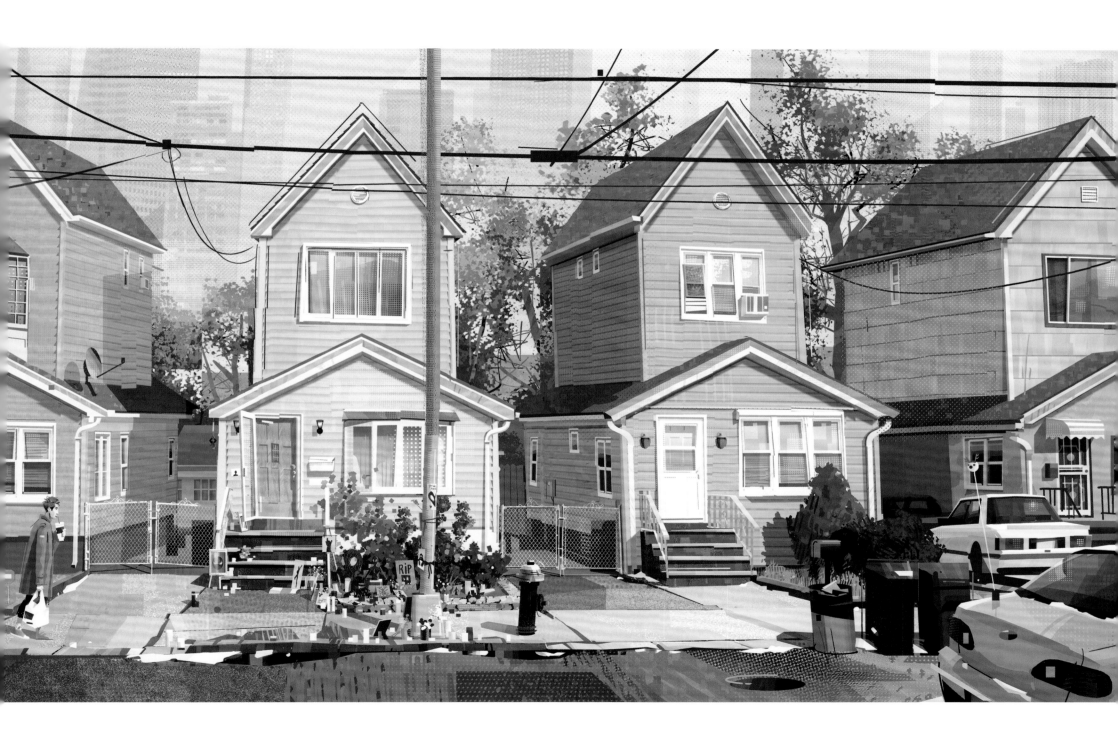

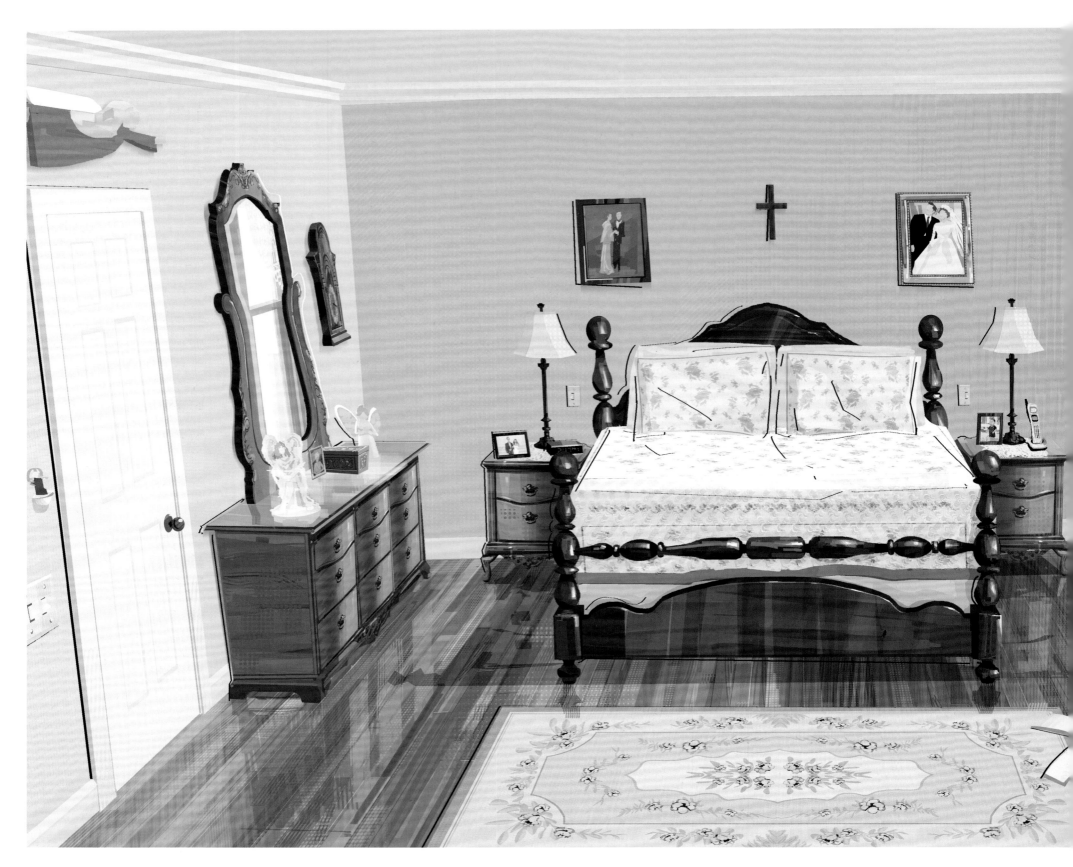

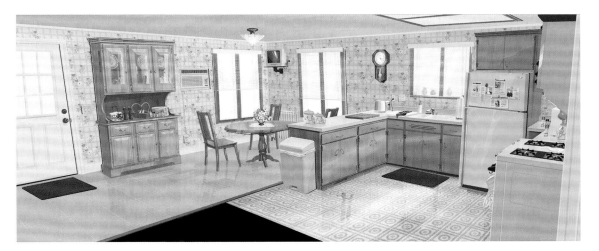

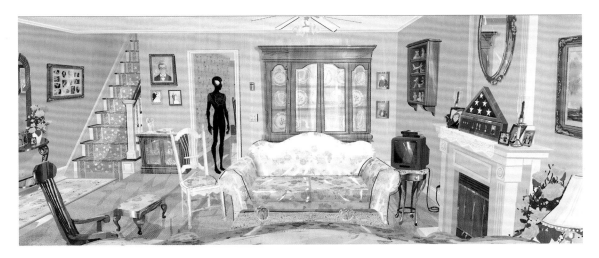

PREVIOUS SPREAD: Artwork by Peter Chan.
THIS SPREAD: Paintings by Yuhki Demers.

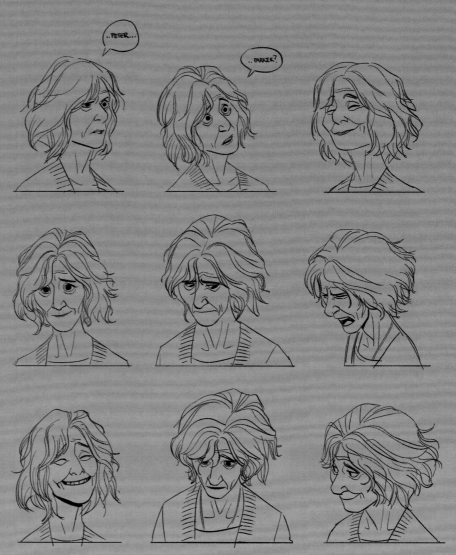

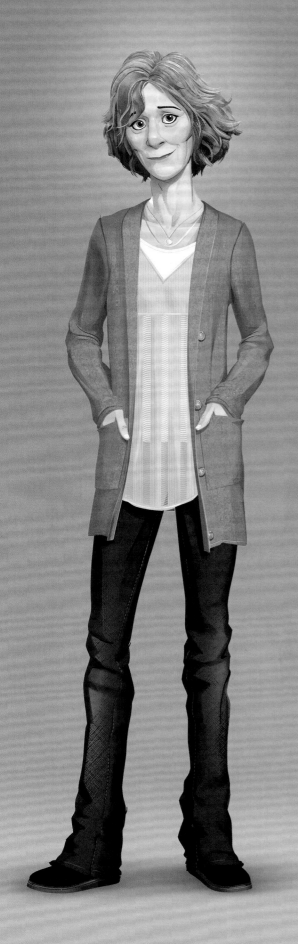

LEFT: 2D design by Shiyoon Kim, 3D design by Omar Smith, and paint by Wendell Dalit. **ABOVE:** Facial expression development by Shiyoon Kim.

This is certainly not your father's Aunt May. Echoing popular mature actresses like Lily Tomlin and Jane Fonda, the film's Aunt May is described as "bad-ass" and "feisty" by the creative team. As character designer Shiyoon Kim explains, "Just as our Peter Parker is different from the live-action versions of Spider-Man, our Aunt May is also quite an original in this universe. She can easily handle herself as well as the other characters from the other Spider-Verse worlds. We looked at a lot of feisty older actresses, especially Lily Tomlin as we see her in the Netflix sitcom *Grace and Frankie*. But along with the toughness, she also has this natural warmth and support for Miles. There is a part in the movie where she seems to be only character that gives him a chance. You need that balance for Aunt May. She can't be too tough without showing her caring side as well."

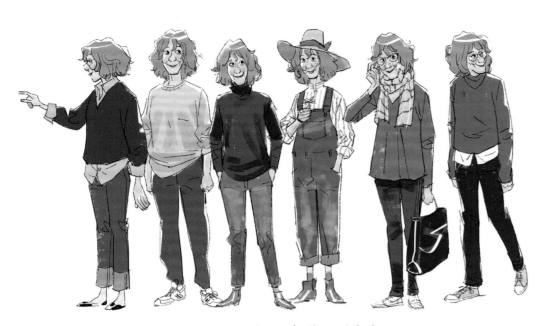

ABOVE AND RIGHT: Full-color concepts by Jesús Alonso Iglesias.
BELOW: Sketches by Shiyoon Kim.

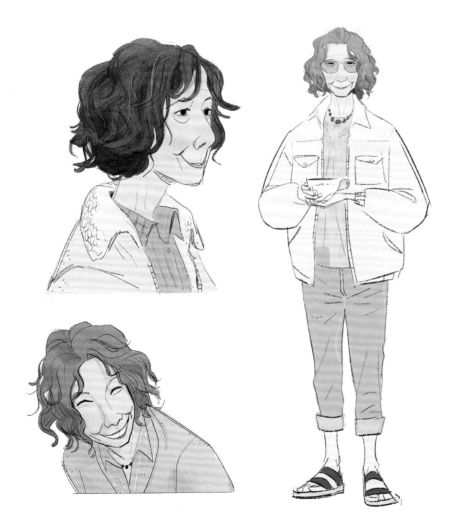

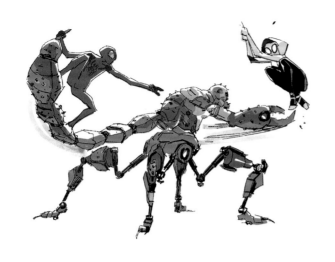

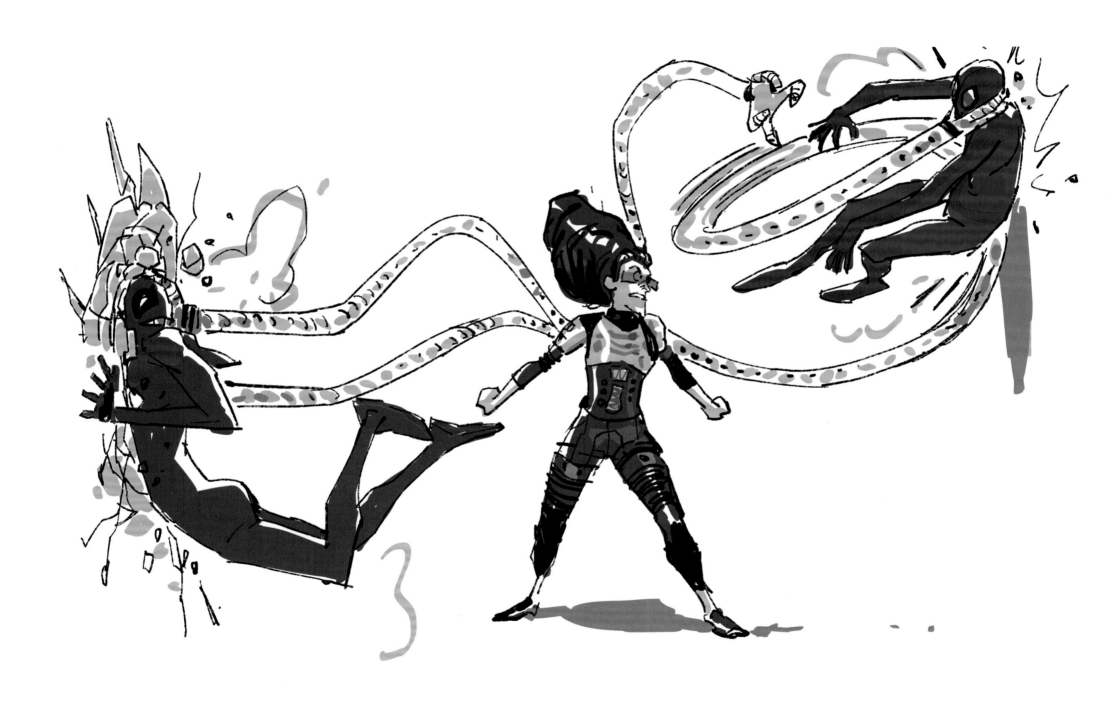

THIS SPREAD: Sketches of the fight scene from Aunt May's house by Jesús Alonso Iglesias.
NEXT SPREAD: Sketches by Jesús Alonso Iglesias (left) and storyboards by Rob Porter (right).

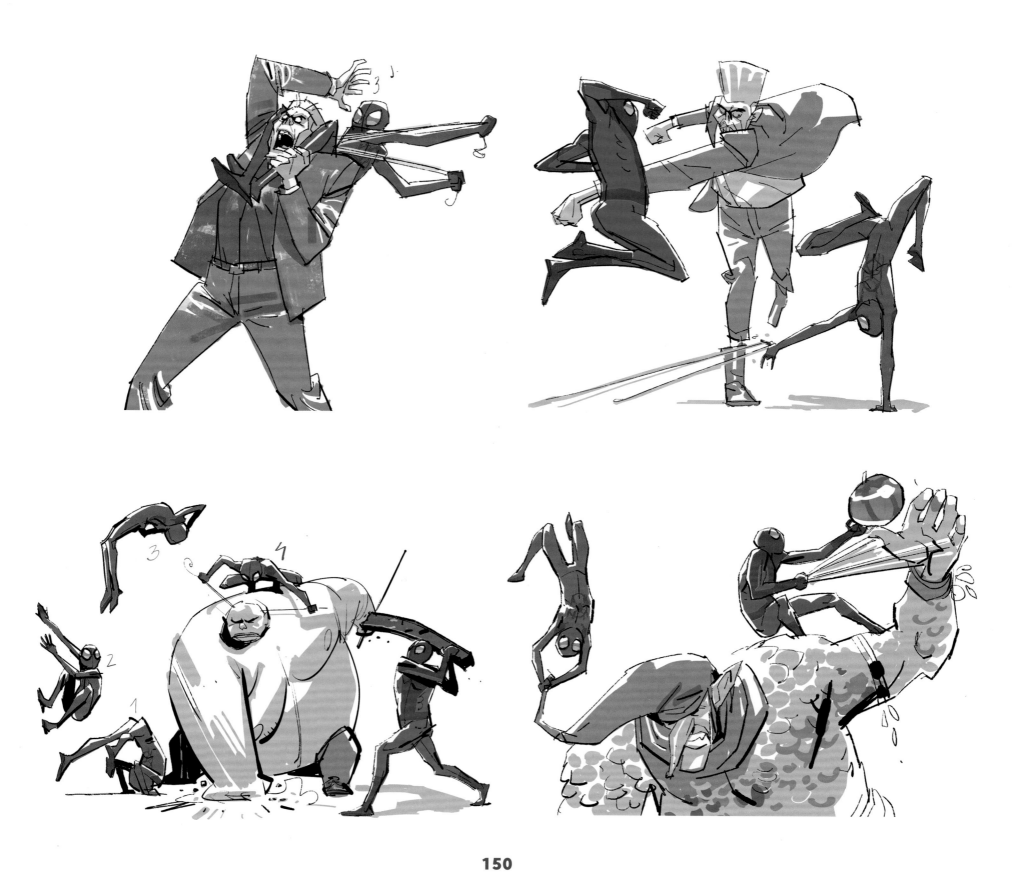

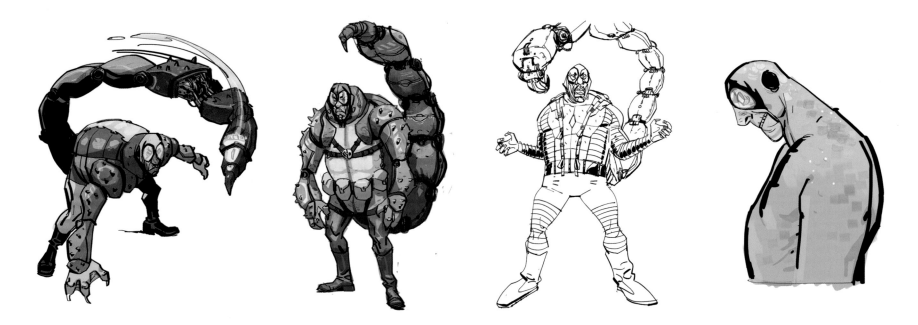

Two of the original villains of the Spider-Man universe have small roles in the movie as they assist Kingpin in his evil plans. Re-imagining them for the movie, the designers kept the basic physical characteristics of the duo, but added a little bit of spin to match the rest of the colorful heroes and villains. "For Scorpion, we meched him a little more," says director Bob Persichetti. "We gave him an incredible tail and mechanical arms, and his legs go from bipedal to quadruped when he's fighting."

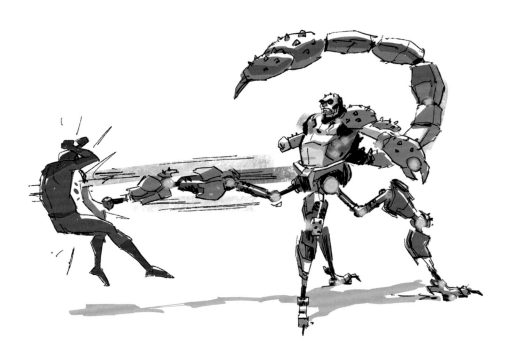

THIS PAGE: Character concepts by Jesús Alonso Iglesias.

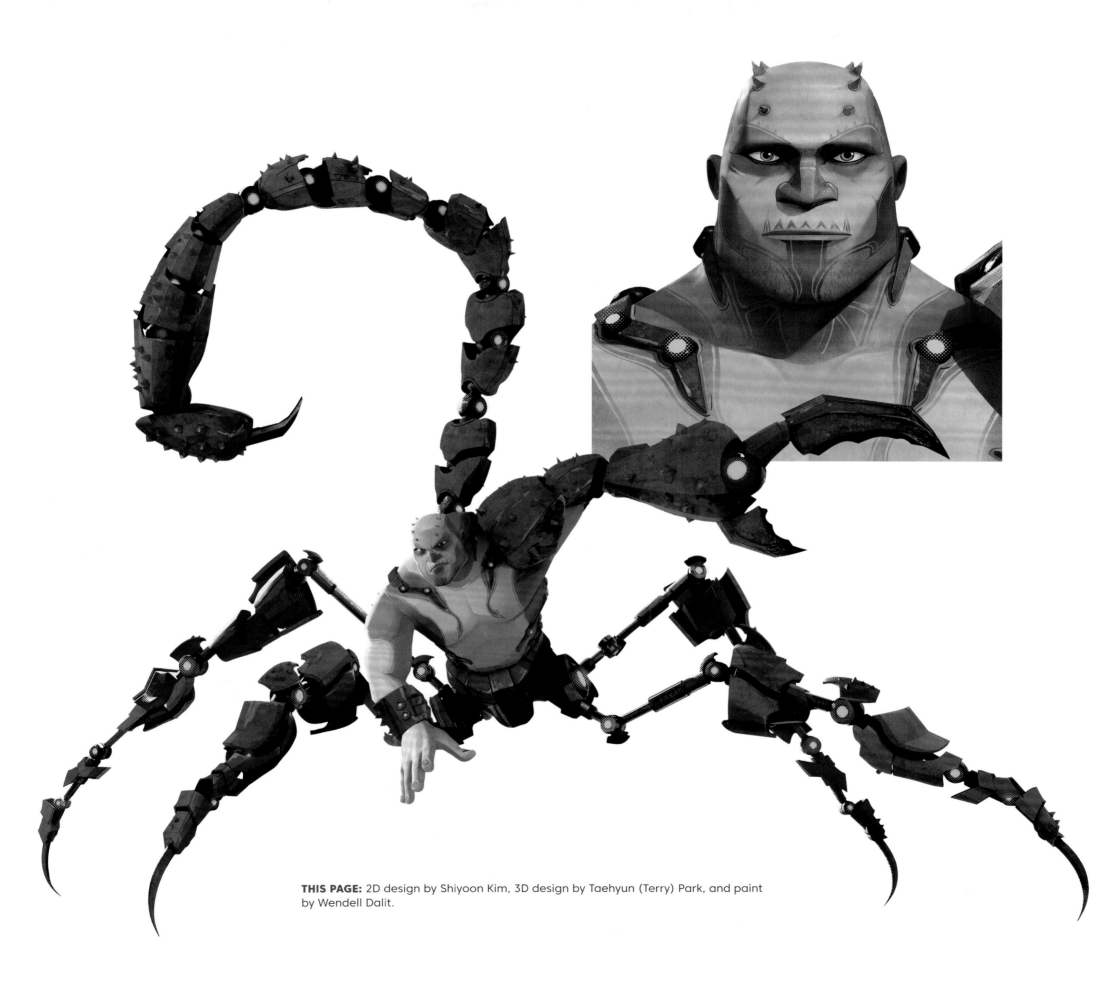

THIS PAGE: 2D design by Shiyoon Kim, 3D design by Taehyun (Terry) Park, and paint by Wendell Dalit.

Tombstone is described as a big Harlem-born thug who serves as Fisk's right-hand man. "Tombstone has always been a dangerous hit man who has fought Spider-Man many times," explains production designer Justin K. Thompson. "It was fun to add Tombstone to the movie since we knew fans would recognize him from the comics. He looks like this giant zombie, and he gets into a hand-to-hand fight with Spider-Noir. He winds up being the perfect counterpart to Noir—a 1930s Spider-Man going against an underworld gangster inspired by the same era."

ABOVE: Action concepts by Jesús Alonso Iglesias. **RIGHT:** 2D design by Shiyoon Kim and paint by Wendell Dalit.

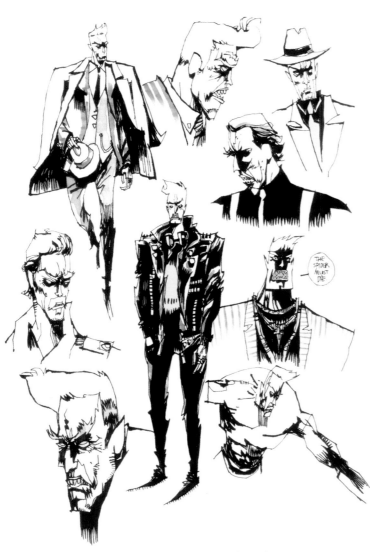

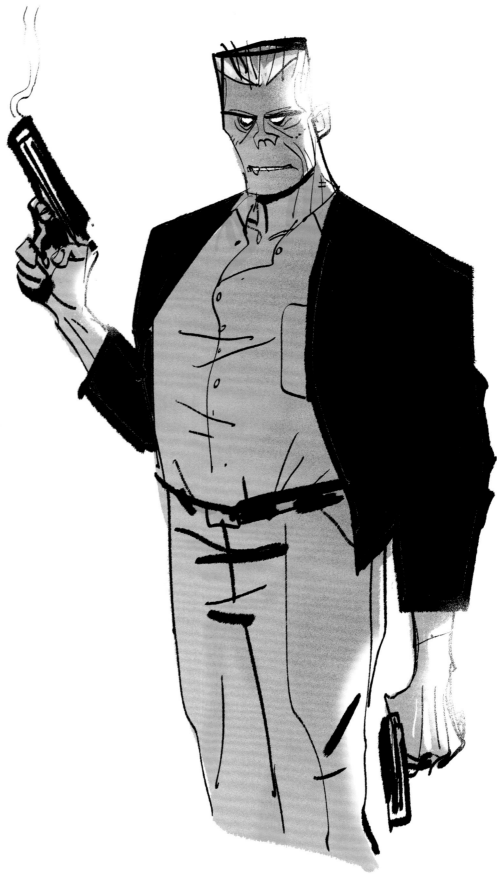

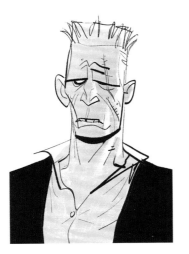

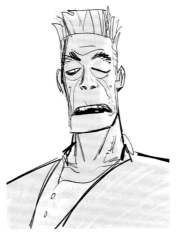

THIS PAGE: Stylized concept sketches of Tombstone by Jim Mahfood (above) and Shiyoon Kim (right and below).

Queens, the key location for Aunt May's house, allowed the artists to create a comfortable contrast to the madness of New York City and the high-octane drama of the film's action sequences. Artist Patrick O'Keefe says his habit of taking pictures of mailboxes, traffic lights, and fire hydrants helped him in conjuring up some of the real-life backdrops. "I can't get enough of stickers on business doors letting me know about the hours of operation and which credit cards are accepted," admits O'Keefe. "Designing the main strip of Queens was a chance to create something iconic, nostalgic, and utterly ordinary. The trick is to recognize and celebrate the inconsistencies: Nothing is really parallel or truly lines up. Some buildings have poor foundations and sink a little to one side. Some façades have paint peeling or doors that don't match. It's the variety of choices that make this world so beautiful."

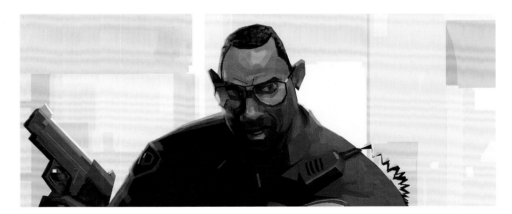

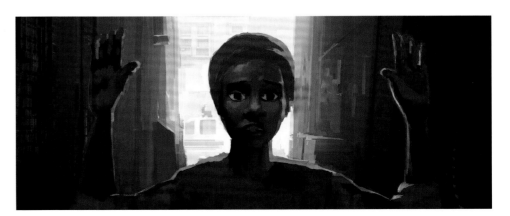

ABOVE: Painting by Patrick O'Keefe.
RIGHT: Lighting keys by Zac Retz.

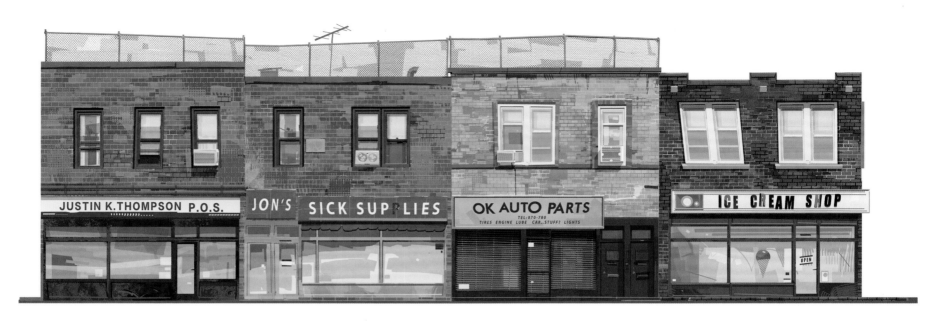

ABOVE: The artists enjoyed adding their own personal touches to the artwork—note the name of the shop in the top left.

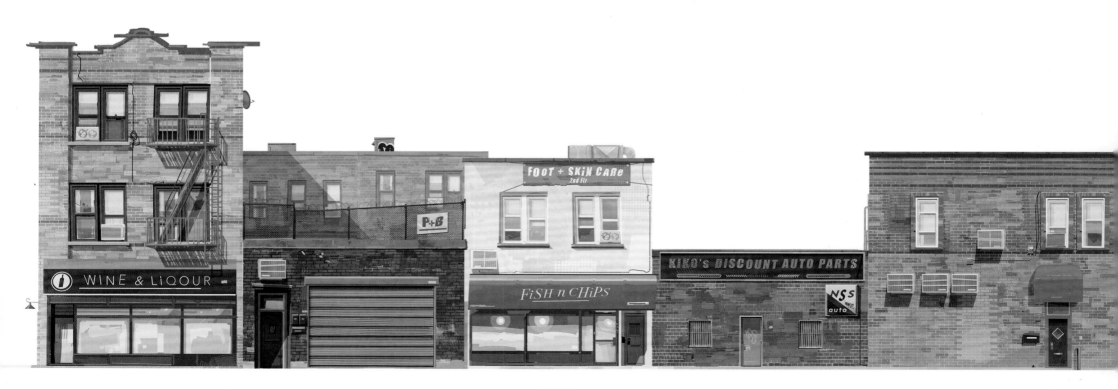

ABOVE AND BELOW: Shop fronts in Queens by Patrick O'Keefe provide a level of detail and authenticity.

FISK'S
FIASCO

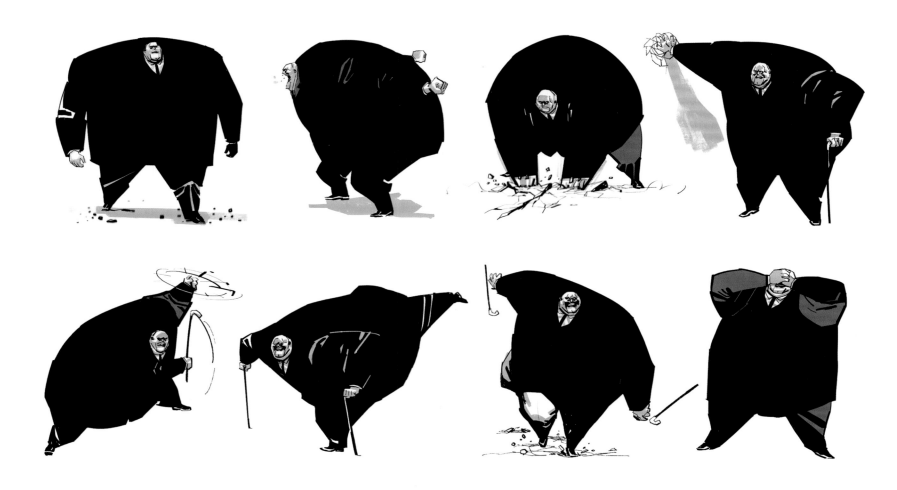

First introduced by Stan Lee and John Romita Sr. in 1967, Kingpin is one of the most powerful and ferocious crime lords in the Marvel Universe. "He is a smart crime-lord and a savvy businessman," notes production designer Justin K. Thompson. "He puts a lot of money into the city, and that's how he throws people off, and gets all the city officials on his side."

Often portrayed as an imposing heavyset man, Kingpin offered the creative team another chance to go bigger than life and explore the villainous character's full possibilities. As production designer Justin K. Thompson describes him, "In the comics, Kingpin was always portrayed as this gargantuan character, so for our movie, I wanted him to be at least eight feet tall, seven feet wide. Since he is responsible

ABOVE: Sketches by Jesús Alonso Iglesias. **NEXT PAGE:** 2D design by Shiyoon Kim, 3D design by Omar Smith, and paint by Wendell Dalit. **NEXT SPREAD:** Artwork by Craig Mullins.

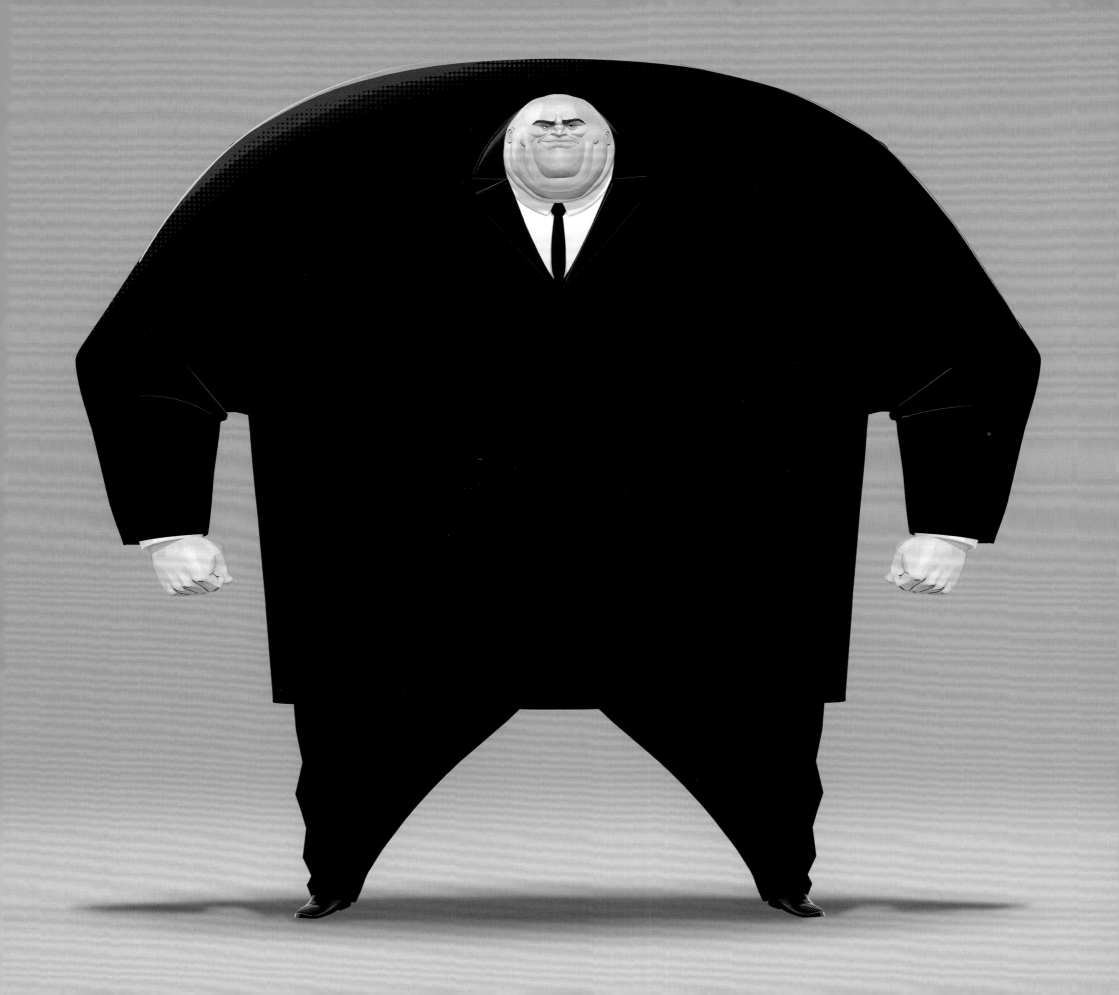

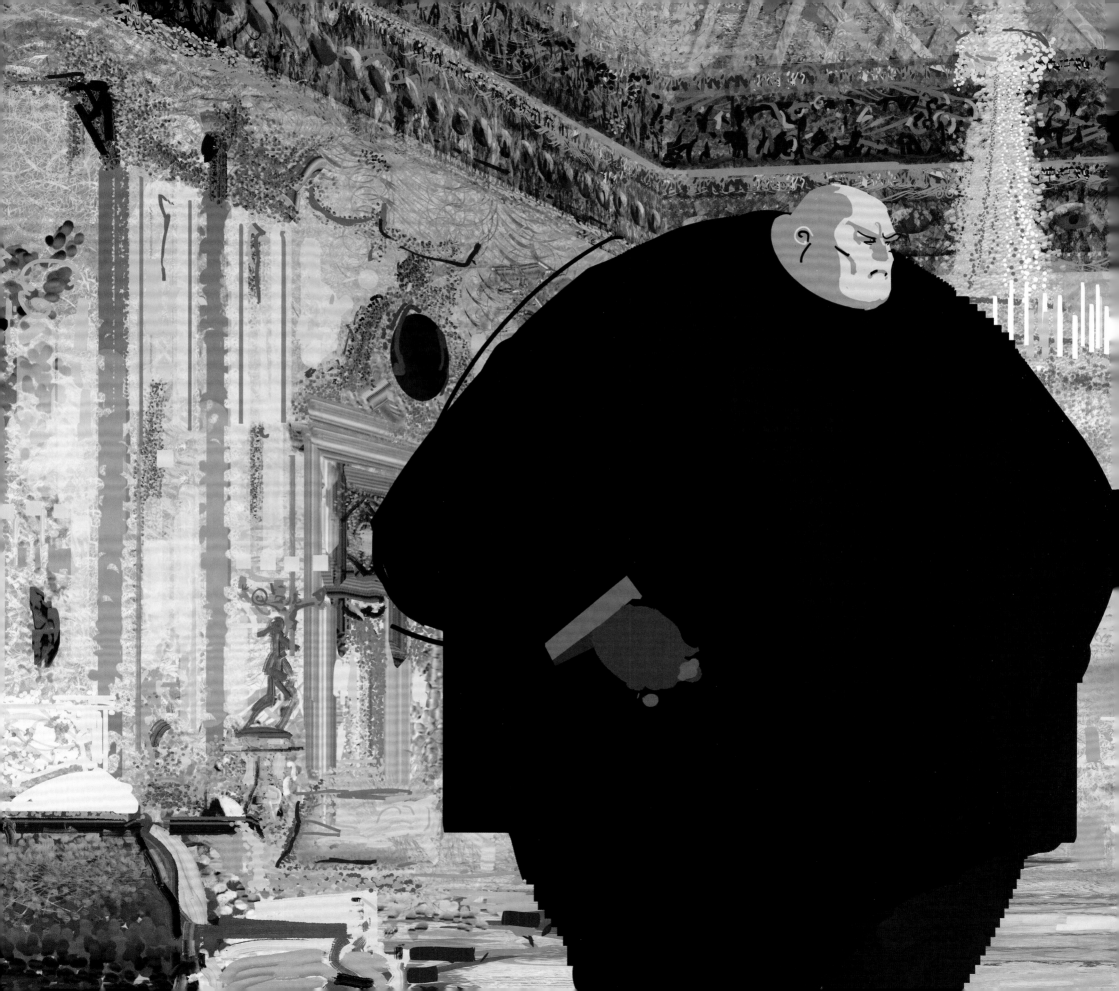

for opening this portal to another dimension, I thought it would be cool to portray him like this giant black hole that moves through space and time and swallows up everything in the room."

This monstrous alter-ego for real estate magnate Wilson Fisk was depicted as an infinite source of dark energy. "Kingpin gave us a chance to play with a very fun, visual experience—limiting ourselves to just a silhouette but still getting really dynamic performances out of him," adds Thompson. "This guy's head and his hands sort of float on this void. We even created this special rig for him that allowed us to almost pose him independently from his anatomy and get these amazing silhouettes out of our shots."

Producer Phil Lord says Kingpin is one of his favorite characters because he seems to eclipse every one of the frames that he happens to be in. "His physical presence doesn't leave room for anything else. He can just stand there, and everything bends to his will, even the camera. He is basically this pure black figure and the most abstracted CG character I've ever seen."

ABOVE: Character sketches by Mark Ackland.

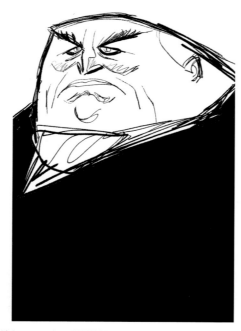
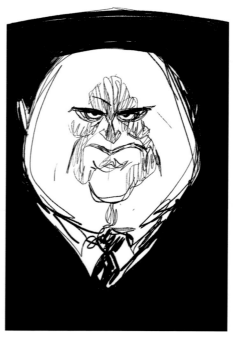
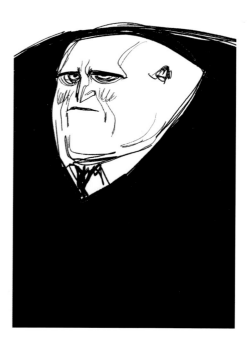

ABOVE: Facial expression development by Shiyoon Kim. **NEXT PAGE:** Character concepts by Shiyoon Kim.

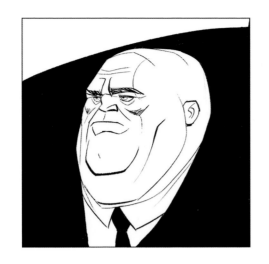

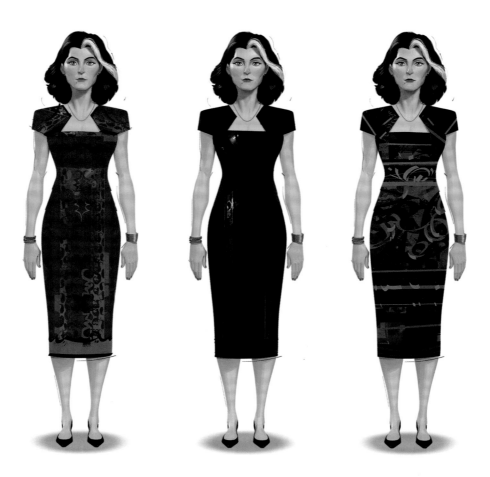

Vanessa is Kingpin's wife, whose death is what motivates Kingpin to open up the portal to bring Vanessa back to the universe. "It's a foolish plan and is destined to fail, because anyone from other universes will be different when they are pulled through into another one," explains Justin K. Thompson. "Kingpin has always been incredibly infatuated with his wife. He is willing to give up everything for her."

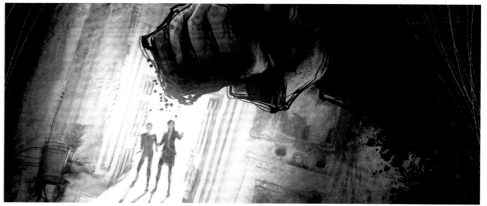

ABOVE: 3D design by Omar Smith and paint by Yashar Kassai (top) and color concepts by Paul Lasaine (bottom).

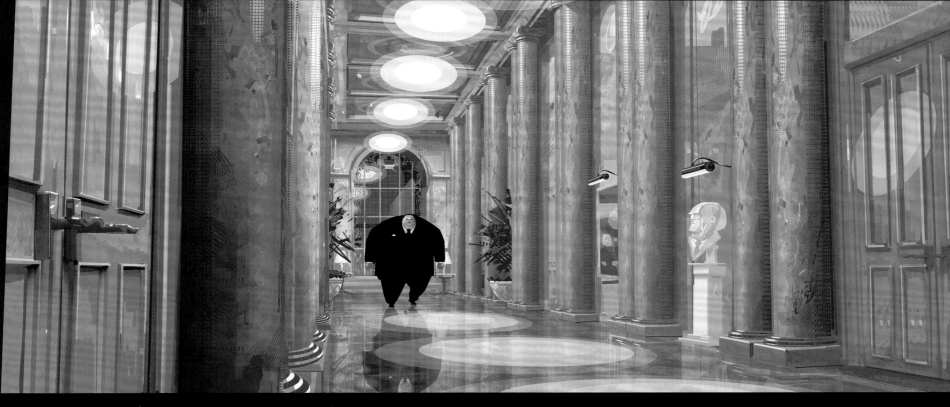

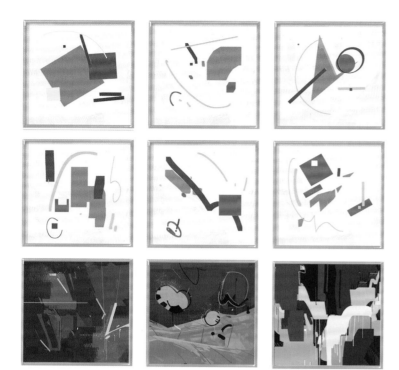

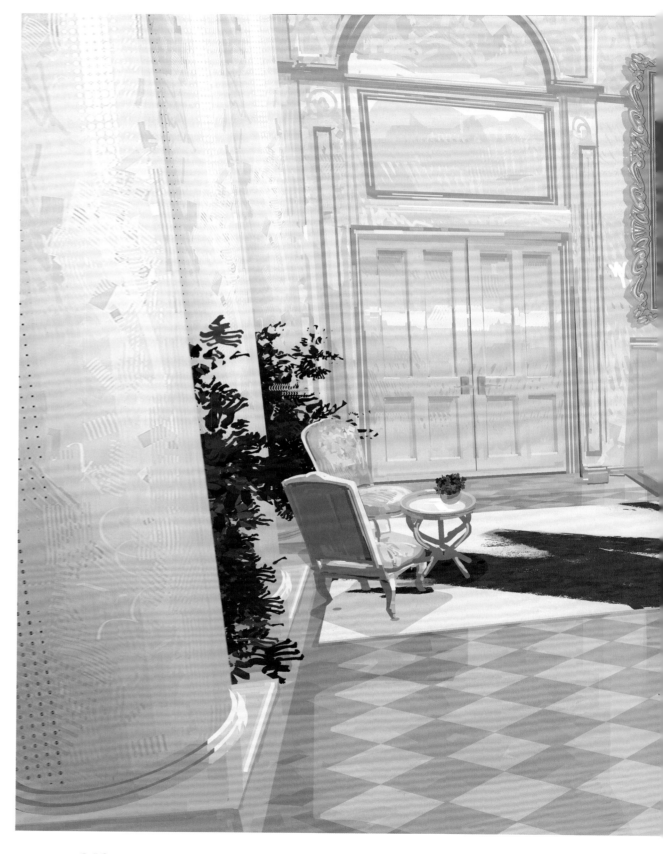

ABOVE AND RIGHT: Artwork of Kingpin's office by Patrick O'Keefe.

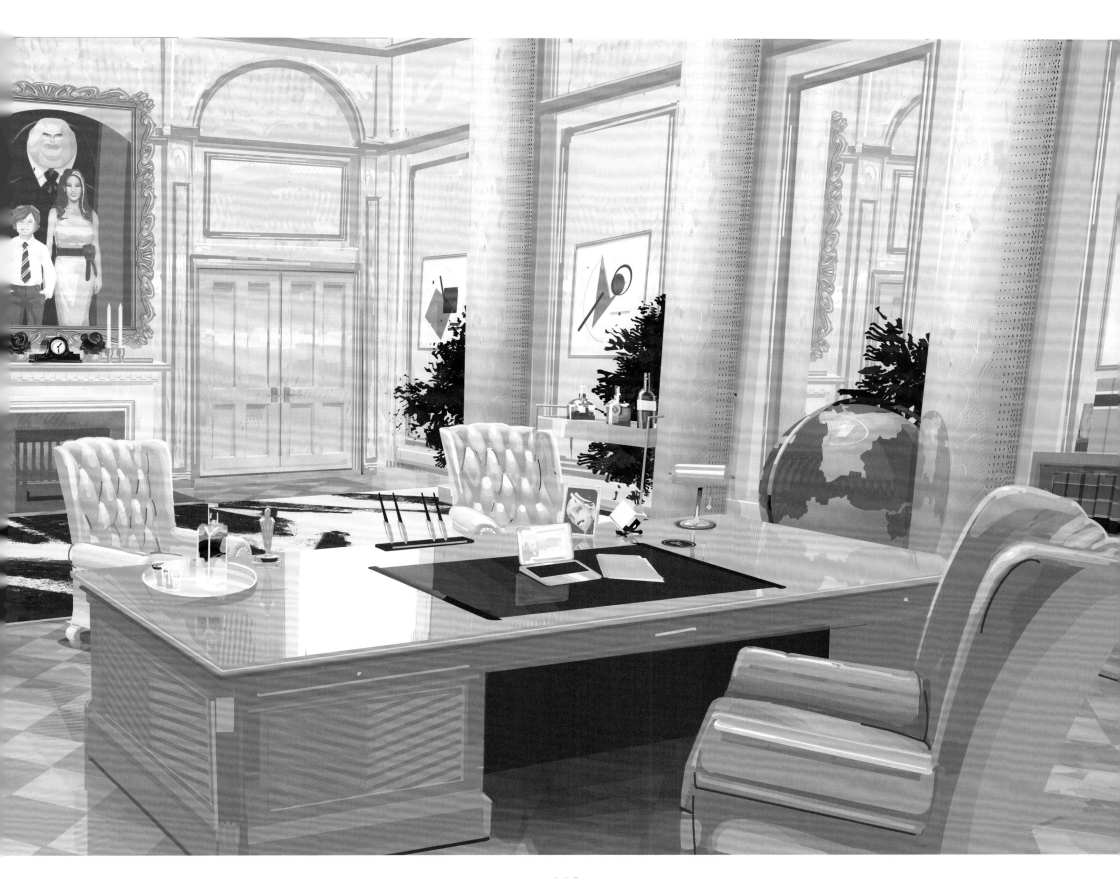

Some of the movie's most inspired visuals were created to illustrate the 'glitches' created because of the arrival of characters from alternative Spider-Verses in Miles' world. Visual effects producer Christian Hejnal, a long-time studio veteran who worked on Sony's first three live-action *Spider-Man* movies, says the effects team was given the green light to be really inventive and experimental with this assignment.

"This was brand new for all of us," Hejnal explains. "The glitching was a modern invention by our team, using the multiple cameras that mirror the multiple universes. They are all shot on the same character and same animation, but are treated differently, creating this cubist, fragmented look. The glitch happens on characters, buildings, cars because of these dimensional earthquakes as different worlds intersect."

Hejnal and his VFX team also had a lot of fun coming up with Miles' Venom Strike and invisibility powers. "The Venom Strike was inspired by a 2D anime style, which were brought to a 3D environment by our

team," he explains. "Our look development and compositing teams worked very hard to get the final look just right, especially to make it work with the screen print technique that is one of the defining visuals of the movie. Miles gets the Venom Strike effect every time he's nervous, and it looks like a sharp lightening effect."

It was the natural world that provided the inspiration for Miles' invisibility look. "Our look dev team looked at how cuttlefish are able to appear invisible when they position themselves in front of an object," says Hejnal. "It's view dependent, so the fish only looks invisible if you are looking at it straight ahead. So, our team had to modify that and come up with a solution so Miles would appear invisible in all directions in a 3D environment, while still maintaining the overall look of the movie with the screen-printing and the line-work on top of it. It was something that I'd never seen before, and it was very exciting to see it being created here."

BELOW: Dean Gordon worked on matching the design of Miles' powers to the aesthetic of the film.

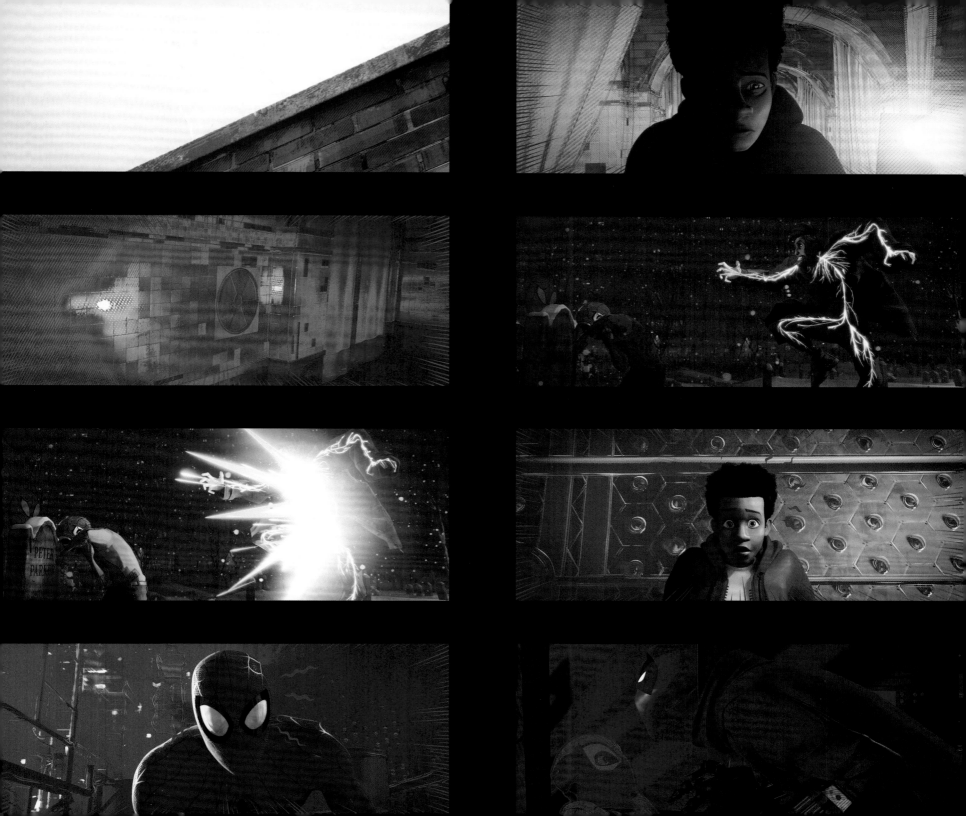

Any die-hard fans of the Spider-Man universe can tell you that when you turn on a powerful particle collider, you can invite a variety of parallel dimensions into our world. The dimensional quakes, which are a result of this tear in the space-time continuum, posed many opportunities and challenges for the visual artists involved in bringing this complex idea alive in CG animation.

THIS SPREAD: Dimensional quakes by Yashar Kassai, environments by Robh Ruppel.

172

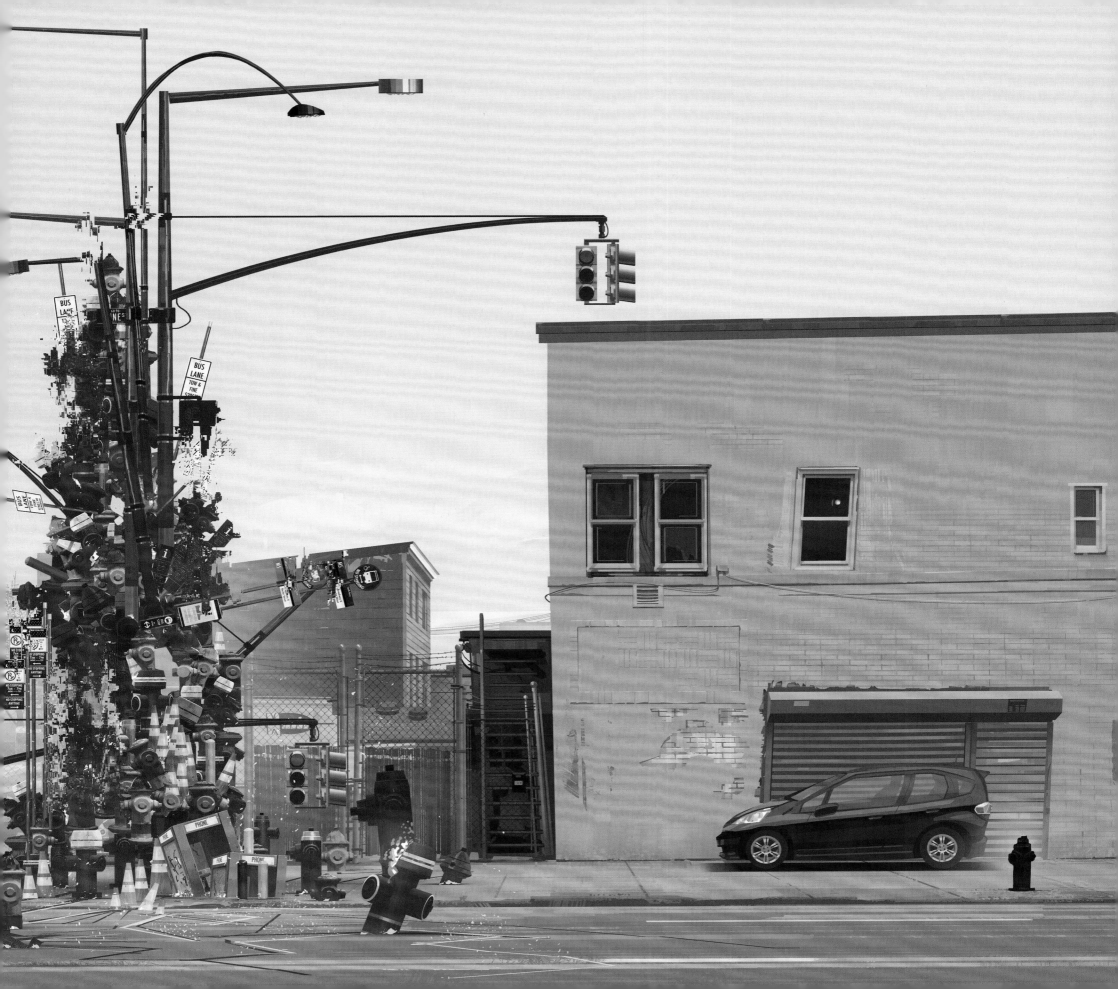

Dean Gordon delves into the imagery: "We knew we wanted to represent parallel worlds from the Multiverse intruding into our own," he says. "Cubism seemed a natural idea since it represents multiple views of a scene within a single picture frame. So in our version, space is fractured, and within each fracture we see a different angle, scale, and rendering, of the same place. Each fracture shows a parallel but slightly different version of our world existing in another universe and now trying to resolve itself in ours."

THIS SPREAD: Beautifully hectic art by Dean Gordon.

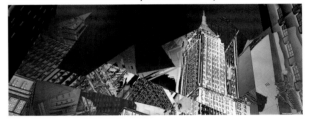

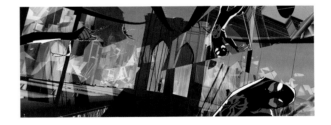

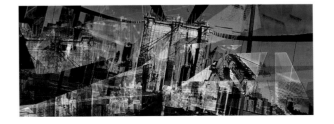

Because the whole movie tries to come up with new and original ways to visualize complex subjects and themes, the portal experience also needed to improve on what audiences had seen before in terms of passageways to other universes. "We didn't want it to seem familiar," says director Bob Persichetti. "It couldn't be a tunnel or a derivative of anything we'd seen in *Doctor Strange.* We really wanted it to represent what would happen when you smash together these subatomic particles and create a tear in the space-time continuum. Other dimensions are drawn to Miles' Brooklyn because that's where the Collider is. These multiple universes are trying to resolve themselves through the portal."

According to Persichetti, the technical team at Sony Imageworks developed a camera array that allowed them to project seven different angles on to the screen at the same time while enabling them to render each one of those cameras in a different style. "Once the portal opens, and we begin to realize that the Multiverse exists, it looks like a mosaic— except that you're looking at seven different locations (the same locations in different universes) from subtly different angles with different render scripts on them. Then we had to develop animation to make all these things smash into each other and resolve into one spot. That's why visually it looks like abstract art. We have taken perspective, unfolded it and laid it out on the big screen, which is pretty amazing!"

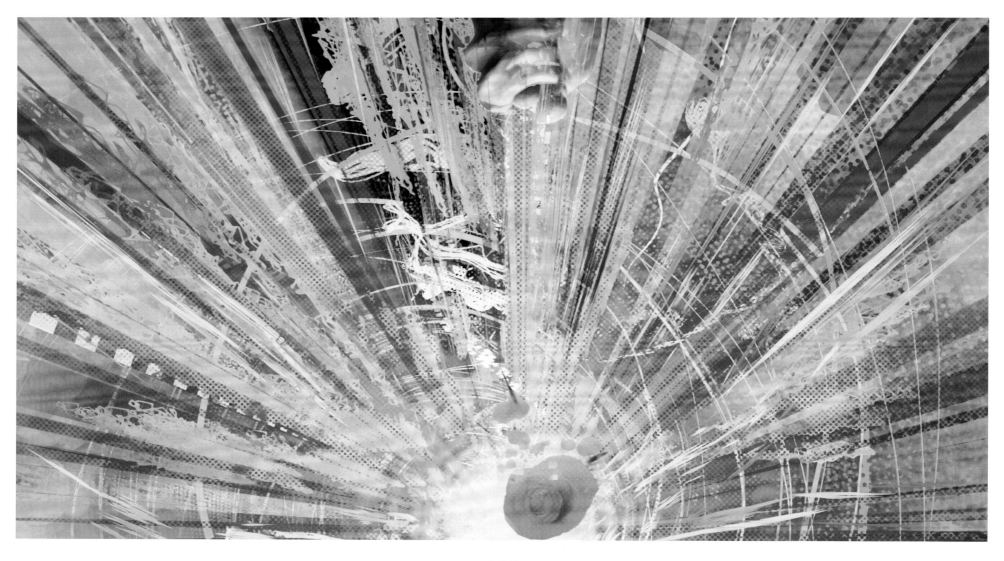

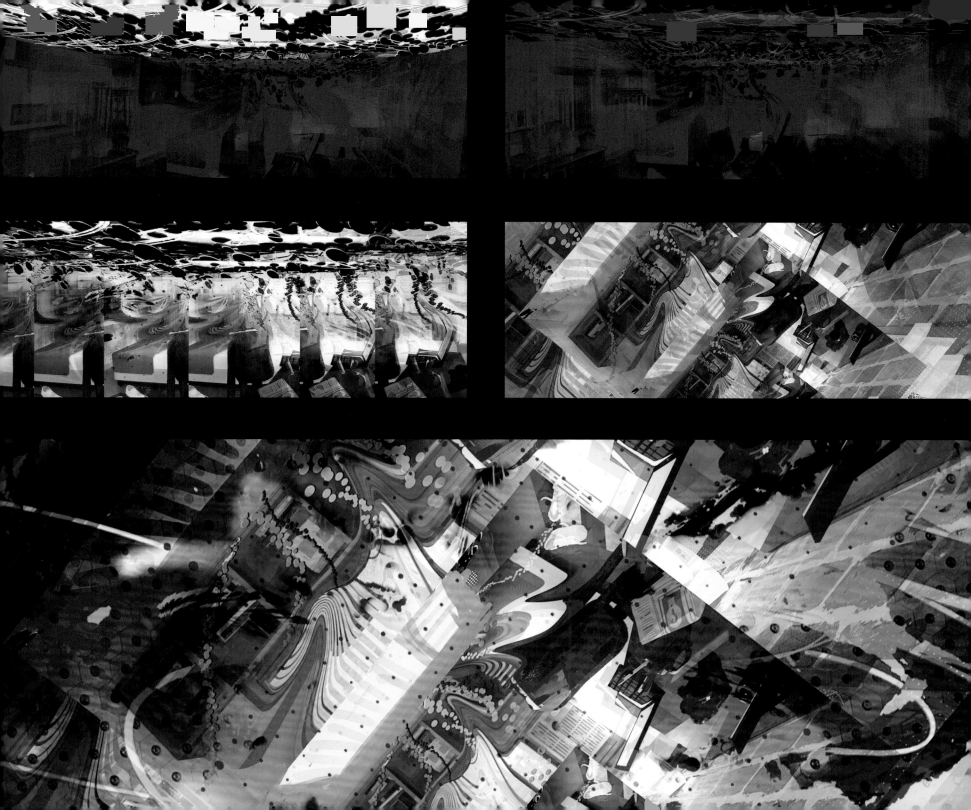

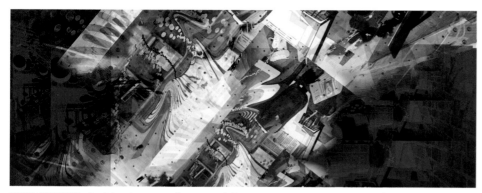

THIS SPREAD: Inside the portal. Artwork by Dean Gordon.

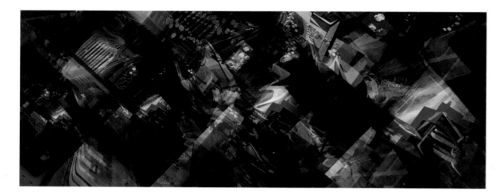

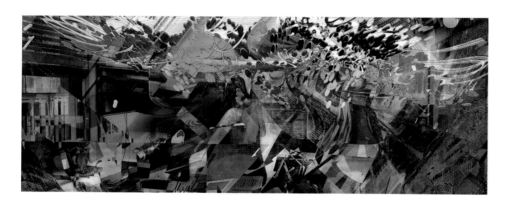

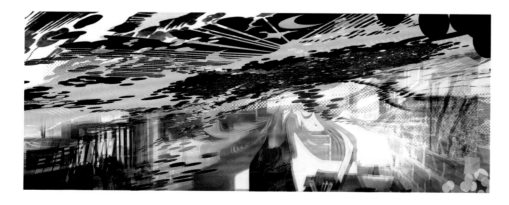

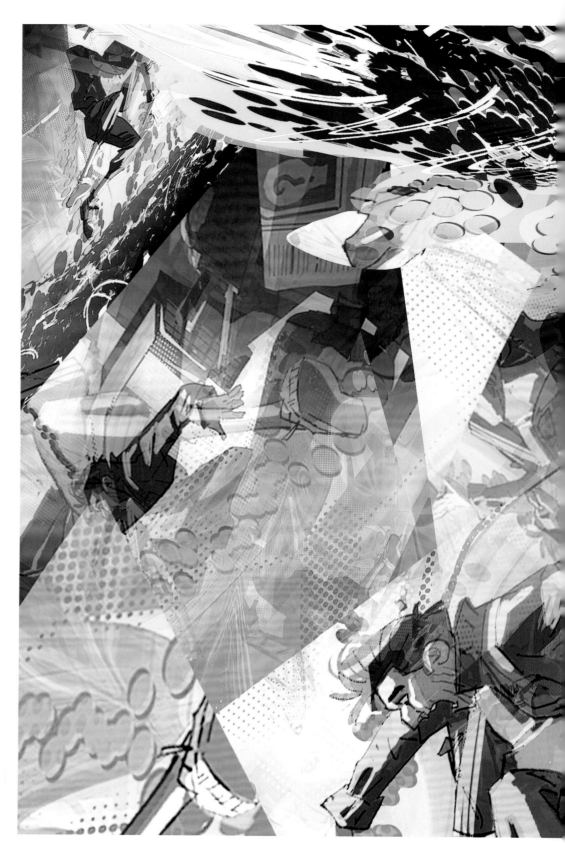

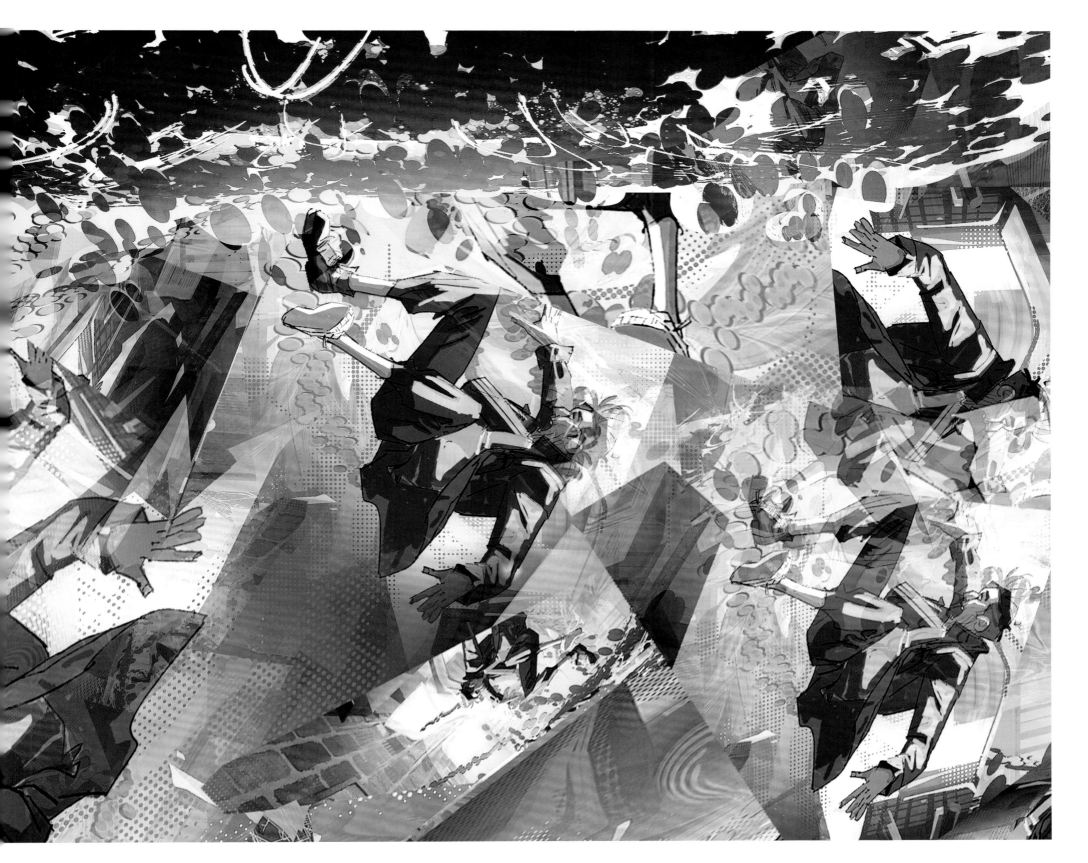

SCENE SPOTLIGHT: SWINGING THROUGH THE CITY

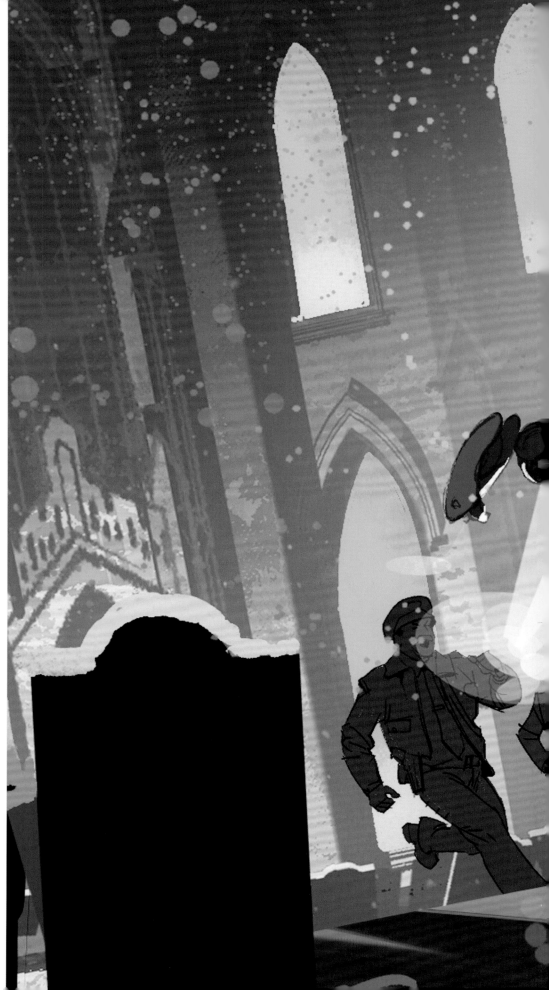

One of the key sequences of the first act of the movie comes shortly after the collider fight. We find Miles shaken by the shocking death of the classic Spider-Man and pushed into the next part of the story, where he becomes aware of the Spider-Verse and the other versions of Spidey pulled in to his world.

Director Bob Persichetti, who has worked on a range of animated movies including *The Little Prince*, *Puss in Boots,* and *Shrek 2*, says the filmmakers lovingly referred to this scene as "the arrival of the Fairy Godmother."

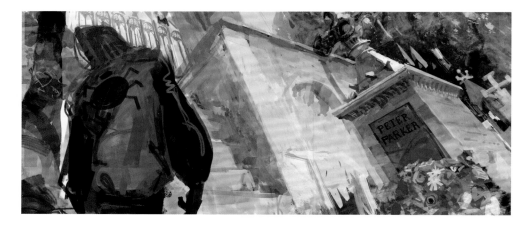

ABOVE: An early concept of Peter's grave by Craig Mullins.
RIGHT: The beginning of Miles and Peter's journey together. Art by Robh Ruppel.

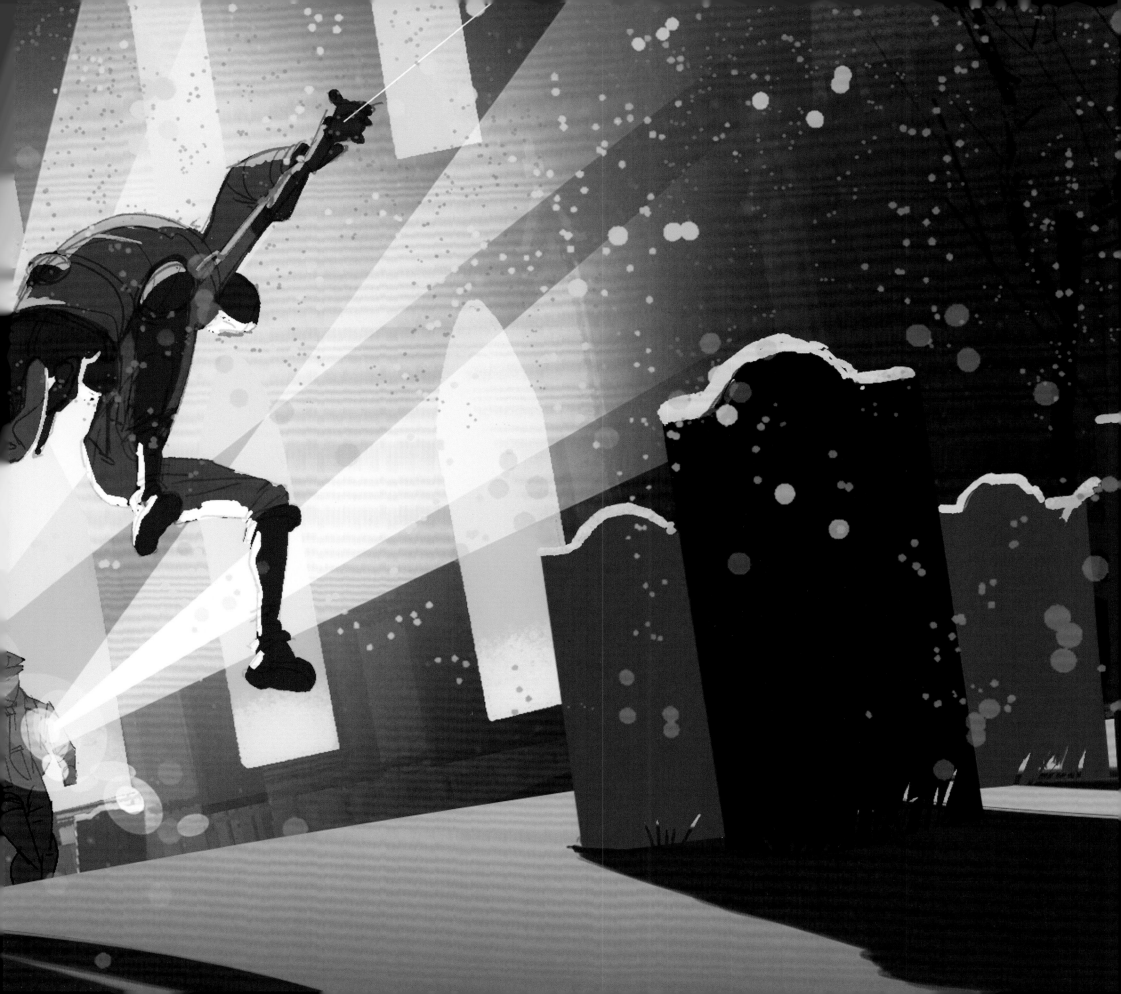

It's in this sequence that the audience first meets the older, more jaded version of Spidey. "The idea is that after the first Peter Parker dies, Miles is at his lowest moment," says Persichetti. "He visits the gravesite and doesn't know how to move forward. That's when a figure emerges from the darkness. At first, we think it's Prowler, but it's the older version of Peter Parker. It's not the version that Miles wanted or needed, but it's the one he is stuck with."

After Miles accidentally delivers a Venom Strike to Peter, he involuntarily fires a web and they stick to each other. When the police show up, they get chased, a web attaches to a passing train and they are thrown into this wild ride through Manhattan. "It's their first scene together, but Peter Parker is unconscious through most of the scene," says the director. "We tried to lean into the fun of a kid Spider-Man and a grown man Spider-Man. We joked that it was kind of born out of the spirit

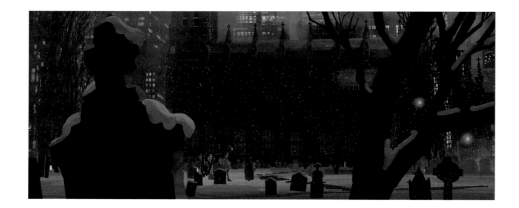

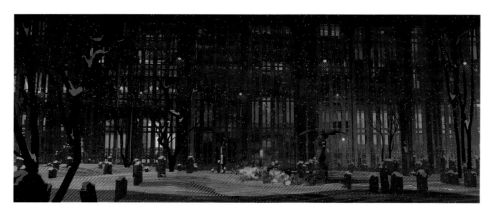

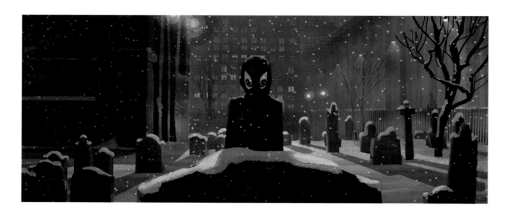

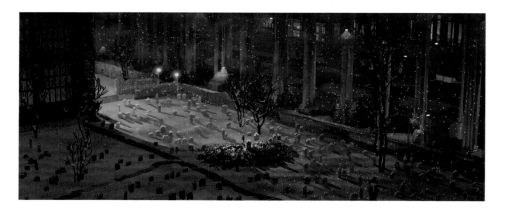

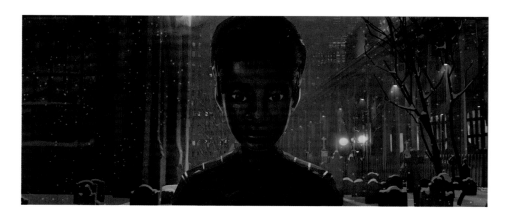

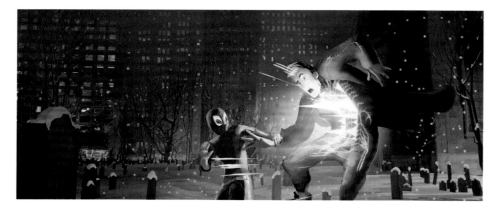

of the 1989 movie *Weekend at Bernie's*. Peter is unconscious, and Miles is puppeting him as they get dragged through Manhattan."

The scene gave the artists the chance to deliver a visual extravaganza. As Persichetti says, "It allowed us to create some of our most expressive, visual statements so far in the film, We were able to abstract the backgrounds, really push the color palettes and lean in to our

animation. The majority of our animation is done in twos instead of ones [images are held for two frames, rather than one] or twelve images per second, instead of twenty-four images. That's rare for CG."

For art director Dean Gordon the scene offered a chance to play with the interaction of city lights with the duo as they get whipped around. "Miles and Pete are being towed for ten blocks, so we wanted

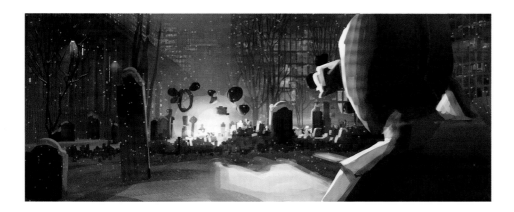

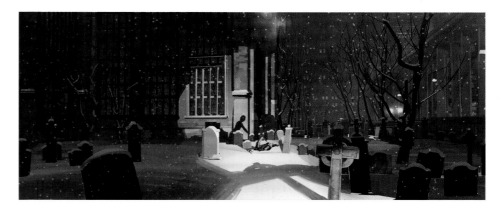

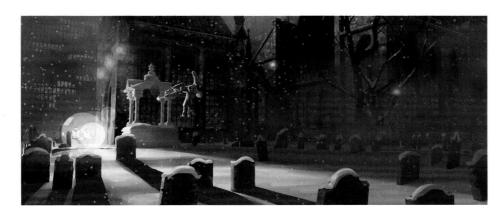

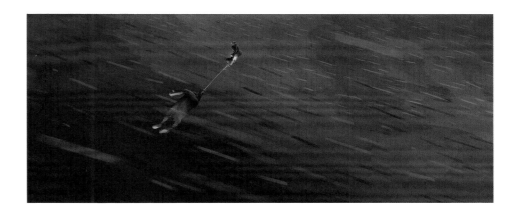

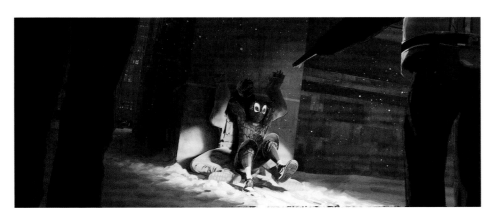

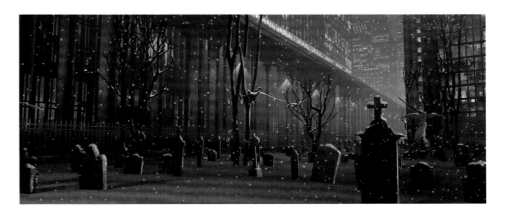

each block to look differently from the last one," he explains. "We used twelve to fourteen lighting keys to differentiate each block. The earlier blocks, as they come from Manhattan, are darker and the scenes get lighter as they progress. We also have all the different colors of the street signs and lights to play with. We have stores, neon lights, and street signs casting their light on the streets as Miles and Peter travel through the air. While we wanted to keep the sequence very active visually, we still needed the main read to be on the characters. They have to stand out against all the busy backgrounds. We used all the tricks, light over dark, dark over light, featuring the most saturated colors to track our main characters."

Another colorful element in the sequence is the reflections of the city on the grounds of the icy streets. "That was one of the cool visuals we played with to showcase reflectivity on the wet streets. If you're down on the ground with a low-camera angle, you can have this great reflectivity of the lights and cityscapes to heighten the visuals."

Paul Watling (*Hotel Transylvania 2*, *Smurfs: The Lost Village*), who is the head of story for *Into the Spider-Verse,* says the sequence was an artist's dream. "We conceived this whole above-ground train chase sequence, with the two characters attached to each other, and whatever we threw at them, they wanted more, and we all kept pushing ourselves to make it more exciting."

Watling recalls the first throw-down of the scene was quite fantastic, but he says with each take, the artists would raise the eye candy factor. "Chris Miller and Phil Lord really wanted to up the stakes, so we added more of Miles and Peter getting chased by police cars and piled on this sense of urgency," Watling notes. "I am a real sucker for slapstick humor, so I was very happy to see Miles and Peter being dragged along for blocks, and all the silly moments added to the sequence."

The filmmakers also eliminated the idea of motion blurs for the film. "That meant all the images needed to stay crispy at high speed," explains the director. "They had to be balanced with something else as we didn't want to take away from the quality of the graphic images. We allowed for multiple imagery as in-betweens and making the backgrounds become more abstract and become these movement tunnels of color and snowflakes. Those elements helped us fight the idea of strobing and all those things that

PREVIOUS SPREAD: Lighting keys by Wendell Dalit, Zac Retz, Dean Gordon, and Michael Kurinsky.
RIGHT: Peter takes a trip with his new protégé. Artwork by Dean Gordon.

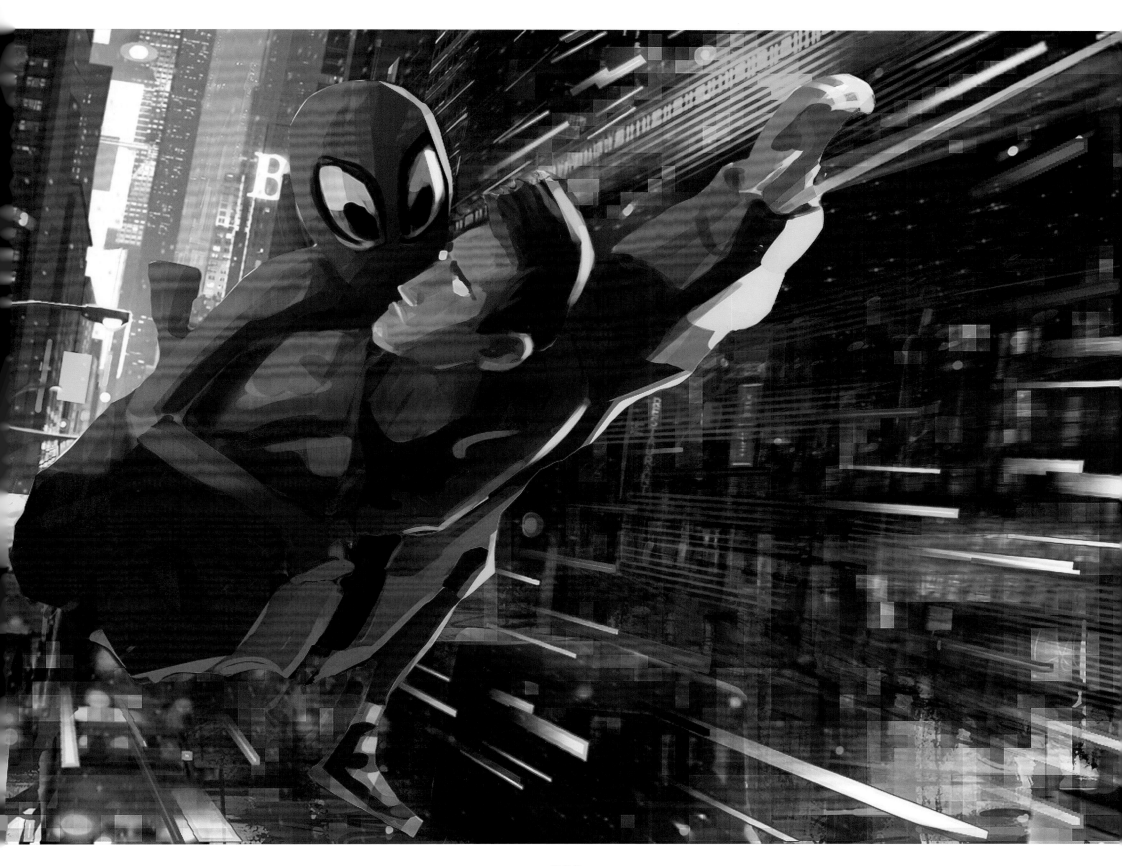

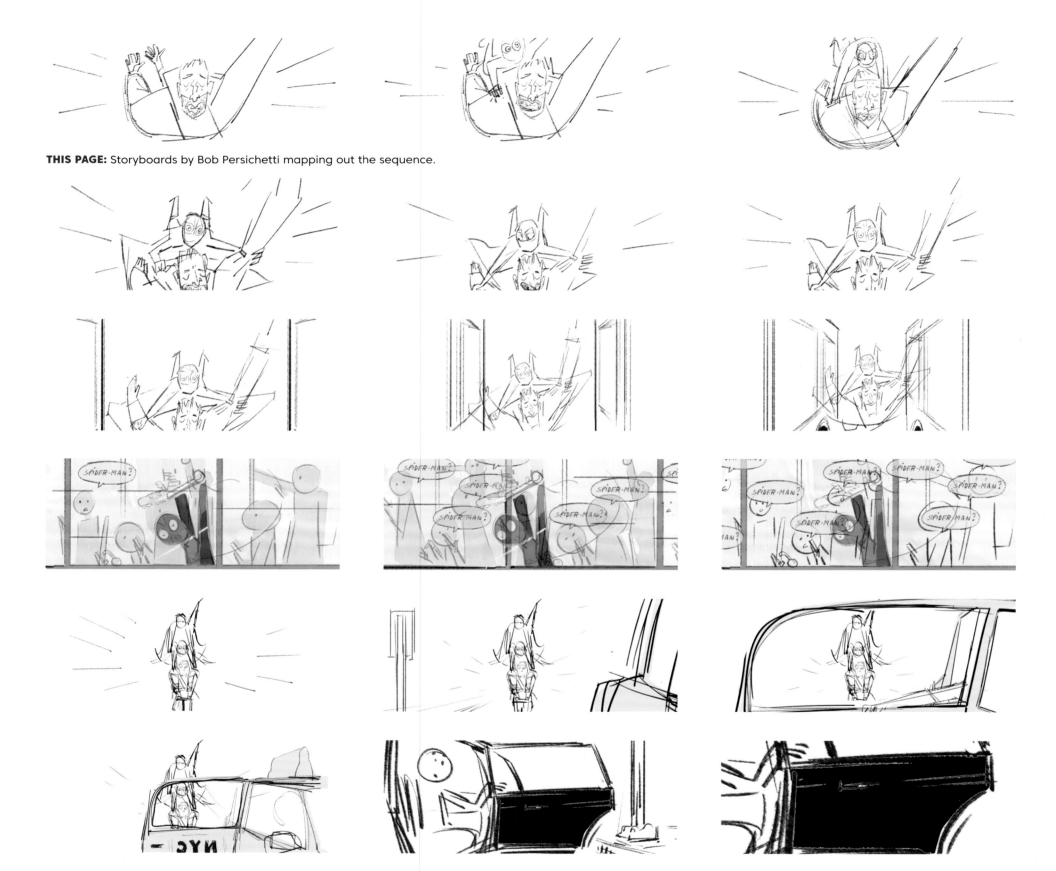

THIS PAGE: Storyboards by Bob Persichetti mapping out the sequence.

Scene Spotlight – Swinging Through the City

most CG films use motion blur to solve. We wanted to come up with a visual solution that made a bolder statement than softening everything so that it doesn't strobe."

The creative team approached the sequence as a transition, in terms of both a storyline and a visuals point of view. This is the moment that takes viewers from the first act to the second, where Miles first experiences what it's like to be Spider-Man. It also marks the introduction of the older Peter Parker character, who becomes Miles' mentor. "They also both get pretty beat up in this section of the movie," says Persichetti. "You don't see the actual damage illustrated this vividly in animated movies. But the physical toll is something that we were keen on showing. Peter's nose is broken. His eyes are swollen and his ears are asymmetrical—even in the CG model that we built. The first Peter Parker is perfect, but then we aged him about fifteen to twenty years and added two decades of Spider-Man wear and tear on him. This makes the older Spider-Man a much more interesting character to follow. He is forced into this three-legged sack race with Miles, and that's when he remembers why he is a super hero. He finds purpose and meaning in being Spider-Man again."

Persichetti says everyone who was working on *Spider-Man: Into the Spider-Verse* was thrilled to be able to push the boundaries of animation with this project, and this pivotal sequence really helped set the right tone. "We are all lucky to be working on a property that has such a huge audience invested in it. That's why we could be riskier with our choices and make the movie visually different from what a summer or winter blockbuster is expected to look like. Our goal became about expanding the taste of the audience and getting them to accept and love something that might initially seem different than the other CG-animated movies they have seen in the past."

Looking back, the director sees the sequence as a big cornerstone. "We were able to share our version of New York, which had this special color palette and visual representation of movement," he notes. "It was the wildest apex of what we had created so far in the movie. Of course, we ended up blowing the doors off the whole thing in the third act!"

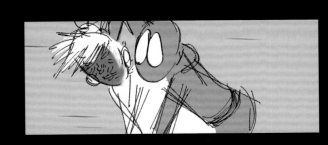
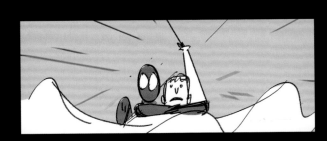

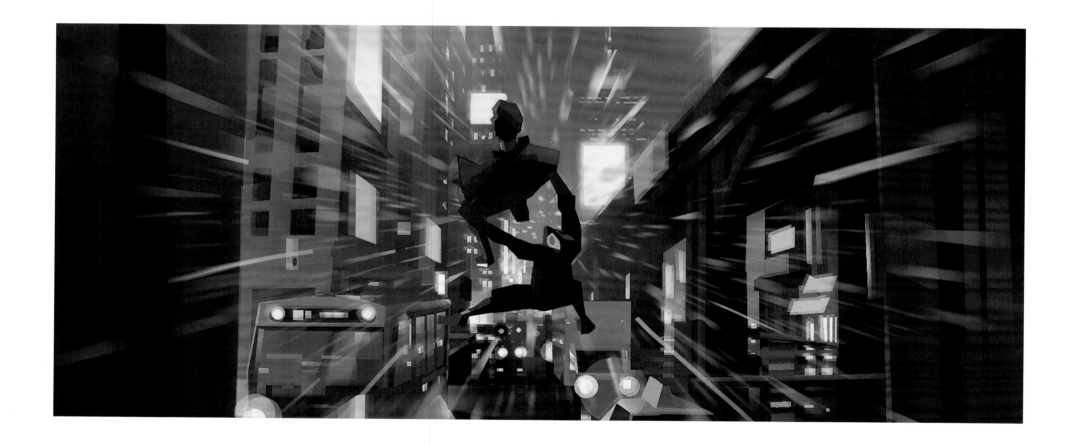

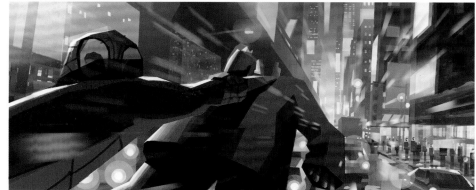

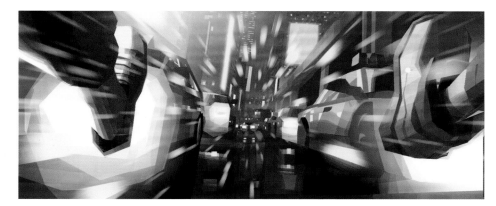

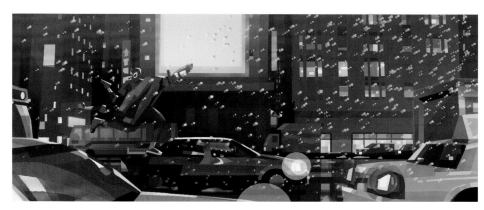

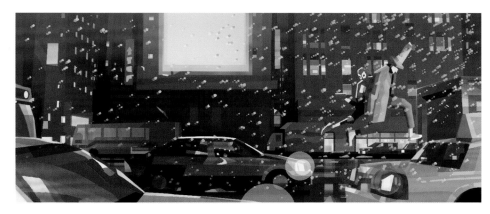

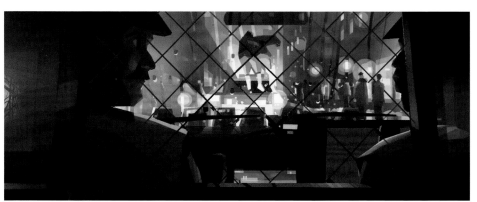

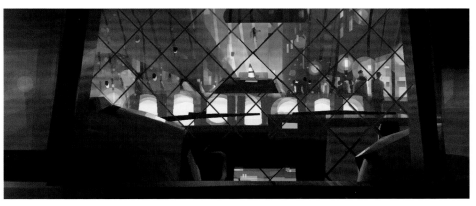

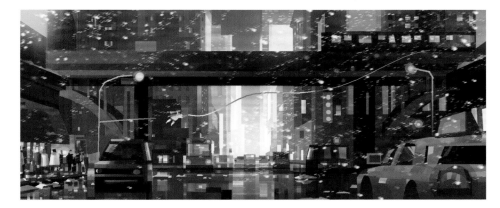

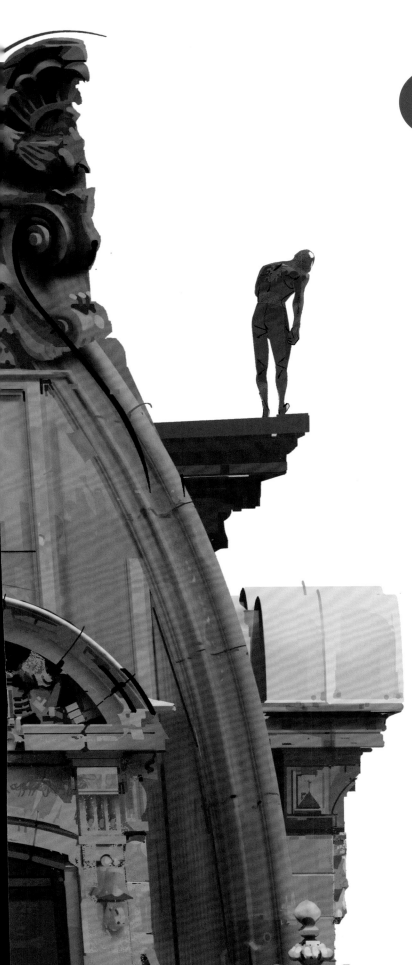

CONCLUSION

Every once in a while—if we're lucky—we are introduced to super heroes who reflect the values, culture, and diversity of the world that we live in. Miles Morales, the new hero of Sony Pictures Animation's bold and visually stunning feature film, is exactly that kind of a protagonist. Half-black, half-Puerto Rican, he is a smart thirteen-year-old boy with a good heart and loving parents, but he's initially reluctant to follow in Peter Parker's shoes. He may be quite different from the original Spidey envisioned by Stan Lee and Steve Ditko in Marvel's *Amazing Fantasy* comic back in 1962, but the heroic heart behind the mask still has the same appeal and honorable goals.

The talented team at the studio, led by executive producers Chris Miller and Phil Lord, and directors Peter Ramsey, Bob Persichetti and Rodney Rothman, have built a hugely immersive, dynamic world around Miles, weaving in visual cues that pay homage to the gritty origins of Spider-Man and the Golden Age of comic books.

As Kristine Belson, Sony Pictures Animation's president mentions, "We are trying to bring something fresh to the table, subvert expectations and take big chances. We want to surprise people with something that they haven't seen before by incorporating the graphic language of comics."

Thanks to the hard work, bold and unwavering vision and sheer talent of the artistic team behind the movie, *Spider-Man: Into the Spider-Verse* is bound to find a special place both in the hearts of comic book lovers and the pantheon of super hero movies.

LEFT: Concept artwork by Craig Mullins.
NEXT PAGE: Character sketch by Jesús Alonso Iglesias.

ACKNOWLEDGEMENTS

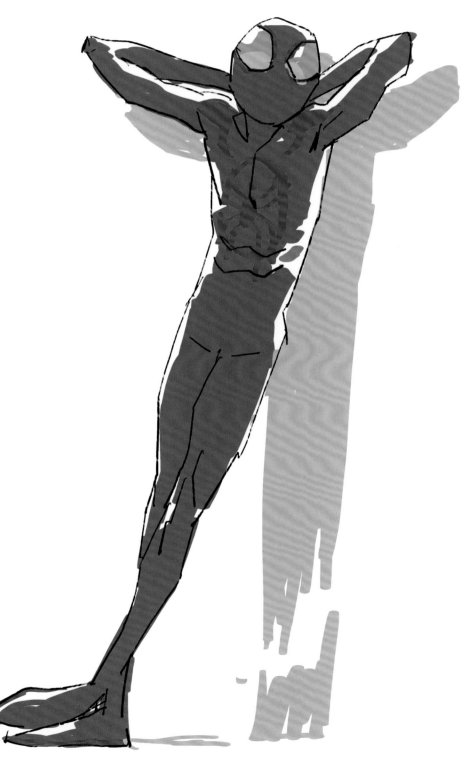

The author would like to thank the amazing team at Sony Pictures Animation for allowing me to tag along for the fun ride with the new Spidey into the mind-bending world of the Spider-Verse. A huge thanks to the brilliant Justin K. Thompson for patiently walking me through the creative process, as well as all the amazing team, including Kristine Belson, Amy Pascal, Avi Arad, Phil Lord, Chris Miller, Peter Ramsey, Bob Persichetti, Christina Steinberg, Dean Gordon, Paul Watling, Danny Dimian, Josh Beveridge, Shiyoon Kim, Patrick O'Keefe, Miguel Jiron, Marcelo Vignali, Peter Chan, Yashar Kassai, Zachary Rets, Yuhki Demers, Christian Hejnal, and Jeffrey Thompson. It was a real honor to hear your stories about the making of the movie. Thank you, Melissa Sturm and Zachary Norton, for being my awesome tour guides on this journey. A special thanks to the lovely and brilliant editor Ellie Stores at Titan Books, who was there beside me every step of the way and loved the Spidey ride as much as I did. Thank you to Tim Scrivens for his incredible work designing these pages. Last, but not least, thanks to the one-and-only Stan Lee and Steve Ditko who created a timeless character who still intrigues and entertains fans all over the world, fifty-six years after he was first introduced. As the TV theme song goes, "In the chill of night, at the scene of a crime, like a streak of light, he arrives just in time!"

Titan Books would like to thank all of the people at Sony Pictures Animation and Marvel who brought the Spider-Verse to life and then took the time to talk to us about it afterwards. In particular to Jeff Youngquist, Caitlin O'Connell, and Jeff Reingold at Marvel Publishing. At Sony Pictures Animation a special thanks must also go to Melissa Sturm, Zachary Norton, and Kyle Rapone. Our gratitude to Brian Michael Bendis for writing the foreword and sharing his thoughts on creating the character Miles Morales.

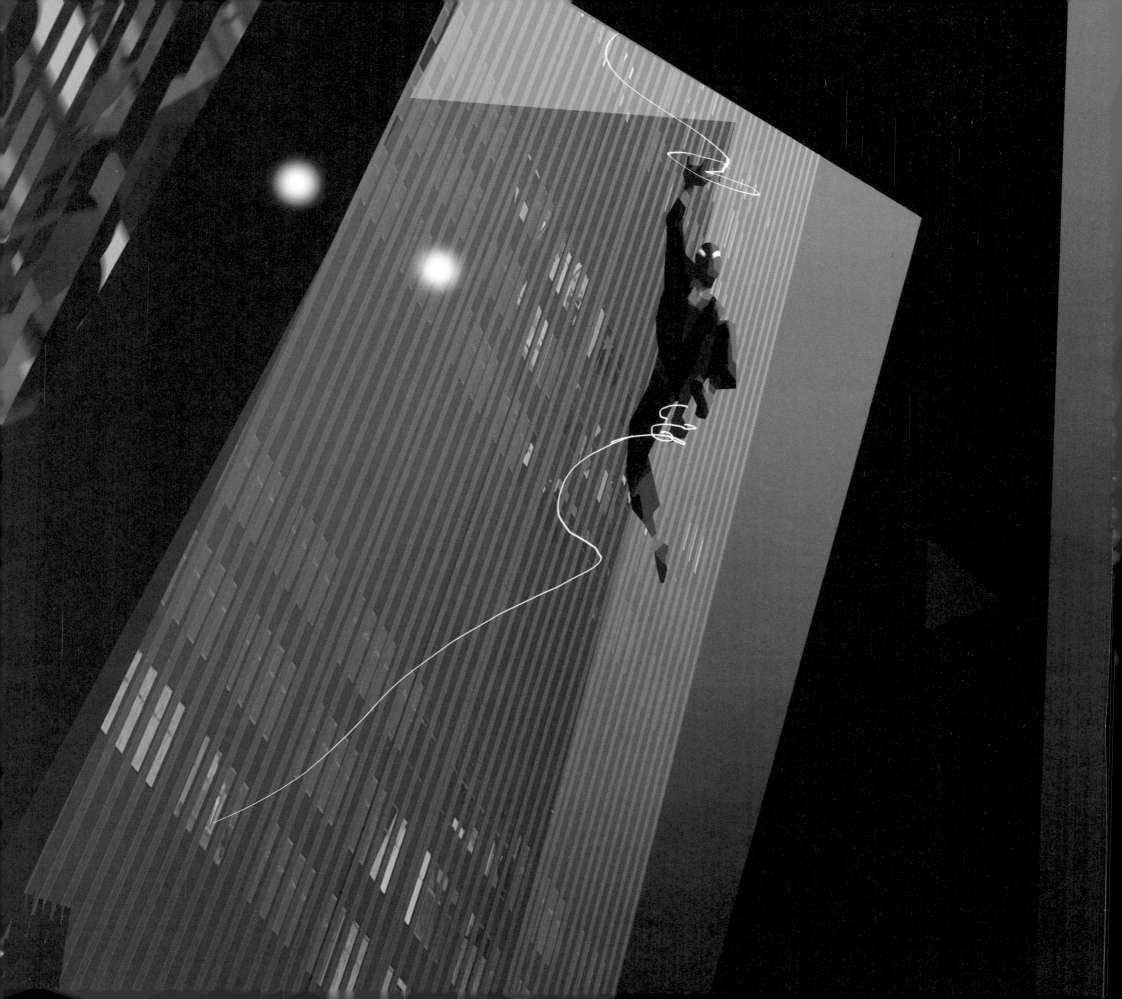